Stan Robbins

Books written and/or illustrated by Cathy Johnson

Quiltwear
The Local Wilderness
Painting Nature's Details in Watercolor
Watercolor Tricks and Techniques
The Nocturnal Naturalist
The Wild Foods Cookbook
Drawing and Painting from Nature
On Becoming Lost: A Naturalist's Search for Meaning
Missouri: Off the Beaten Path, with Patti DeLano
The Sierra Club Guide to Sketching in Nature
Creating Textures in Watercolor
A Naturalist's Cabin
The Naturalist's Path
Quiet Water Canoe Guide, New Hampshire, Vermont, with Alex Wilson
One Square Mile: An Artist's Journal of the American Heartland
A Rainy Day, with Sandra Markle
Kansas: Off the Beaten Path, with Patti DeLano
Nature Walks
Living History: Drawing on the Past
First Steps in Watercolor
First Steps in Drawing
The Walker's Companion
Who Was I: Creating a Living History Persona
Walk Softly: Moccasins in the Primary Documents

The Sierra Club Guide to

Painting in Nature

The Sierra Club Guide to

Painting in Nature

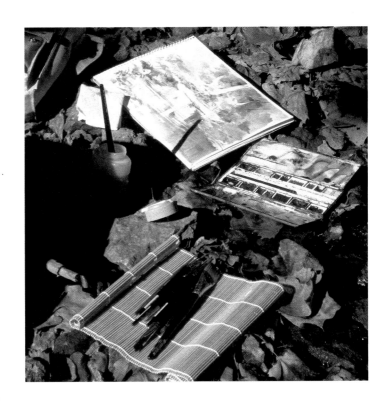

Cathy Johnson

Sierra Club Books / San Francisco

The Sierra Club, founded in 1892 by John Muir, has devoted itself to the study and protection of the Earth's scenic and ecological resources—mountains, wetlands, woodlands, wild shores and rivers, deserts and plains. The publishing program of the Sierra Club offers books to the public as a nonprofit educational service in the hope that they may enlarge the public's understanding of the Club's basic concerns. The point of view expressed in each book, however, does not necessarily represent that of the Club. The Sierra Club has some sixty chapters coast to coast, in Canada, Hawaii, and Alaska. For information about how you may participate in its programs to preserve wilderness and the quality of life, please address inquiries to Sierra Club, 85 Second Street, San Francisco, CA 94105.

www.sierraclub.org/books

Published by Sierra Club Books, in conjunction with Random House, Inc.

Library of Congress Cataloging-in-Publication Data

Johnson, Cathy (Cathy A.)
 The Sierra Club guide to painting in nature / by Cathy Johnson.
 p. cm.
 Includes bibliographical references and index.
 ISBN 0-87156-934-5
 1. Plein-air painting—Technique. I. Sierra Club. II. Title.
ND2365.J65 1999 751.4—dc21 99-14619 CIP

10 9 8 7 6 5 4 3 2 1

BOOK DESIGN BY BARBARA MARKS

Dedicated, with love,
to the memory of Harris Johnson

Acknowledgments

THIS BOOK HAS BEEN both joy and sorrow, challenge and frustration—like life itself. There were many who helped me through the process, and to them I owe my deepest thanks. My editor at Sierra Club Books, Jim Cohee, is always encouraging and helpful, patient and wise—he has become a friend over the years we've worked together. Hannah Hinchman and Clare Walker Leslie, fellow painters and naturalists, were both inspiration and friend. Artist Thomas Aquinas Daly has been a guiding light. Grateful thanks go to Richard Busey and his wife, my sister Yvonne, who shared insights and painting time in the desert; Judy Gehrlein, who inspired and encouraged and painted with me; Greg Albert, my longtime editor at North Light Books and now editor in chief, who so graciously helped with this one, as well; Roberta and Keith Hammer, who helped in so many ways; Radford and Judy Polinsky, Mike Williams, Rick Sherman, John Johnston, Joseph Ruckman, Camille Przewodek, Dennis Miles, and Karen Mullian, who offered insights, read parts of the manuscript, kept me thinking, helped me to focus, made me laugh, kept me warm, and encouraged me to keep at it even when things got tough.

Contents

Acknowledgments ix

Introduction xiii

1 **Painting on the Spot** 3

2 **How to Sharpen Your Powers of Observation** 19

3 **Mediums and Techniques** 29

4 **Gearing Up for Outdoor Work—
 Beyond Choosing Your Medium** 67

5 **Getting Started** 81

6 **Basic Elements of Landscape** 101

7 **Catching the Changing Effects of Light** 135

8 **Painting Through the Seasons** 153

9 **Flora and Fauna** 175

10 **Finding a Special Place:
 Relationship Between an Artist and Landscape** 203

11 **Demonstrations** 211

 Appendix I Where to Buy Equipment and Supplies 237

 Appendix II Workshops and Outdoor Painting Opportunities 241

 Bibliography 245

Introduction

THIS IS A BOOK about painting on the spot, about how to paint from nature—but it's also a book about seeing, and about responding to what we see in a deeply personal, meaningful way. It is about finding our own path. It's about taking time to observe, about slowing that headlong rush long enough to see, really *see* the world around us. It's about allowing ourselves to forge a relationship with nature that will last a lifetime. It is a dance—a joyful one at times, tentative at others; loving, vital, exciting.

Creativity is an intensely human activity that belongs to all of us. It sets us apart from the animals, it puts us in touch with the angels. We do it all the time. When we create order out of chaos, when we make a serene place to live in, when we make peace between warring factions (even if they are our teenagers), when we cook a good dinner or plant a beautiful flower garden, when we whistle a tune, when we throw on our clothes with a bit of panache, when we make sense of the senseless—we are being creative. Painting is just another facet of the larger picture—the one that's gotten most of the press.

"Painting shouldn't be an esoteric activity practiced only by geniuses and weirdos," says Judy Gehrlein, artist and teacher—and she's right. It can be as natural as breathing and as much fun (and as sensuous) as dancing; it can also be as precise as fly-fishing and as satisfying as bread. Even if you've never touched brush to paper before (and most of us have, in school), don't let that stop you. The finished product isn't really what matters; it's *process* that brings the satisfaction, if you'll let it.

The watercolorist Ed Whitney once said, "There are two reasons to put paint on paper—to communicate an idea or an emotion and to decorate a surface. The more interesting and more important goal is a

synthesis of both." It's a goal we can aim for when painting outdoors—making a painting, and communicating our feelings about nature and our place in it. It is an invaluable record, even if no one sees it but ourselves.

My own paintings of the world around me let me recapture a moment with an almost exquisite clarity—not through the paintings themselves, some of which are pedestrian indeed, but through the way they trigger memory of the time I spent in the painting.

In this book we'll explore ways to paint outdoors. It *is* different from studio painting, both more challenging and in many ways more satisfying. You see things you would not when you are closeted away in air-conditioned comfort. You hear birdsong and the clamor of spring peepers. You feel the wind on your face.

You may also find it difficult, at first. We're not used to trying to paint, after all, with that wind catching at our paper and drying the paint more quickly than we expect. You may be the main course for biting insects, or you may sit too close to poison ivy. This book is intended to guide you past those drawbacks, tell you how to prepare for the difficulties, and show you how to enjoy the process with the least amount of discomfort. It's more than worth the effort!

Here we'll explore how to prepare our gear to fit the challenge—things will go much easier if you take only what you actually need. It's sometimes a long walk from the car to the locale where you want to paint. And even when it isn't, painting on the spot can be such a fleeting experience as the light changes moment by moment, you won't want to spend half an hour setting up.

You'll notice that many of the illustrations in this book look different from those of most art books. That's because instead of being shot in a controlled studio environment, with photofloods and a tripod, they were taken on the spot—as the paintings progressed. The paintings were laid on the ground or in the grass. We hope that brings home to you that this book really *is* about painting in the out-of-doors.

We'll also discuss preparing mentally. Expectations may need to be adjusted somewhat, not only because we won't be lugging along everything in the home studio, but because life most emphatically intervenes in the field. What will you do if it starts to rain? It's happened to me on a number of occasions. Can you protect your work so what you've done so far isn't destroyed? Have you chosen a place to paint that will allow you to continue until you get finished? Sometimes your car or a handy shelter is an option. If not, will you come back to finish another day?

You won't have air-conditioning—but you'll have fresh breezes

scented with desert or forest or seacoast. You may not have a comfort-able painting chair—but the view can't be improved upon. Choose your spot carefully, and you can have an immediate source of water without having to carry it along—preferably not falling from the sky, of course!

There's a wonderful freshness about a painting created wholly on the spot. Sure, it's still possible to overwork and create a muddy mess. I've done it! But as you get more used to the process and learn to focus, to edit, and to use your time wisely, you'll find clean, fresh images appearing on your paper more often than not. It's a process that is actu-ally aided by the apparent inconveniences. The light changes quickly; you get tired sitting on the ground; the mosquitoes find you—so you learn to work quickly to capture the essence of the scene. If you need to return to the site later, or finish in the comfort of your own home—fine. But often you'll see, with the perspective offered by the passage of time, that nothing further needs to be done.

If it makes you happy to finish up where you are more comfort-able, do that instead—some of the original plein-air painters did. Just be careful not to kill the freshness.

By definition and tradition, plein-air painting is done all in one go. But we're not painting definitions or traditions, we're producing paintings we will be happy with. We are forging connections. We are recording our response to nature, and to a moment in time. We're creating.

Those of us who enjoy the outdoors in other ways—hiking, fish-ing, picnicking, backpacking, photography, and so forth—will find painting outdoors simply adds another dimension. We stop and take notice, and respond to what we see in ways we may not have consid-ered before. Recently, after a long bout with illness in my family, I found that the time I spent outdoors painting each day added immea-surably to my peace of mind and refreshed me more thoroughly than a night's sleep. It gave me the strength and perspective I needed to deal with the problems life was handing me. It also gave a balance to my days. It was reward, and relaxation, and just plain fun.

When I found a painting buddy to accompany me at least part of the time, my enjoyment only increased. We talked about art, and life, and a dozen other things, and we noticed the world in completely dif-ferent ways. Her paintings of virtually the same scene look very differ-ent from mine—it was fun comparing how we saw the subject we had chosen, and we learned a great deal from each other.

Perhaps you won't make a painting worthy to hang in the Louvre; I won't either. Maybe you won't ever even make anything

you'll want to show another soul. Does that matter? Should you deny yourself the opportunity to create, simply because you won't make a living at it, or because someone else may not appreciate it? Art is joy, it is action, it feeds your soul.

The fact is that painting is another way to respond to nature, to learn about the world about you. It gives you yet another reason to be out where beauty happens without your having to do a thing to make it so. Subtly at first, and then like a rising symphony, you hear the first achingly clear notes of birdsong interwoven with a breathy woodwind breeze. The sun kisses your face and that same wind seems to caress you. You see things you've never seen before, though they've been there all along—*you* weren't, not fully. When you paint in nature, you slow down, you take a deep breath, you *notice.* You'll notice the heart-stopping blue of a bluebird, the almost prismatic, luminous grays of a fogbank, the gold of autumn prairies punctuated by wildflowers. You become aware of the scents and sounds that surround you as you sit with your paints and that wonderful blank paper, full, already, with possibility. It's a gift to yourself. If it goes no further than that, it is enough.

What you respond to doesn't matter. I would as soon paint the skull of a deer as the loveliest flower; the subject is as wonderful and the time spent is as satisfying. I am at my happiest when I use my artist's tools as a way to learn, when I am not just making art, but living my life.

The Sierra Club Guide to

Painting in Nature

Painting on the Spot

THE PRACTICE OF PAINTING on the spot, or plein-air painting, as it has been called, entered the limelight with the Impressionists in the 1870s, with the works of Monet, Cézanne, Cassatt, Manet, Pissarro, Renoir, Boudin, and the like. However, it had certainly existed before that time. The first artists who decorated the cliffs in the American West worked outdoors, as did those who carved images in stone in ancient Britain and Ireland. In the eighteenth century, artists often worked to capture what they saw on their Grand Tours of Europe. There are a number of paintings of artists, male and female alike, at work in the outdoors, giving us a hint as to working methods and commonality of the practice,

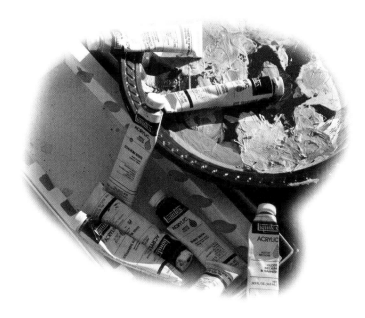

and reminding us that although more formal studio work was the norm, it was by no means the exclusive method of painting during that period.

The artists who accompanied various expeditions of discovery in our young country worked out-of-doors—that was the whole point. It was never a concern of the artists themselves—at least the best of them—to create a movement or a genre. I suspect most simply thought—I have to paint that. Because painting on the spot *is* addictive. The more you paint, the more you see that you *want* to paint. It's an exciting old world out there, full of beauty and life. When we begin to respond with an artist's eye, no matter how tentatively, we are building a relationship.

It is fascinating to look at the work of artists like John White, the first governor of the Lost Colony of Roanoke, who painted what he found in this new country in the 1580s, and the paintings of Karl Bodmer in the nineteenth century, to see not only what the land looked like, but how they worked to capture something of the reality of what they saw.

In Bodmer's case, particularly, the body of work at the Joslyn Art Museum in Omaha, Nebraska, clearly shows the technique of the young Swiss painter who accompanied Prince Maximilian of Weid up the Missouri River in 1833. Quick sketches and unfinished works depict the river and the wildlife found there in ways that teach us about not only the land itself but much of the artist's working methods. Those methods are, in fact, timeless. It is as though Bodmer purposely

This painting is done in a style that has been popular with artists from Rembrandt to Bodmer—pen and ink with a watercolor wash on top.

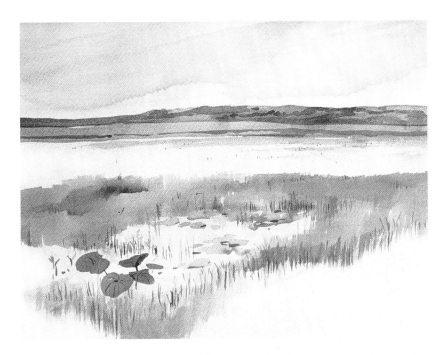

Close to my home is an ancient oxbow of the Missouri River; it may have been the original channel when Lewis and Clark traveled on the first leg of their Voyage of Discovery to the West in 1804; it may have been what Karl Bodmer saw in 1833. It fascinates me and seems to contain much of the history and natural history of my area—I've haunted it for twenty years and more, and done literally dozens of paintings and sketches. This watercolor is one of my favorites. The painting is simplified, but still captures the reality of the spot with its broad expanse of still water, American lotus, reeds, and other aquatic plants that have grown there since the river abandoned it fifty years ago.

left a record of the step-by-step process used to create these evocative paintings; we can learn a great deal about working in nature from looking closely at his work.

We can see where he chose to do quick pencil or ink sketches and lay washes over them—still one of my favorite methods for working on the spot. We can see his use of negative spaces, painting the area *around* his subject rather than the subject itself, a technique used by countless contemporary artists, but surprisingly few in the past. We can find the use of opaque white combined with watercolor to give added dimension and depth or to suggest fine details.

The fact that much of what Bodmer painted is gone or irrevocably changed makes his paintings doubly poignant. The mighty Missouri

River is dammed, channelized, and leveed so that it barely resembles the historic "Pekitanoui," as it was called by the peoples who once lived in its floodplains. Then it was wide and shallow and braided in ornate natural channels, a haven for millions of migrating birds. To see Bodmer's work is to view a different river altogether from the one I cross near Liberty, Missouri. As we paint our impressions of the landscape as we find it, we make the same kinds of irreplaceable records, for change is a constant, even today. Since the 1993 floods on the Missouri, I can track the transformation in the more manicured stream it has become.

The paintings of Winslow Homer do the same for the Maine coast, the ocean, and the islands, as Georgia O'Keeffe's did in the American Southwest. We can almost feel what their lives were like and sense their connection to the scenes they loved.

We form a relationship with wildness when we stop to paint it, more so when we return to the same spot over and over. We enter into conversation, as van Gogh suggested. We may fall in love. We may find where we belong, and what belongs, in a larger sense, to us.

John Constable, J. M. W. Turner, Corot, Pissarro, and Monet also worked from nature—whether labeled Impressionists, Hudson River School painters, or some other appellation, there were plenty of artists who worked outdoors and painted what they saw. George Catlin captured the vanishing Native American tribes, as had Bodmer before him. The flamboyant and dedicated John James Audubon worked passionately and single-mindedly throughout his life to catch the birds and mammals of America on paper. We also have a few sketches and rough paintings of the people and locales he visited. There are many paintings of Victorian artists working in nature; the form reached a kind of zenith in the nineteenth century, and even Queen Victoria herself enjoyed painting outdoors. She kept a stable of painters who recorded her pastoral landscapes and their people, as well, and to this day painting out-of-doors is much more common among British artists than American ones.

The great naturalists and landscape painters offer a picture of their times, a window into the past. Charles Herbert Moore, Thomas Moran, J. M. W. Turner, and even John Singer Sargent, when he became fascinated with watercolor and tired of commissioned portraits—these are our heritage.

But many of us have chosen to paint to express ourselves, not with the expectation of making great art. We paint for the sheer fun of it, or out of a need to create—something, anything. There's no need to imagine we have to be an artist or become one, professionally, at least. As the author Henry Miller wrote, "I had learned to harness ignorance

with presumption. I was ready to become an unacknowledged water-colorist." I love the blend of rueful humor and reality of that statement! And of course it holds true for any medium, when we attempt to capture what we see on paper or canvas—or what we feel.

Whatever your interest, from finished painting to field sketch, from landscape to microcosm, you can explore it with brush in hand and make not only a record of your own passing hours and your discoveries, whether large or small, but a record for others of a transient moment in time; painting, it has been said, is another way of keeping a diary of our lives.

But as van Gogh said—the language of nature is far more important than the language of painters. We may learn from those who have gone before, to be sure. It is wonderful to see the body of work that these men and women produced; we can't help but be inspired. But until we enter the conversation ourselves and respond to the beauty around us in our own way, what we produce is but a reflection of someone else's vision—a hearsay account of an authentic experience. We have to trust ourselves to find our *own* way of expressing this encounter. Each time we try we come a little closer.

Painting outdoors is a vast storehouse of inspiration—you will never run out of subject matter. Painting through the seasons or through the hours of the day, painting some exotic locale or the raging snowstorm through your kitchen window—each provides its own satisfactions.

I've painted many a watercolor in the comfort of my studio, from sketches or photo references, from memory or imagination. I am often satisfied enough with the results. But there is nothing like being out there, working in the field, to truly satisfy my soul. The finished product may not be close in quality to what I can produce under controlled conditions—not, in any case, a work of art. But the results are intangible as well as tangible, and go far beyond merely making a pretty picture.

In Europe, working on the spot is often the norm. Massachusetts artist Clare Walker Leslie has gone to Europe several times to work and study with artists who find this the only way to go. She has developed a lifelong love for this method herself.

According to Plein Air Painters of America, the discipline "reflects the painter's interest in Impressionistic concerns, especially with the fleeting quality of natural atmospheric light and its

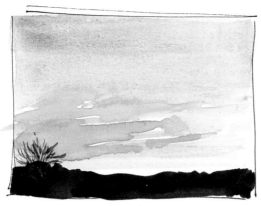

land is nearly black

One morning the sunrise caught my eye with its stunning coral and pink against a translucent sky. I decided to pay attention for a while, so painted it at ten-minute intervals—amazing how much change there was in that short time. And by the time the next ten minutes had passed the clouds had moved in and the color was gone.

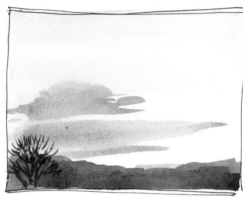

10 minutes later

beginning to have some definition

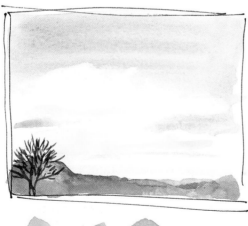

10 minutes later still

land is lighter now

interplay with the subject. The artists paint rapidly, always outside, to complete their work before the light can change substantially." Many of those nineteenth-century Impressionists themselves signed a letter that outlined their goals—they wanted to "bring art back to the scrupulously exact observation of nature, applying themselves with passion to the rendering of the reality of forms in movement, as well as to the fugitive phenomena of light."

That makes it a perfect modus operandi for many of us—quick, creative, and outdoors. Anyone who enjoys nature can benefit greatly from a new way of seeing this world of ours, and a new way of recording what we see. More immediate than the camera in many ways, this hand-eye coordination filtered through the creative, right side of the brain lets us respond instantly to light and circumstance. It's like a conversation. Nature opens with a salutation—you can ignore it or answer with your own response. As the light changes and time passes, you try to keep up—it can be almost like a fast-paced game of tennis or a stimulating conversation with a friend you like to spar with. It can be frustrating or exhilarating, depending on your mood, your temperament, or your goals—but it can never, never be boring.

Challenges

Painting on the spot *is* a challenge, and it's not only the changing light that keeps you on your toes. The wind kicks up, the temperature drops—or rises to sweat-trickling heights. Gnats explore your eyes and nostrils and a mosquito settles in to feed on your forearm. Your behind starts to feel like granite and your spine like concrete. There are, of course, things to do to make the process more comfortable, and we'll explore them in a bit.

It isn't only nature itself that presents a challenge. If you are shy, other human beings can present an occasional trial to your equilibrium or concentration. Comments can range from downright funny to bizarre, but most people are only honestly fascinated by what you're doing. There is a kind of magic to making a painting, and it's almost impossible *not* to watch someone who's doing it.

My favorite spontaneous comment came from a couple of lads in Maine who happened by as I painted the lovely spikes of lupine that grow by Penobscot Bay. "That's *wicked*," one boy exclaimed. Fortunately, I knew that in Maine, wicked means "good" and not an indication of some fatal flaw in my painting! I grinned my thanks and kept on working.

One of the most often heard comments is: "My aunt/niece/son [fill in the blank] can paint so well it looks like a *photo.*" How you choose to answer this somewhat puzzling remark depends a lot on your personality. Assuming it isn't a comment on my own lack of ability—and it usually isn't—I just say, "Good! He/she should keep it up." Others are not so patient (or so used to dealing with spectators)—so if *you* find yourself inclined to make a similar comment to an artist at work, don't.

Sometimes kibitzing visitors may lean over your shoulder and note that your painting doesn't *look* like a tree. (As someone has said, it isn't—it's a *painting* of a tree. A real one would never fit on that flimsy

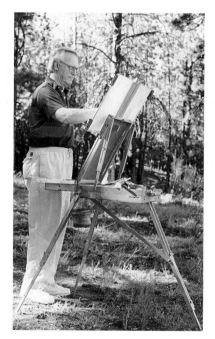

Richard Busey working outdoors in the West, with a watercolor easel

paper.) You can treat such comments with humor—and say something similar to the above—or just try to keep painting and pretend to be so engrossed you didn't hear. Actually, you probably will be, and that seems to keep most observers at a respectful distance.

Most kibitzers have the best of intentions, in any case. When I discover a subject I just have to paint from the highway—and it's best not to attempt this from an interstate, where it is actually illegal—I often find at least one Good Samaritan stopping to ask if I have car trouble. While I appreciate his or her goodwill, it's hard to imagine someone with a flat or an overheated radiator hauling out the folding stool, water jug, paints, watercolor block, and brushes and setting up to work beside her disabled automobile. However, a simple "Thanks! Just painting!" usually sends the helpful party on his or her way, feeling good about having offered—and we all win.

If you are truly bothered by onlookers, you'll want to find a place to work that is off the well-beaten path. That's usually not too hard. When I can, I tote a lightweight painting kit as far away from other humans as possible and sink into the natural world. If this makes you feel vulnerable and you find yourself looking about nervously, find a painting buddy. I go with a friend about 10 percent of the time, and it's both fun and rewarding to see how someone else responds to the same surroundings. It is probably safer, as well.

You might enjoy going with a whole *group* of other painters. My brother-in-law, the artist Richard Busey, was the workshop chairman for the Nevada Watercolor Society for some years. He tells me that

they have a dedicated group of painters who work outdoors together, no matter what the weather. They not only have the benefit of safety in numbers, they also have the advantage of seeing how others respond to the same scene. That can be an eye-opener.

It can also offer the opportunity to learn more about outdoor gear. Almost always, someone else in a group has discovered some little jewel at the art supply store. Or perhaps he or she has modified some common household item that works better than whatever it is you are using in your "traveling studio." We will cover some of these in Chapters 3 and 4.

Working responsibly in nature goes without saying. The old adage "Take nothing but pictures, leave nothing but footprints" applies as much to artists as anyone else. Used paint rags have no place in nature, even if they are biodegradable paper towels. Make sure you've found all your brushes and pencils. Check your painting area before you leave, and be careful with your gear. I was once mortified when I turned over an entire jar of liquid latex masking agent on an oceanside rock and it ran down into a crystalline tidepool. It quickly congealed on the lovely formations I had been admiring, turning them to a gray gunk. I cleaned up as much as I could, but it was not a good feeling.

Benefits

No one ever said painting on the spot was as easy as working in your studio. But in the studio you won't hear the prehistoric *"skronk!"* of a great blue heron or watch it reel overhead on pterodactyl wings. You won't see a storm of snow-white pelicans swirling over the lake. You won't be serenaded by chorus frogs or whippoorwills, or feel the caress of the evening breeze. You won't see the sudden illumination of a range of hills as the

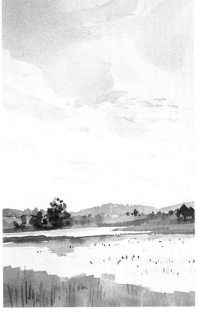

This painting of Cooley Lake is quite simple. I was interested as much in the sky as I was in the lake—here, more so. The clouds were textbook illustrations of meteorology and of the kind of perspective you can find overhead.

light breaks through the clouds, bringing a catch to your throat. You won't have the vast solitude of wilderness around you, with delicious distractions that are far different from those of home and responsibility. It's a trade-off I'm more than willing to make.

Speaking of memories, one of the most marvelous reasons to paint on the spot is to preserve those wonderful travel memories. They seem to have a life, a vitality, far beyond the usual snapshots and postcards. My friend Judy Gehrlein took her small traveling studio with her to Paris and produced a number of wonderful little sketches, studies, and paintings. This quick one is of the flowers and trees on the street near where she stayed.

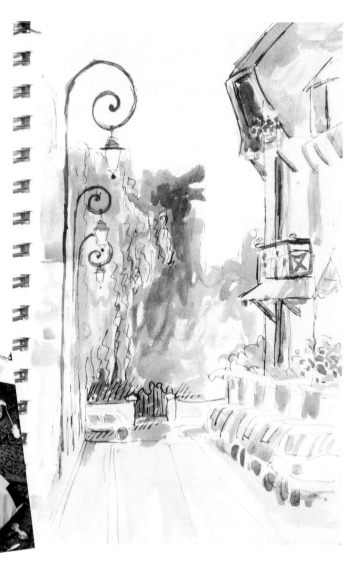

Judy's traveling studio

There's more to it than the chance to be in nature, alone or with others; I could do that without lugging along painting gear. When I paint what I see I am responding to the beauty before me. I am attempting to preserve it, if only in my own mind—for, truth be told, sometimes my efforts on paper have little enough to do with the scene, or even what I hoped to produce from it! For one reason or another—fatigue, lack of time, or even lack of skill—what I produce often has more value to me as a reminder, a keepsake, than as a piece of art. And that's perfectly all right with me. I am not there to create a masterpiece; I don't expect that of myself. If I did, I'd be afraid to touch brush to paper. Instead, I am responding to something I love, and making memories.

Dealing with Discomfort

First, we need to accept the fact that a certain amount of discomfort will simply be there, so we will be mentally prepared to meet the challenges it presents. It's like the difference between staying in a modern motel and camping. There are great benefits to camping—waking in the very midst of birdsong, filling your lungs with the freshness of morning, is wonderful. But you won't feel quite like you would have if you had slept on a great mattress with a shower and room service at your beck and call. If you are mentally prepared for the differences between working in a home studio and working outdoors, the inconveniences will seem slight indeed. If you are *not* ready for them, they may seem insurmountable.

To avoid that kind of frustration, then, we need to be prepared physically as well as mentally. Insect repellent will help with mosquitoes, chiggers, ticks, and blackflies—just be sure to wash it off your hands because it can affect how your painting surface accepts pigment. Wear a broad-brimmed straw hat in summer to protect your head from dive-bombing deerflies—common in my part of the country—and you'll reap the added advantage of staying cooler and having a bit of shade for your painting surface.

Often, artists who work outdoors will take along an umbrella. This can provide shade as well as protection from the sun. Ones made specifically for artists are generally white, which will shade you and your painting surface while still allowing a soft, diffused light to come through.

Try to position yourself out of the wind, if possible. It not only will try to snatch your painting surface away from you but, depending on your medium, can make it dry more rapidly

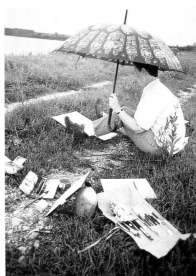

Judy with umbrella

than you want. It can also accentuate a chill in the air. Look for a landform of some sort to provide a little protection—a bank or hill or rocky bluff. In cool weather, try to make sure you will receive sun, too—with a rock bluff at your back and the sun falling on you, you can stay comfortable far longer.

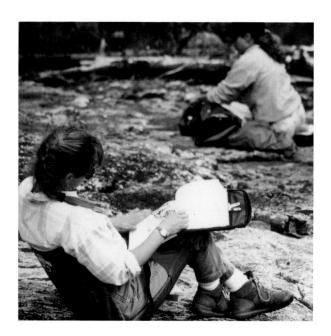

Artist/naturalist Hannah Hinchman, author of *A Trail Through Leaves,* says she always takes her folding portable Crazy Creek chair for working outdoors. It attaches to her knapsack and makes for comfortable working conditions.

I have a small square cut from a foam pad meant for sleeping on when camping that fits nicely in my knapsack. It's just large enough that it helps keep my backside drier in wet weather and it's also a bit kinder to sit on than the hard ground. You may want to go all out and take a lightweight folding stool or chair if your back needs it—I find it easier to sit on the ground with my square of blue foam. (I used to take a tiny folding stool until I found myself sinking into the soft ground beside a lake as I worked. I managed to fall over backward trying to catch myself! Must have made quite a sight . . .)

There are a number of pictures of the original plein-air painters with folding easels, stools, and umbrellas, and in fact an original Winsor-Newton art catalog from the nineteenth century offers a painting tent. It was a simple wedge, like a military tent of the time, or a child's pup tent, and provided open-ended protection as well as a bit of shade.

Get up and move around occasionally—a good stretch will help prevent fatigue or stiffening. A few yoga exercises may help, but usually just standing up and walking around a bit will do the trick.

Be sure to take something to drink as well as liquid to paint with. It can be very frustrating to find yourself just getting rolling with a painting you really like, only to discover you're suddenly parched for water. In hot weather, ignoring that thirst can be deadly. A Thermos or other water container will keep you much more comfortable for a longer period. If you like and if the weather warrants, hot coffee or tea is a welcome addition to your painting gear.

Likewise, a piece of fruit, a carton of yogurt, a bit of cheese, an energy bar, candy bar, bag of nuts, or even a sandwich will let you enjoy your stay without the rumblings of hunger—or the shaky hands that sometimes result.

If the weather is likely to change, a sweater, windbreaker, or pon-

cho may be a good idea. The longer you can keep yourself relatively comfortable, the longer you can work with genuine pleasure.

Changing light conditions are a given with painting on the spot. Here, you will need to learn to work fast, return at the same time each day to work under similar conditions, or create a value sketch to help you remember the position of shadows—but we will cover this in the section on painting light and shadow.

Be flexible and prepared—and if not that, then be ready to improvise, because the opportunity *will* come up. No one says your painting must be done on a piece of fine paper or mounted canvas. If all you have is the back of an envelope, use it! When I got the chance to paint this group of raccoons that showed up on my deck, playful as a circus troupe, I was completely out of paper. The chance was too good to pass up, though, so I grabbed my sketchbook and tried to get down the basics on the cover.

I sketched the busy, playful coons first, but then it was obvious they weren't going anywhere as long as I didn't startle them, so I went carefully to get my paints to add a little color and definition.

If you are going into the truly wild places to paint, stay alert. Don't get so engrossed you are unaware of approaching wildlife. A buck in rut is a dangerous animal, and so is a mother bear protective of her cubs. Wherever you are, don't mistake wild animals for pets. Resist the urge to pet or feed them. It's not good for the animals to become acclimated to humans or dependent on our handouts, and if they bite or scratch you, it will definitely put a crimp in your painting expedition. Seek medical attention ASAP!

Dogs are a more likely problem when painting outdoors, for most of us. Staying calm is one of your best lines of defense. Once I stopped to write and sketch a bit, sitting on the ground, when suddenly I heard a rustling in the underbrush. An excited bark joined by several more brought instantly to mind my neighbor's warnings of a pack of feral dogs that had been decimating pets and carrying off the occasional chicken. I felt very poorly armed with only my watercolors and walking stick. Had they caught my scent?

The dogs burst out of the buckbrush, stopping in midstride when

they saw me; perhaps they hadn't smelled me after all. They appeared surprised and confused. One, the leader, apparently, quickly recovered and bared his teeth in a snarl.

It was the ugliest dog I'd ever seen. Stocky and broad as a warthog, it was covered with a grizzled pelt of black and gray. It had strong jaws and a mouthful of fangs it was pleased to display in warning. Its forehead was broad and blunt, and one eye glittered oddly, pale as mist. The other dogs circled a few feet away, howling like banshees, but this one came within two feet, barking and snarling. I sat still, speaking quietly to the agitated animal (I couldn't think of anything else to do)—but keeping one hand on that stick.

"It's my territory, too," I told the critter. "I don't mean to trespass."

After a few minutes of this odd standoff, the other dogs lost interest. Maybe the sound of my voice reminded them of homes they once had. Without direction from their leader, they wandered away, snuffling and barking. Meanwhile the mutt decided I was no threat and promptly plopped himself beside me, apparently to keep me company while I painted. Since it seemed to be the thing to do, I went back to my business with profound relief and soon had lost myself in my work when I felt something warm and wet on my leg. The dog had claimed me as part of its territory, and I didn't know whether to laugh or to beat its silly head in with my stick. I laughed, and we've been sometime hiking partners ever since. The ugly thing joins me whenever he finds me in the woods, and I've not heard a sound from him since that day (nor been rechristened). He's woodswise and quiet, and seems to enjoy my company as much as I do his. When he stops to sniff at some invisible trail marker I invariably look to try to see what it is that's caught his interest. When I stop he comes to lean against my leg. Then, independent as a wild thing, he takes his leave when I head back to the relative civilization of my cabin.

Of course, most places you paint, the biggest problem you may encounter with wildlife is if a bird decides to make a deposit on your painting surface. Even that is unlikely to happen in most places, but Clare Walker Leslie recounts a recent painting trip to North Berwick, Scotland, where such things were a constant danger. Working closely with John Busby and other dedicated bird artists of the European tradition—which meant working outdoors almost exclusively—she wrote, "Gannets, oh gannets, are the best to paint as their postures, behaviors, cackles (and odors) are endless; but they leave you covered with whitewash and your freshly laid painting may be a random stream of orange goo across it. (This happened to me as one taunt-

ing gannet flew over and dropped a sliding mess across a painting I rather liked.)"

Was it worth it? Leslie thought so. She also wrote, "I love this kind of painting, this being out there with the birds swirling over you and hours and hours to draw and throw away and draw again. There's the sense of the whole process of being with wildness that counts, not of merely focusing on the finished work of art."

Familiarity Breeds Wonder

One of the best side-benefits of painting in nature is that the more you do, the more beauty you find all around you. Something you may have driven right by a thousand times is suddenly the material of a painting, once you are seeing with a painter's eyes. The world is infinitely more beautiful when we pay attention. I find that there are suddenly more things I'd love to paint than I'll ever have time to get down on paper.

Painting on the spot, quickly and in one go, offers fresh, immediate results—and immediate satisfaction. We're not as likely to overwork and muddy the results when we're working in this fashion, whether you're after completed paintings or sketches for future works. Don't be hard on yourself; you have no one to please but you. If your work seems unfinished and you feel you need to do more later—do it! If you want to use this as a sketch or a beginning for a later work, that's

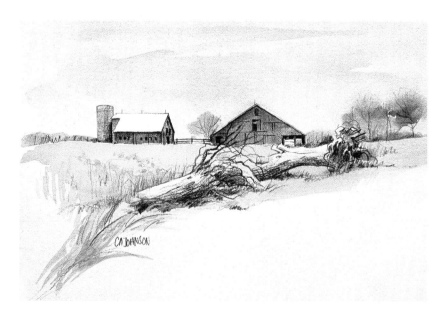

Barns from the road—colored pencil sketch and wash

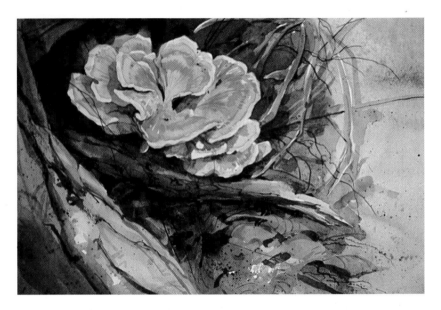

When I first painted this gorgeous bright fungus I was disappointed in my work—it failed to capture the wonderful contrast between the color of the shelf fungus and the drabs of the forest floor. I tucked it away for years, but on seeing it again, I like it much better. Now, it returns me to the magic of the scene, whereas before I was judging it on how faithfully it *captured* that magic. I realize that it preserved it better than I thought, and although it still has problems as a painting, I like it very much as a memory-catcher.

fine. Some of the original plein-air painters considered their work unfinished till they got back to the studio and added the final touches.

Keep at it. If you are dissatisfied with your results, go back and paint again tomorrow. And tomorrow again.

Interestingly enough, often a painting I disliked when I quit for the day will improve somehow overnight—or over time. It's a kind of magic that perhaps only painters know. Give yourself some slack. Give yourself time to gain some perspective, as well. We compare our work to the wonderful complexity of nature and find it wanting. We can't match that intricate, interwoven magic—there is simply too much. Attempting to copy it twig for twig usually results in a muddy, confusing, and overworked mess. We can only produce an impression of it. And that is enough.

Time in the outdoors, a way to record your experiences, a way to slow down and notice things you'd never see otherwise—these are the *guaranteed* results of a day—or even a few minutes—of painting on the spot. If you never produce something to hang on a gallery wall, you will have already gained the best results of all.

How to Sharpen Your
Powers of Observation

2

As a naturalist as well as an artist, one of the things I stress when I talk about what it is I do is how to increase the powers of observation—how to see, and how to understand what you're seeing. Not only does this heightened seeing improve the ability to appreciate the complexity of the world around us, but it makes us, quite simply, more alive. For an artist, that heightened awareness is stock-in-trade, and the skills of observation are invaluable.

 I'm not suggesting that to paint decently you must paint exactly what you see (or think you see), superrealist style. But what you see more clearly, without preconceived notions, you are able to express

more truly. You can respond to it in your own unique fashion, with your own mind and heart, and that, in the end, is infinitely more important than producing a work of art.

Take the time—it's worth it.

Listen carefully by a stream. Sort out the braided sounds—a mosquito's disconcerting hum, the chuckle of water over a small riffle, the syncopated drip of dew as it gathers at the tip of a leaf and falls on a hard rock below—and then a new noise, a musical chirring may be the voices of baby raccoons communicating with each other or with their mother. You may see them come streamside to search for crayfish or other aquatic creatures, with small black "hands" so like our own. Raccoons are amazingly dextrous, with clever fingers that can open anything from a mussel shell to the latch on my shed. Painting them is always a treat.

Build a little flexibility into your schedule to allow time to paint—raccoons or anything else that strikes your fancy—and give yourself permission to use it. Imagine your car bears a bumper sticker that reads, "I brake for *life.*"

Make use of "lost" time. When you have to wait, when the place that was supposed to be open early is not, don't fret and stew. Consider it a gift of time, found moments in a too-harried world. There's nothing else you must do, and nothing you can—so stop, look around, and see what's there to be seen. You may find yourself calmly regarded by a deer you would not have seen had your appointment been on time, or

I was stuck in the airport this spring, and rather than fret about how long this was all taking and when my delayed plane might arrive, I instead took that opportunity to capture the glorious mountains that surround Salt Lake in my traveling sketchbook.

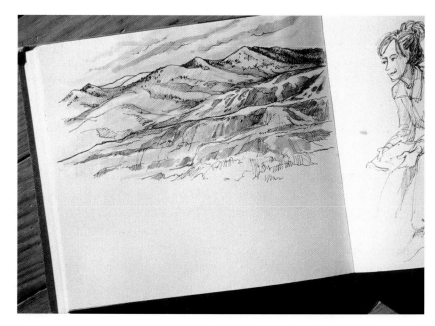

watching a raccoon make its way along a creek bank, leaving a ribbon of tracks behind it in the snow. Sometimes learning to see as an artist relies on just such serendipitous opportunities.

Walk slowly, looking from side to side with the eye of an artist. Sit down, look around, and wait for something to hit you. Be quiet, and listen to the hum of life around you. Let yourself *respond*—and at your own speed—you didn't punch a time clock here, remember? You don't have to paint the first thing you see, even if that something is rather nice. Find the thing that best expresses the day for you.

You may not even begin by thinking of painting. Some artists who enjoy plein-air painting suggest taking a picnic along with your art supplies. Then when you are settling into your surroundings, having a leisurely lunch, you can be considering the possibilities without jumping in too soon. I sometimes ease into my surroundings by taking a little while to sit and play my pennywhistle. Now this may annoy the wildlife, but it does serve to calm me down, and slow me to nature's timetable as well. And in fact, rather than frightening the wild creatures, sometimes the high, sweet notes seem to call them in closer—I've attracted a small band of chickadees and titmice that way, and deer seem to be curious rather than frightened, allowing me the opportunity, if I move very slowly and deliberately, to change from making music to making art and capturing their image on paper.

The sweep of landscape may be quite grand, but if you respond more fully to a patch of weeds sprouting from an old stone wall on your way to the big vista, paint that. If you *want* to paint the bay with fishing boats against dark fir trees at water's edge, fine; but if that's not what hits you personally, on an emotional level, keep looking. You may prefer the rough, hardy flowers just back from the edge of the sea, or the patterns the waves and tidal wrack make on the sand. Wait till *you* feel ready—and inspired. Or paint another day.

Winter Weed — seeds all over my paper, now

Even the smallest details are worthy of attention. This small winter weed caught my eye on the way to the compost heap, and I loved the subtle colors and the angularity of the delicate shapes. A quick little sketch was all it took.

Keep an open mind. If you're used to looking at a broad landscape with foreground, middleground, and background all in their familiar places, in their familiar proportions, see what it's like from another viewpoint. Lie down flat and look up at a tree. See what there is to see at ground level; a mouse's-eye view is one not often explored, and your subject is simplified—and clarified, distilled somehow—at the same time. Climb that cliff and look down on the landscape.

Even if you want to do an abstract painting, good observational skills are a great asset. It may be simply a juxtaposition of unexpected colors (nature's good at that one!) that you would never have thought of back in the studio, and the colors may be what your painting is all about.

We take our surroundings for granted—artists less than some others, perhaps, but still we can become bored and inattentive. Our work suffers for it. I've heard too many people say, "There's nothing to *paint* where I live." Or, "I've painted everything around here till I'm sick of it." If that's how you really feel, you're not looking at your surroundings—or perhaps not really *seeing* them. Don't worry about it, don't become anxious or berate yourself for a perceived lack of creative inspiration—just relax and look around you, and let it happen. Be playful about it. Be an otter, if you will.

Think of Fairfield Porter, who discovered the magic of light itself, right in his proverbial backyard—as did Edward Hopper. Think of Andrew Wyeth, who has never tired of the environs of his two small neighborhoods—because he sees them so clearly. Think of Georgia O'Keeffe, who discovered a new way of looking at the world around her through the bleached pelvis of a cow. I could name a hundred artists who have overcome the temptation of boredom and familiarity to produce some of the world's great art—but you get the picture, if you'll pardon the pun.

There are several good books on learning to see, before you need worry about the added challenge of painting. Consider Frederick Franck's book *Zen of Seeing* (or any of his later books, as far as that goes), or Clare Walker Leslie's books, *Nature Drawing, a Tool for Learning* and *Nature Journaling,* with Charles E. Roth; Betty Edwards's *Drawing on the Right Side of the Brain.* These will help you to get past some of the preconceived notions and symbolic thinking we learn in grade school and set you to thinking of new ways to see the world before us.

Learning how to see without the kind of visual clichés that result in stale, rote, overworked solutions—or worse, unrealistic expectations—can do wonders for your work. Most important, perhaps, is that you will see with your own eyes, in your own way, filtered through your own experience. You won't be using anyone else's solutions. That may sound odd coming from a writer of how-to books, but I hope that you'll use my books—and everyone else's—as a jumping-off place for your own creative adventures, not as a destination. There's nothing wrong with being inspired by the work of others, of course, and I'd definitely suggest a trip to your local art museum. But these are just the beginning, a key to a door that only you can open. All you need to do is first open your eyes.

That, of course, is easier said than done, so here are eleven exercises—some practical, some fanciful—that may help.

Field journal page with pennywhistle

- Let yourself take time. Relax. Stop and look around, with no agenda, no plan. Just sit, until something catches your attention and holds it. This is *not* a waste of time; there is no hurry, and it is important. Give yourself permission to be there, doing just what you are doing.
- Look closely at things you've taken for granted—a raindrop, dew on a petal, a dragonfly's wing. Try to paint just what you see, or as close to it as you can, and you'll be amazed. Forget formulaic solutions, the kind of learned symbolic thinking wherein a canoe shape represents an eye and a circle represents a head, or what you *think* you know. Paint what you see, and it will not only look right, but will

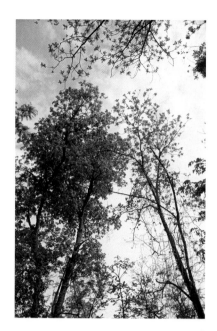

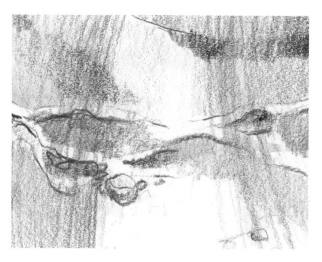

Frozen stream

Looking up at trees

Sketch of
microscope

open your eyes to new subtleties and complexities. Hard to get
bored with this stuff.

• Try a different viewpoint altogether—up a tree, over a cliff, or,
from lying on your back, an ant's-eye view. I once did a painting
from the base of trees, looking up into the foliage, with the lines
of the trunks all receding away from me in an acute perspective—
it was interesting and evocative, and reflected the kind of awe we
sometimes feel walking in the Renaissance tapestry of autumn
woods.

• Magnify details with a hand lens. There is incredible beauty in the
small things: the pattern of seeds in a sunflower's head, or the
graceful turning of a vine. Of course, not all detail paintings need
be of botanical subjects—I once did a painting of a cat's eye that I
liked a lot (the painting *and* the cat). You might try the seemingly
abstract patterns of a piece of burl maple, or an agate rock, or the
frozen bubbles in an icy stream.

• Try a microscope if these details aren't close enough for you.
Once you realize that there is a whole different world inside the
one we see every day, you'll never lack for subject matter—or for
appreciation of the world around you. I was amazed to find the
colorful, miniature world of lichen on the edge of an old stone
bridge near my home—I'd never have seen it were it not for that
hand microscope.

• At the other end of the perception scale, use a pair of binoculars
to bring the distant up into your lap. It is difficult to paint

through binoculars, or even a telescope on a stand, though (I get a headache), so be advised and look away often.

- Look only at shadows, not their object—that is, not at what casts them. I was amazed, on trying this, to find how crisp and expressive they were in strong sunlight. They're sharply defined close to the object, softer as they fall away. Often, these shadows can help you define your object with clarity and vigor; they can take on a personality of their own, as we discuss later in this book, and may become your subject.
- Pay attention to negative shapes instead of positive ones. Look at the space around your subject to help define its shape. For instance, look at the sky shapes between limbs to help you capture their interesting assymetry. This can be used on virtually any subject, and is a great aid to seeing.
- Try looking at the world through a prism. You've seen a beam of light passing through a prism to throw rainbows on your walls,

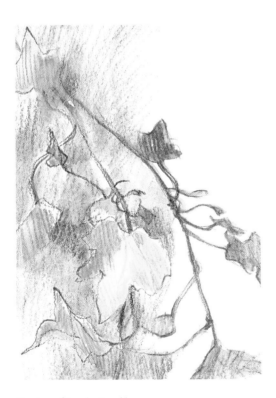

Shadow of ivy plant and leaves

Negative shapes

Prismatic picture,
leaves

but have you ever held one up to look through? Suddenly edges take on rainbow colors that are nothing short of magical. You may have looked at Wayne Thiebaud's large landscapes and wondered about those colorful outlines—maybe they're his vision of life as he sees it; maybe he looked through a prism when he got his original inspiration.

- Watch a cat, a squirrel, or some other especially alert animal. Try to see what has it so interested, and sketch that from the animal's viewpoint. Put yourself in Puss's boots—the world is alive with possibilities. Your sketch doesn't have to be overly realistic; we don't know just how animals perceive the world—but try to imagine the emotion behind the perception, or the liveliness of the subject. The point is seeing through eyes other than your own.

- And if that's too much of a stretch, take a kid out with you and try to see through a five-year-old's eyes. *Ask* what it is that little Keely sees, or what Brian's found so interesting under that rock, if you can't tell. Recapture the curiosity of a child. Better yet, let the child draw right along with you—do the same subject, and you'll have a quick peep into a rather magical window.

- Back to earth now—try making field sketches. This one directly reflects what a naturalist-artist does, but it is good for anyone who paints the world around him. Field sketches are a bit differ-

ent from ordinary sketches because they are usually heavily anno-tated. When I'm doing a field sketch of an unfamiliar plant, for instance, I try to draw it from several angles, with a number of details in close-up—leaves, petal shapes, pistils and stamens. My written notes call attention to other details—how the leaves grow along the stem (alternate, opposite?), whether they are smooth, hairy, or shiny, how many petals the flower has, etc. These notes not only allow me to identify the plant later from field guides or with the help of experts, but they make me see what I am drawing *as I'm drawing it.* I pay attention. A cursory sketch of a wingstem sunflower, for instance, would identify it as a type of sunflower, all right, but unless I've observed closely I won't have seen the vanes or "wings" along the stem that identify it as what it is—not just any yellow flower, but a *specific* yellow flower. And of course that suggests that color notes are also important, if I plan to work from my sketches later. I can add written notes or put color direc-tion on my field sketch.

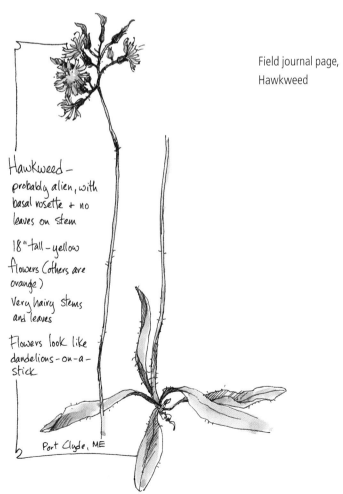

Field journal page,
Hawkweed

Hawkweed —
probably alien, with
basal rosette + no
leaves on stem

18"-tall - yellow
flowers (others are
orange)

Very hairy stems
and leaves

Flowers look like
dandelions-on-a-
stick

Port Clyde, ME

Does the world need to know about the wonderful color hidden inside an acorn? Probably not, but when I discovered the gorgeous hot-pink and chartreuse colors there, I couldn't help but sit right down and capture it on paper one balmy day.

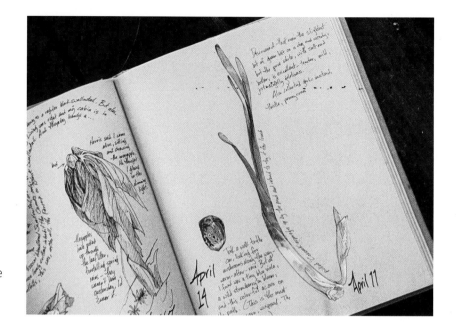

There is a terrific painting by Thomas Moran called "The Upper End of Little Cottonwood Canyon"—it's fourteen by eighteen inches, with watercolor and gouache over a quite visible pencil drawing on gray paper, and it's fascinating to see because it shows the artist's thought processes so clearly. Also visible, right on the painting, are written notes as to color, position of shadows, and types of landscape—rocks, etc. It is a classic field sketch by a wonderfully accomplished artist.

Does it matter whether my painting contains wingstem sunflowers or black-eyed Susans instead? Maybe not, in a grand landscape (though in a botanical work, the details make the painting). But it matters very much in a completely different arena; the more I know, the more I *notice* about the world around me, the more endlessly fascinating it is, and the more excited I am about painting it.

Mediums and Techniques

P. 32 Palette & Color Choices
p. 35 Water-Soluble Colored Pencils
 39 Pastels
 43 Watercolor
 56 Gouache
 58 Acrylics
 61 Oil Paints
 63 Mix Mediums

Now that you've explored the pros and cons and decided you want to paint in nature—and why else would you have bought this book?—and gotten to spend a bit of time learning to see like an artist, you're ready to outfit yourself. Your first decision will probably be what medium you wish to take with you to the field. Watercolors? Gouache? Oils? Acrylics? You may enjoy the linear versatility of water-soluble colored pencils, which combine the simplicity, familiarity, and immediacy of drawing with the more tonal effect of painting. Pastels offer similar options, being neat to carry if not to work with—I get dust to my elbows. But each has its advantages and disadvantages.

If you've painted before, in your studio or in class, you may already know that you prefer one medium over another—watercolor over oil, for instance. But if you've never painted at all and are not sure *what* you would like best, we'll explore some of the possibilities and offer suggestions from those who are experienced in working outdoors.

Some mediums or types of materials are easier to work with in the field than others; what you choose depends largely on how you want to work, the final effect you're after, and what you may be used to back in the studio. It depends, too, on what's important to you, and how you think about things. There are plenty of books that describe the mechanics of various mediums like watercolors, acrylics, or oils, but when it comes down to it, that's seldom why you choose one over another. You choose what feels right to you, what is most easily available, what matches your temperament, and what responds to your individual touch.

Medium: a type of painting material, e.g., oil, acrylics, watercolor, etc.; also can refer to a solution used to carry or thin pigment, as in acrylic medium or linseed oil.

We'll explore the most common painting mediums to give you a glimpse of what you might prefer, both from the technical aspects and from the intuitive and creative standpoint. We want to give you a feel for the soul of each medium, what sets it apart from the others; then you can choose where to start. If you're an old hand, bear with us—use this section as a review or an inspiration to try something new.

If you normally deal with oil paints, and their attendant varnishes, oils, turps, and so forth, on a regular basis, then you probably won't mind painting in oils on the spot—you'll be used to the unique challenges of paint that takes a relatively long time to dry, and enjoy the wonderful buttery quality and rich color that make oils such a joy. But if you prefer not to worry about transporting wet paintings and carrying messy, volatile brush-cleaning and paint-thinning liquids with you, you may want to choose a water-soluble medium like watercolor, gouache, acrylic, or water-soluble pencils.

Don't be daunted by the array of choices. Start with only one or two mediums, if you're unfamiliar with the territory, and try them on for size. If you are already a painter, the choices should be easier; it's simply a matter of translating your favorite medium to working outdoors. But don't be afraid to branch out into something new. A new way of working—that is, on the spot and far from your usual conveniences—can benefit from a fresh approach. How often do we get set in our ways and feel we *must* work in exactly the same way, no matter if it

be in the studio or in the field? Pick an unfamiliar medium and you are *forced* into new ways of thinking. It can be great fun, and a door to new creativity.

If you're just getting started, you may want to purchase an inexpensive starter set, no matter what the medium. These are usually limited in their range or colors, and of course, those colors are already chosen for you. They are also often student grade, which can become frustrating—it's all right to start there as an experiment, but you won't necessarily know how much you may like the medium from working with less than professional grade . . . that said, it *can* be a great way to try something on for size.

I hadn't painted with acrylics for many years, and I hated to invest in all the colors I normally use just to see if I really wanted to paint with that particular medium again, so I bought an inexpensive set of small tubes. It had only one red, yellow, and blue, as well as white, black, and brown. It did not include my usual warm and cool red, warm and cool blue, and range of yellows that are on my watercolor palette. It also didn't include my favorite earth colors, burnt umber and raw sienna. But the price was right, and it was a good experience to try to mix the colors I wanted instead of squeezing them directly from the tube.

I was surprised to find that I could make a pretty creditable raw sienna by mixing burnt sienna and cadmium yellow. It made me realize that I could simplify my painting kit, *whatever* my medium, by mixing more colors from the basics. And when you are working outdoors, *simplify* translates to a lighter kit that is easier to manage.

Mixed acrylic colors

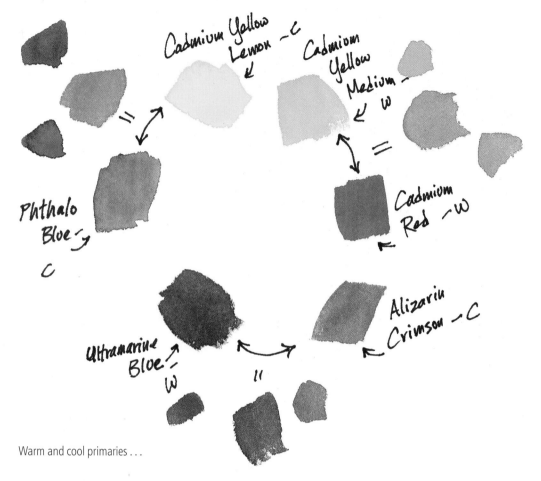

Cadmium Yellow Lemon - C

Cadmium Yellow Medium - W

Phthalo Blue - C

Cadmium Red - W

Ultramarine Blue - W

Alizarin Crimson - C

Warm and cool primaries . . .

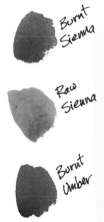

Burnt Sienna

Raw Sienna

Burnt Umber

. . . and earth colors

Color Choices

For those who are curious about what I mean by warm and cool reds, blues, and yellows, I've used watercolorist John Pike's advice for years and bought a warm and a cool of each primary color and a couple of earth colors, which lets me paint almost anything. In my case, these are usually alizarin crimson (cool) and cadmium red medium (warm), phthalo or Antwerp blue (cool) and ultramarine (warm), cadmium yellow lemon (cool) and cadmium yellow medium (warm), plus burnt umber and burnt and raw sienna. I supplement this list with a Hooker's green dark, sap green, and a Winsor green for fast mixing, and use a permanent rose when I'm doing flowers that require some delicacy, which makes beautiful pinks and lavenders in mixture with blue. This palette sees me reasonably well through watercolor and acrylic painting as the color names are the same. With the addition of a white, it would work with oils as well. The dry mediums like pastel and water-soluble pencil use different color names or simply numbers.

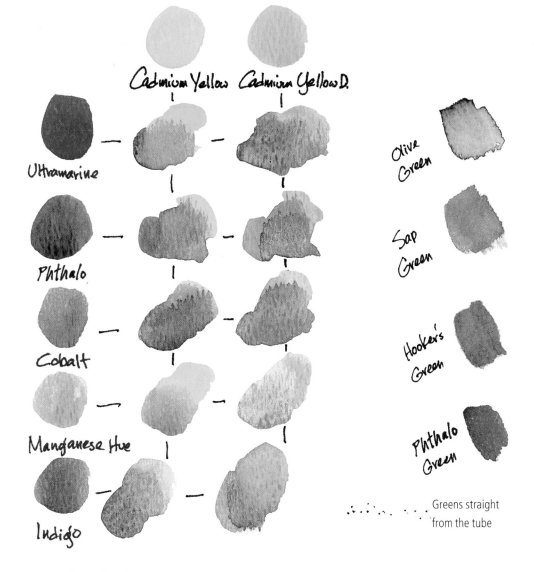

Cadmium Yellow Cadmium Yellow D.

Ultramarine

Phthalo

Cobalt

Manganese Hue

Indigo

Olive Green

Sap Green

Hooker's Green

Phthalo Green

Greens straight from the tube

You can mix a variety of interesting greens from your warms and cools—here are just a few possibilities. For even more, see the color samples in Chapter 8.

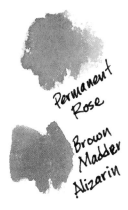

Permanent Rose

Brown Madder Alizarin

Here are brown madder alizarin and permanent rose for a bit more flexibility with warm colors, either straight from the tube or in mixtures.

33

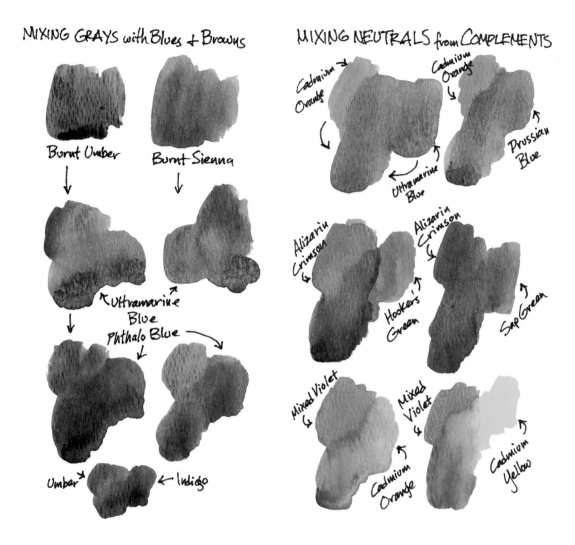

MIXING GRAYS with Blues + Browns

Burnt Umber

Burnt Sienna

← Ultramarine Blue

Phthalo Blue →

Umber →

← Indigo

Mixed grays

MIXING NEUTRALS from COMPLEMENTS

Cadmium Orange

Cadmium Orange

Ultramarine Blue

Prussian Blue

Alizarin Crimson

Alizarin Crimson

Hooker's Green

Sap Green

Mixed Violet

Mixed Violet

Cadmium Orange

Cadmium Yellow

Mixing neutrals from complements

Mix a variety of atmospheric neutrals from the colors on our palette—no need to buy them unless you just want to. Blues and browns make wonderful grays, blue grays, and gray browns.

Or make them from complementary colors. If you remember your grade-school color studies, red, yellow, and blue are the primaries. You can't make them from anything else, they just are. Between them on the color wheel are the secondary colors, orange, green, and purple. Whatever is opposite on that wheel—blue and orange, red and green, or yellow and purple—are the complementary colors. You get a nice range of grays and browns when you mix these colors.

Although these samples were done with watercolors, the principle is the same no matter what your medium. It doesn't matter whether

you have chosen oils, acrylics, or pastels—though often people who work with pastels primarily choose a stick of the color they want with less reliance on mixing colors.

The Mediums

In this section we will explore a variety of mediums, from the more traditional watercolors, acrylics, and oils to some more portable options. All have been used outdoors with great success. Try them and see what suits your modus operandi.

We'll explain a bit about what the medium is and how it works, tell you the basic supplies you will need to get started, and then offer some suggestions for exercises to let you get familiar with each. You may want to try them out first at home to see how you like them before venturing afield.

Water-Soluble Colored Pencils

Sometimes called watercolor pencils, these may be the simplest to work with in the field, especially if you are used to drawing or sketching. They are virtually pure pigment enclosed in a traditional wooden pencil form. Caran d'Ache and Derwent are two good brands to look for. Both also make larger crayons that are not wood encased for broader effects and quicker coverage.

With these tools, you draw or sketch your subject as usual, perhaps layering for color subtleties, using as much detail or bold areas of color saturation as you like. That is, you can do a fairly linear, open drawing, one just shaded with crosshatching, or you may put down densely layered pigment. Then wet with clear water and a brush, either on the spot or later when you return home or to base camp. The more linear effects, of course, will result in a paler finished product. You can scrub to lift and blend more of the color for a smoother effect, or just barely touch brush to paper to retain most of the underlying lines with only slight blending. You can even moisten with a fingertip and saliva if you have no other available tools.

Dip the tip of the pencil into water and then draw with it, or draw back into a wet area with a dry pencil for interesting and more emphatic effects. These can be extremely convenient in the field, since it isn't necessary to carry a water supply or painting mediums with you unless you just want to.

You may not feel these are really "paintings," and initially, they are not. When you add the water, the lines of pure pigment truly

Mineral-water well, water-soluble colored pencil

become liquid. There's a kind of magic to seeing what will happen when you add water, turning a drawing into a painting the first time. Be aware, though, that some colors change dramatically when wet.

You can buy a fairly complete set of these pencils for not a lot of money. Caran d'Ache makes a set of forty in their own metal carrying case for about $45; they also make larger water-soluble crayons for broader effects and quicker coverage. Derwent's thirty-six-color pencil set goes for under $30. You can, of course, opt to buy smaller sets of six, ten, twelve, or more colors, or, at the larger art supply dealers, even

pick up a single pencil from their open stock displays if you just want to experiment or need to supplement your set or replace a pencil you love so much you've used it up long before the rest have begun to wear down.

You will need a painting surface—a sketchbook with good-quality drawing paper is nice. I often use a Strathmore Bristol pad with a regular surface for this—the two-ply paper will withstand getting wet without too much buckling, which a lighter-weight paper will not. A pad of drawing paper will work, too, as will a pad or block of water-color paper—just don't get one with a rough, mechanical surface, as it will be hard to draw on.

You will also need a brush or two to moisten the pencil lines and blend the pigment. Although sable brushes are nice, for getting started and for field work, brushes with man-made "hairs" work well. They are much nicer to use than they once were, have good resiliency and a nice point—I do 90 percent of my painting with them now, both on the spot and in my studio.

If you are comfortable with sketching, even for quick field notes, you'll like watercolor pencils. It's easy to move beyond a sketch or drawing to a more complete painting. And as noted, you don't even have to take the water with you—just get the bones of your painting down on the spot, then blend later, a little or a lot. Although they are a bit dry to the touch when working, there is still a satisfying range of colors. They are generally lightfast, which means they will not fade with time and exposure to light.

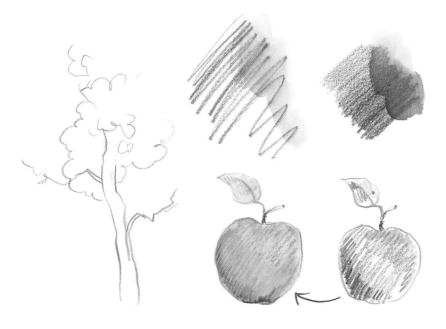

Try out several techniques with these colored pencils. Use linear effects. Or quick squiggles . . . Or smooth areas of color. Then wet to see how they look. Try out a simple shape—an apple or other fruit. Layer strokes, then wet with clear water.

Trial Run

You may want to do a whole page of samples using each of your colored pencils. Some, as noted, change color in surprising ways when you wet them—unless you are prepared, your painting may be somewhat brighter than you anticipated.

Colored-pencil samples

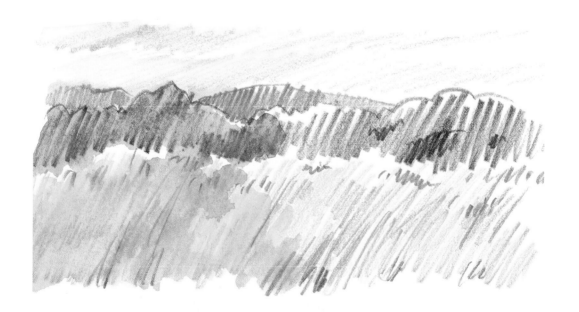

Try a simple landscape—here, prairie grasses stand out against dark trees. The area at the left was wetted and lifted to blend; the right side is untouched.

Pastels

These are really pure pigment, wonderful and sensuous. They come in stick form, either round (softer) or rectangular (harder), and there are sets of literally hundreds of colors. (Sennelier makes a set of 525 colors!) Of course, you can also buy sets of only twelve colors, or stock one at a time. Some brands are smoother than others, using only the finest European chalk blended with pigment. Though these are, to my eyes, more for drawing than painting, they don't have to be. I have seen some wonderfully rich and subtle pastel paintings—and yes, they are called *paintings.*

Like watercolor pencils, pastels are wonderfully convenient for field work. There's no need to carry water at all, except for drinking. For ease in carrying and cleaner transport, you can even buy pastel *pencils,* that is, pigmented chalk encased in wood, just like a regular pencil. They will blend just as nicely on your working surface and allow you great control for details.

Artists who work in pastel generally work on paper; you may buy loose sheets and use them as is or cut them to the size you prefer. There are specially prepared surfaces, some of which are sanded—that is, the surface actually contains a fine abrasive. Other pastel papers just have a bit of "tooth," meaning a rough surface that is somewhat pastel receptive.

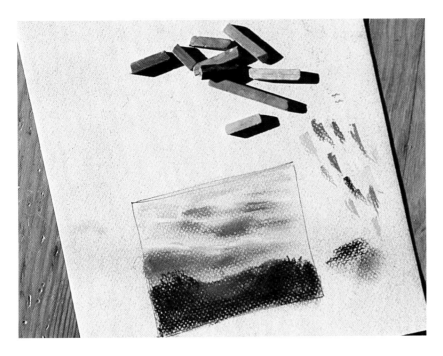

Test out your colors for effect, if you like, before committing to your page. Here, my little sunrise painting is done on blue-gray paper to capture the predawn light. To make sure I had picked the colors that best expressed that, I tried them out on the margin of the painting.

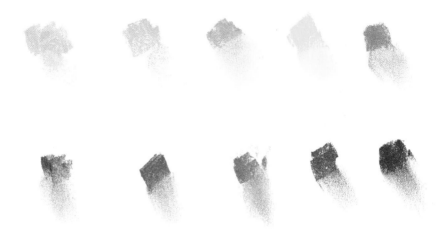

Pastels blend softly—here, I've tested all the colors in the inexpensive set of soft pastels I sometimes carry with me.

Pastelists often choose a toned paper with an underlying color that sets the mood they're after, perhaps a warm buff for a sunny day. It's also a traditional technique to choose a paper with a middle tone—gray, brown, whatever—then paint with light or dark pastels to create an image that pops from the page—a very nice effect when working in nature.

The good news is that pastels blend beautifully, producing wonderfully subtle effects—and the bad news is a tendency to smear. The only real difference is that one you control, the other, you don't. The solution is to be careful how you touch the surface of your work, and to spray it as quickly as possible with a light application of fixative. A workable fixative, either aerosol or pump spray, for instance, protects your painting but allows it to be added to later, after the fixative dries, if you decide you are not finished.

You *do* draw with pastels, but you can also blend quickly and easily, or layer colors for atmospheric effects. You can use the end or a corner for finer details, or the side of the pastel "crayon" for broad effects. Your works can be very soft and abstract, if you will, or almost photographic. You can produce a linear work, really a drawing, or you can cover every inch of your paper. You can layer lights over darks or vice versa. On the downside, pastels are dry and powdery, and therefore can be extremely messy; if you are the kind of person who prefers to stay neat and clean, this is not your medium. You can also get too much chalk on your paper to the point that it will no longer take additional layers, even after spraying with fixative.

When working indoors with pastels, some people wear a mask or filter against the dust. Working outdoors, it is not quite the same problem, but do be aware and try not to inhale too much pastel dust.

Trial Run

There are many ways to use pastels; these are just ideas to get you started.

Make marks on your paper—single lines or squiggles. Blend with your fingertip here and there.

Layer marks, crosshatching closely, and blend here and there.

Use the side of a pastel to make a broad area of color. Layer one over another. Blend part of the area to see how it looks.

Tortillons and stomps: Usually rolled paper sticks used to blend pastels. A stomp is pointed on both ends, and a tortillon has a finer point for detail work.

Then blend with your finger, a soft cloth, chamois, or a pastel "tortillon" or stomp to see how they look. You will most likely get broader effects with a cloth or chamois, and finer ones with the other tools.

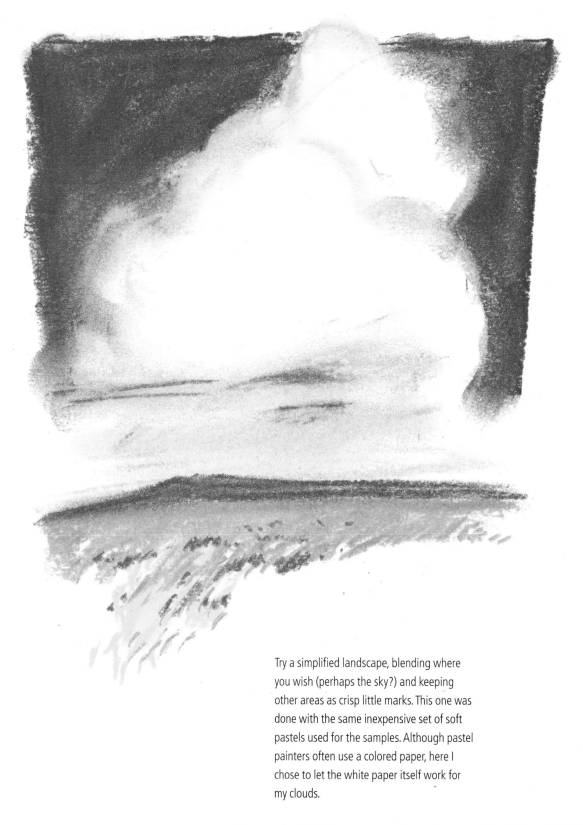

Try a simplified landscape, blending where you wish (perhaps the sky?) and keeping other areas as crisp little marks. This one was done with the same inexpensive set of soft pastels used for the samples. Although pastel painters often use a colored paper, here I chose to let the white paper itself work for my clouds.

Watercolor

Watercolor is pigment and a gum arabic binder—it truly is liquid, blending in soft, flowing passages when made into washes with water. It has great range, depending on the colors you choose, from pale as sunlight on snow to rich midnight darks. It is transparent, glowing; the white of the paper shines through its stained-glass glazes. It's fresh and immediate, perhaps the best for capturing the effects of light. With watercolor, you can paint broad areas or fine, sharp details.

It can also be tricky and frustrating. Until you learn to *wait,* to let things happen in their own time and allow one wash to dry before placing the next, you can create a muddy mess. Letting colors blend on your paper is one thing; stirring them to a grayish mulligatawny stew is quite another!

The other drawback to watercolor is the need to plan ahead to preserve lights. Generally speaking, you work from light to dark (although some people prefer to place their darkest darks quite early to

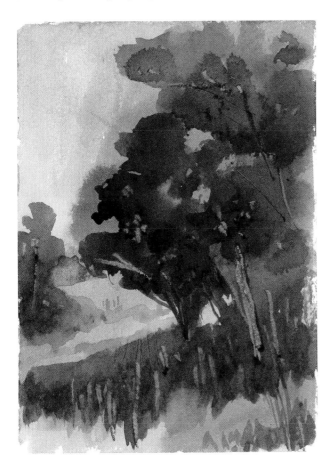

This small, sketchy painting was done in cool colors that capture the feeling of summer—*green*!

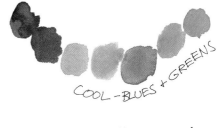

COOL – BLUES & GREENS

Here are some of the colors used.

43

let them gauge all others against that). The only problem with that approach is that the darks sometimes lift easily; the paint remains soluble in water and requires a very quick touch. It is possible to protect that white paper from the beginning, so it isn't necessary to paint around whites, a sometimes difficult and awkward exercise. It's possible, as well, to lift color again to get almost back to white paper unless you have used a very strong staining color; watercolor isn't as unforgiving as you may think. We will try out some exercises that may just help you get over the fear of making a mistake with this medium—it's much more malleable than some people imagine.

"Do not fear mistakes. There are none." —MILES DAVIS

Although Davis was not speaking of watercolor, his words apply here, too. There are no mistakes, only, at best, "happy accidents" and, at worst, learning opportunities. In the field, when the point is to bring home your impression of landscape—there are no mistakes. I will admit that watercolor can be unpredictable. That may sound like a minus, but in fact it's exciting—it keeps me from becoming bored or complacent; it keeps me on my toes. That's good news for those of us who enjoy dancing on the edge a little bit. That description often seems to apply to those of us who like to spend time outdoors, as well.

Almost everyone who paints has heard of "happy accidents." That's when your medium decides to have a mind of its own—and you appreciate its innate intelligence. Whatever it is that the interaction of pigment and water and sheer good luck has decided to pull off, it's wonderful and you couldn't have done it better if you thought it out ahead of time. That unplanned-for texture in the foreground is perfect, and the soft-and-hard edges where a puddle dried looks like you wanted to suggest the far line of trees in just that way. Even an inadvertent handprint in a wash can suggest a wonderful texture. (More on the

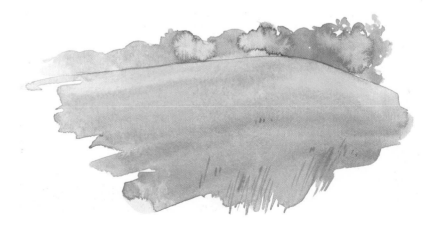

climate that encouraged these serendipities later—wet-in-wet and hot-press paper techniques come to mind.)

Even if you're the type that likes to be in tight control, there are ways to handle watercolor that will allow you that—drybrush or glazing, for example. And it's *still* exciting.

This is also a terrific medium for taking into the field—it's simple, lightweight, and doesn't require anything more complex to clean brushes with than water. It dries rapidly, so you can easily transport your paintings almost as soon as you quit for the day.

With this medium you will need a bit more equipment than the previous two. You may be happy with working in the pads and sketchbooks mentioned with the watercolor pencils, or you may prefer to get a bound pad of watercolor paper. In the field I often prefer a block of paper, watercolor paper that is bound or glued on all four sides, with a small opening on one side that allows you to cut each painting free as you finish it. With a watercolor block you can generally work fairly wet with minimal buckling—and the hills and valleys dry flat as the water evaporates.

Watercolor Papers

Try to find an acid-free painting surface with a neutral pH, that is, a surface that will not deteriorate or discolor over time. For most instances when painting with watercolor, choose a bright or a creamy white paper, since the white paper will provide your lightest lights, and the transparent nature of the watercolor paints themselves rely on the luminous effect of white paper.

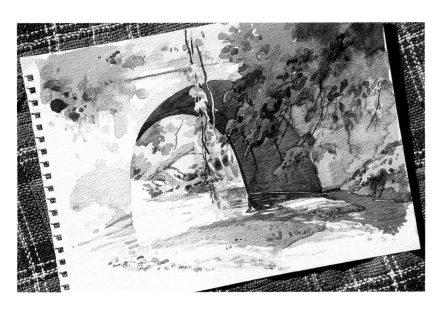

This day the filtered light was warm and translucent; it seemed like the perfect opportunity to try out the small pad of tinted watercolor paper I'd brought with me. This was a light, warm tan that really gave an atmospheric quality to my painting.

Of course, if you like you can branch out and try something different. Daler-Rowney offers a nice range of Bockingford tinted watercolor papers that lets you match mood to painting surface. The pastel tones can set the ambience, with a sunny tint for a summer day or a gray paper for suggesting overcast conditions. This works fine for acrylics and gouache as well.

Watercolor paper, which can also be used for acrylics and gouache (or even oils thinned to a watery consistency for color sketches), comes in several surface textures. These are generally called rough, cold pressed, and hot pressed, or plate. *Rough* is the unaltered surface of paper. The paper pulp, a soupy mixture, is poured onto a screen. It is allowed to drain and dry without further manipulation. Degree of texture varies from brand to brand, depending on the pulp itself, and "rough" can be quite rough indeed (think relief map of the Appalachians) or only mildly textured. *Cold-pressed* paper is paper that has gone through the same basic process, but has been weighted down until dry. It has a medium surface that is very versatile, allowing the artist to create his or her own textural effects. *Hot-pressed* paper has been literally pressed with a hot metal plate like a cotton shirt. It can be very, very smooth, and is sometimes called plate or bristol.

Interestingly, it is easier to do smooth washes on rough paper than on hot pressed, since all the little hills and valleys kind of average out the water and pigment mix. The same mixture tends to puddle on the surface of hot-pressed paper, which can seem either delightfully fresh or disastrous, depending on the effect you were after or your mood at the time. Cold-pressed paper is a good all-around paper, very versatile for most effects.

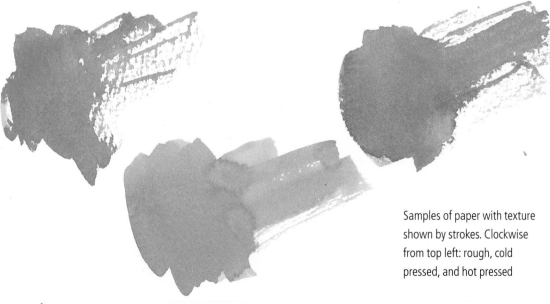

Samples of paper with texture shown by strokes. Clockwise from top left: rough, cold pressed, and hot pressed

Choose your paper according to what you want to do with it. This little seascape shows how you can use rough paper in a drybrush fashion. I used quick, surface-skimming strokes that hit just the high points of the paper to suggest the sparkle of sunlight on water.

One-hundred-and-forty-pound or three-hundred-pound papers are probably best; they're least likely to curl and buckle when wet. This refers to the weight of a ream of paper, of course, not a single sheet.

Watercolor Pads

If you work fairly small, which is often the best idea for working outdoors, you can get any number of watercolor pads with paper that's heavy enough not to buckle to any great extent. These usually come with a spiral binding, which can get in the way, but you soon learn to work around the wire. The advantages of the spiral binding are that the pages stay firmly in the book if the paper is fairly sturdy (at least until you want to tear them out), and the pages turn readily and will lie flat, allowing you to work on the last page as easily as the first. Some pads are glued on one side, which may mean pages will come loose as you turn them; you may wish just to tear out each painting as you go. The

advantage of this type of pad is that it is more comfortable to work with. My personal favorite is the Canson Morilla 1059 watercolor pad, a spiral-bound pad that is a bit hard to find but has a wonderful, rough, almost organic surface.

Watercolor Blocks

Watercolor blocks are made up of fifteen to twenty sheets of pre-stretched watercolor paper fastened down on all four sides, except for a small slot where you can stick a fingernail or dull knife to work your painting loose when dry. They have a backing of very heavy cardboard, so you don't need to carry an additional painting support, and come in a variety of sizes and surfaces to suit your needs. The disadvantage here is that you must remove each painting as you finish it, or you can't get at the next sheet.

For many outdoor painting needs, I like small, postcard-sized sheets of paper bound together on all four sides or on only one. Heavy, three-hundred-pound paper in this size is available from some suppliers, and is even printed with a space for an address and a postage stamp—you can send it through the mail. Your friends will be delighted! One of the nice things about working so small is that you can work very quickly to cover the painting surface (sometimes when you're working outdoors, time is definitely of the essence). Also, you're usually not as tempted to overwork such a small painting; you tend to simplify your subject, which most of us would do well to translate to the larger sheets as well.

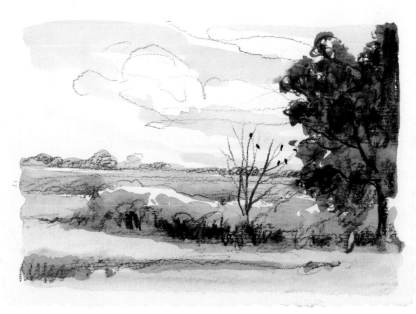

Postcard and tiny pads are handy for outdoor work—"On the Way to the River."

To Stretch or Not to Stretch

It isn't necessary to stretch your paper in order to have a flat surface to work on, in spite of what you may have been told. For working in the field, either take a lightweight support (thick Fome-cor board is fine) and tape your paper to it with masking tape (the paper will flatten out when it dries), or use a watercolor block. When you are working small, which you may opt to do for outdoor work, it is not as necessary to stretch, in any case, since the smaller paper buckles less.

Brushes

As noted in the section on water-soluble pencils, man-made brushes have come a long way. Especially for field work, where I might lose my wonderful Kolinsky sable, I use Loew-Cornell's La Corneille round and flat brushes for most work, because they are easily available in my small town. A number 5, a number 8, and a number 10 round work for most things and are much more affordable than sable. I also like to have a three-quarter-inch and a one-inch flat brush handy.

Mail-order art supply houses expand my horizons to provide just about anything an outdoor painter might need. Daniel Smith imports a nice Series 75 brush for the watercolorist that handles very well. Liquitex makes Kolinsky Plus brushes, which combine man-made and natural bristles for reasonable sums. There are several similar brands, such as Langnickel and Winsor-Newton; try them to see which you prefer. If price *is* a serious consideration, realize that a number 3 Kolinsky can cost almost $20 at this writing and a synthetic brush of the same size will run a fifth of that or less. I prefer the latter, since if I lose my brush while crossing a stream or jumping a ditch, I don't worry too much. If I can retrieve it, of course, I do. If I can't—well, it's just gone.

For serious field work, where size or weight is a consideration, there are several types of folding or telescoping brushes. Daniel Smith offers several with handles that screw off, becoming a protective cap for the brush hairs during travel. Others have a slip-on "lid" that fits either over the hairs or over the end of the brush to lengthen it for comfortable handling. You may even enjoy inexpensive Oriental watercolor or *sumi-e* brushes, which often come with a slip-on cap.

Trial Run

Mix a pool of color by dipping your brush in clean water, then swirling it over your mound of paint. Transfer that to your mixing surface (palette) if you want to make a bigger wash or add more color. Don't be shy! One of the problems beginners with this medium face is being afraid to use paint. Don't be. Make a generous puddle to work

Wash: an area of color, large or small, applied to paper with a water-based medium

with. It's better to have too much than too little; if it's necessary to mix up more, you may get a hard edge as the first part dries before you can get back to it. If you know you need to cover a broad area, mix a healthy puddle—two to three tablespoons of water (or a quarter cup or more, if you like, in a small container)—and however much paint it takes to achieve the degree of intensity or value you're after. Use a scrap of the same paper you're painting on to test your mixture.

ROUND BRUSH — #7

FLAT BRUSH — ½"

RIGGER or LINER — #1

FAN BRUSH — #3

Make some marks with your brushes—round brushes and flat ones make very different effects, but both can be handy. Play with these marks—have fun. You will become comfortable with what each is capable of, and reach almost instinctively for the one you need. It can be fascinating to see.

Keep in mind that your brushstrokes can be very expressive. The Oriental *sumi* masters used specific strokes to symbolize their subject. A bamboo leaf is expressed with a simple stroke that *looks* like a long, straight bamboo leaf; rugged, mountainous rocks are painted with rough drybrush strokes. You don't have to be painting *sumi*, of course, to keep this in mind. A stroke that goes quickly upward takes your eye with it—it just has that feeling. You can use it to capture the effect of crisp grasses. Think how best to express your subject.

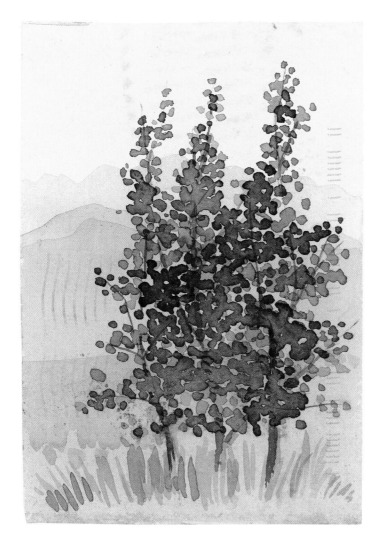

Small dots of paint can suggest the round leaves of aspen as they do in this small postcard-format painting by Roberta Hammer. (Yes, she did actually send it to me through the mail!)

Make a spot of each of your colors—add more water to each, along one side, until you have an idea of the range, from strong, almost pure pigment to the palest wash. If you want, write what each of these colors are and keep this list with your painting supplies so you'll know what color to reach for. Some artists like to label their plastic palette with the pigment name, right next to the mound of color.

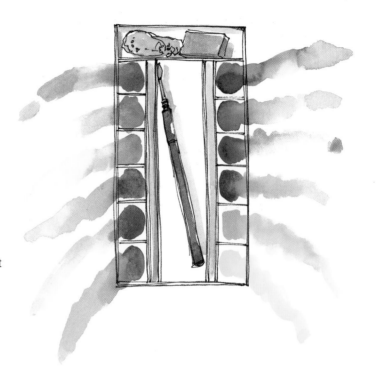

FLAT WASH

GRADED WASH

Flat washes: Make a good pool of water and pigment, and make a line at the top of your paper; keep your support at a slight angle to encourage the paint to flow downward, forming a puddle or bead at the lower edge. With your next brushload of paint, pick up that puddle and draw it down the page. Continue until you have filled the desired area, then lift the final bead of paint with a wrung-out, "thirsty" brush or it will make a backrun or "flower" as it dries.

Graded washes: Begin this the same as you do a flat wash, but with each brushload of color, add a bit more clear water. Continue down the page until you have almost pure water in your brush, then lift the puddle as before. If you like, you can begin from clear water at the top and add more and more pigment, finishing up with strong color. For advanced exercises, try adding a different color as you go instead of clear water, so your wash grades from, say, ultramarine blue to alizarin crimson.

Do both these exercises on each of the papers you've chosen, and try them with a round and a flat brush to see which you prefer. I often find I get better results with a flat brush.

You may also want to try them on both dry and somewhat wet paper; some people have better luck with a graded wash on paper that has been wet and has begun to lose its shine somewhat—although, of course, the paint won't bead along the bottom edge of the wash in the same way. Try it and see which technique you prefer.

Wet-in-wet

This brings us to classic wet-in-wet techniques. Wet your paper down well before painting. If you are using a nonporous support like Plexiglas, your paper will stay wet much longer and allow you to work back into it. Make a big, juicy wash on your painting surface and flood in another color or two. Tip your paper, if you like, to see how the paint flows. You can keep working into this until it begins to dry, but be careful: it's a short step between nice flowing colors and hard edges.

Of course it isn't necessary to prewet the whole sheet; allowing one fresh wash, however small, to flow into another is still wet-in-wet painting.

This small painting proves that point—I wet down the sky first and used very subtle colors to suggest an early misty morning. Then when that was dry I wet the rest of the paper with colored washes as I went, starting with the far hills in a mix of ultramarine blue and burnt

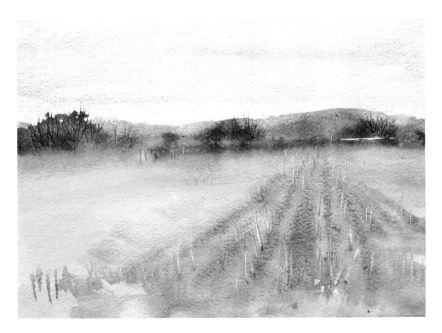

Wet-in-wet
stubble field

sienna. I left one hard, light-struck edge between the hills and the field, then continued to flood in strong washes to suggest the distant trees (using the same colors but a different mix), the brushy edge of the field (now heavy on the sienna), then the field itself. This latter I painted mostly with raw sienna with a touch of brown madder alizarin. When that wash just started to lose its wet-wet shine, I laid in the ultramarine blue shadows that suggest perspective of the rows still visible in the harvested field.

Once everything began to dry but was still damp to the touch, I scratched through the pigment with my fingernail. Where the paint was wetter it made dark lines, and where it was drier (and I varied the pressure) it lifted out lighter ones.

Some time later it occurred to me that the line of far hills was too sharp-edged in relation to the rest of the painting, so I lifted and softened it with clear water here and there. This painting also had another, later fix. I discovered I had placed the horizon line dead center, cutting my painting in two equal halves. Not a problem, the sky was obviously subordinate, so I just whacked it off with a sharp blade. Voilà, an improved composition!

Drybrush

This is a bit of a misnomer; your brush is not *completely* dry or it wouldn't make a mark. Dip just the tips in a puddle of color or wet the whole brush, then wring out the excess moisture in a tissue. Touch the paper with a feather-light stroke; separate the brush hairs to make a scattering of strokes at once, if you like. Try layering or crosshatching tiny strokes of different colors. This technique is a classic with egg tempera, but it works well and allows for great control with watercolor as well, as painters like Andrew Wyeth have proven.

Samples of drybrush

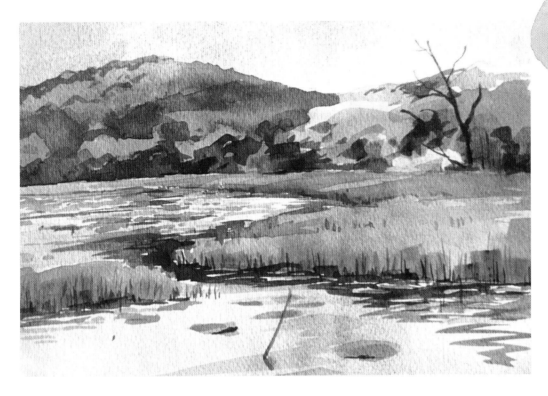

Glazing

This is an old, old technique, and one especially well suited to watercolor. Each layer is transparent, so it allows the colors underneath to show through. Subsequent colors are affected by those underlying tones; it's like stained glass.

Lay down a tone of good, strong, pure color; yellow, say. When it is completely dry, put down an overlying wash of phthalo blue. Just as we've always been told, there's green—and an especially nice, clear hue at that. You can layer almost indefinitely, if you allow underlayers to dry completely—and if you work with a light, deft touch. Otherwise you may lift the underlying layers and sully your wash. Again, the drying time here allows for greater control than with a splashy or wet-in-wet technique.

More subtle uses of glazes are shown in this painting done at Cooley Lake—the hills were modeled with successive glazes of color as the underwashes dried. The water and clouds were handled in the same way.

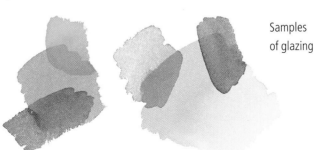

Samples of glazing

Gouache

Gouache is sometimes called body color or opaque watercolor. Very popular in Europe for generations, it is only just beginning to catch on here. For years there's been a bias in the large watercolor societies against using opaques. When I was young I was taught it was a bit like cheating.

It's not. It's a wonderful medium in its own right.

Water-soluble gouache is handled like watercolor. The basic difference is that rather than watercolor's transparency, gouache has an opaque quality and may easily be used with a darkest-darks to lightest-lights approach without the preplanning necessary for watercolor. Your brushes won't be harmed as this paint is easily washed out.

Try out gouache using some of the same exercises that you did with watercolor and you'll find many differences—and similarities. Like watercolor, it is easy and clean to work with, cleans up with

This jack-in-the-pulpit was done as a field study with gouache on black paper (notes were done with a white colored pencil).

The simple night landscape was done mixing opaque white with my watercolors or using white straight from the tube.

water, doesn't ruin your brushes—you can use the same brushes and papers as you did for the previous medium, or enjoy a more strongly tinted sheet to set the mood. Painters who use gouache can even work on black or deep blue paper for wonderfully dramatic effects.

Also like watercolor, gouache can be squeezed onto your palette a day or two before going out, so it dries. That way the palette isn't so messy. Just wet each mound of color a bit before you're actually ready to paint, to soften it so it will lift and mix quickly.

Gouache Exercises

Test your colors. Even when mixed with a lot of water, gouache remains more opaque than traditional watercolor. Gouache colors can be painted over each other without the undercolor showing through.

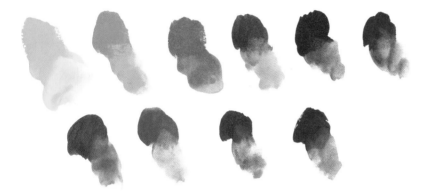

Play with mixing your gouache colors to see what you can come up with. You will find you don't need to carry too many colors into the field with you.

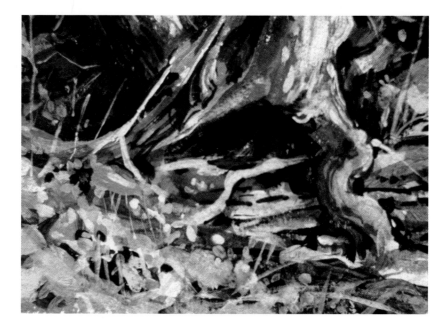

Here acrylics were used in a very opaque manner with brushstrokes clearly visible.

Acrylics

In acrylics, pigment is suspended in a plastic base—the paints are thick and buttery and may be used like oil paints, even for thick impastos or heavy textures. Use them right from the tube, which results in a rather opaque effect, or thin to a nice atmospheric glaze with acrylic medium, either gloss or matte. Or you may prefer to use these paints more like watercolors, thinning them with generous amounts of water and applying them in washes and overlapping glazes. One difference here is that unlike watercolor, underlying layers won't lift with subsequent washes—acrylics dry impervious to further handling. If you like to lift color away for soft effects, best stick with watercolor.

Acrylics dry much faster than oils, however (used like watercolor, drying time is about the same, but even with thicker applications, they dry within a half hour or so). For that reason you may find them more practical than oils for working outdoors, especially when you need to transport several paintings over a distance.

Brushes

You can use brushes especially intended for acrylics, bristle brushes made for oil paint, or softer ones intended for watercolor. You may enjoy using a palette knife to apply paint to your working surface.

I would definitely recommend a synthetic brush rather than a fine sable tool when painting with acrylics, since these can dry in a brush and virtually ruin it—at least without a great deal of rehab work. Bris-

tle brushes work well with acrylics, as well as with oils, and are sturdy and inexpensive enough to take rough handling. Try a flat- and a round-bristle brush and see how you like how they apply the paint. And remember to clean your brushes promptly with lots of water. There are products on the market that will take acrylic paint out of your brushes, but it takes some manipulating and can be hard on a good brush.

Acrylic Painting Surfaces

If you choose acrylic, you can work on a variety of surfaces. In fact, you can prepare almost any surface to accept acrylic paint by coating it with gesso, which dries to a flexible, durable surface. White is generally preferred for most uses, but you can also buy gray or black gesso, or tint it with some pigment for interesting moody effects.

If you plan to use acrylics with a watercolor technique, you will be able to use the same paper you used for watercolor or gouache. You may also choose canvas, canvas board, wood, multimedia art board, or even Masonite prepared with gesso as your painting surface, but be sure to buy oil-free Masonite, as marine-surface board will bleed through gesso with an oily, mottled effect.

Exploring Acrylic Paints

My sampler set only came with these few colors, plus black and white. Thinned with water, they can be much more transparent than gouache, and, as noted, some people use them with transparent watercolor technique. You can also use them with heavy impastos—thick brushstrokes, like with oils.

Try out your colors, just as you did with the other mediums. Make a spot of each of your colors, then drag it off to one side to soften it. Thin with water on the other to see how you can make a watercolor-like glaze.

BRISTLE
BRUSH

ACRYLIC
BRUSH

WATERCOLOR
BRUSH

PALETTE
KNIFE

- Experiment with applying paint with a bristle brush. You'll see many more visible lines in the paint.
- See how an acrylic brush differs—it's a softer effect.
- Using a palette knife, try applying paint in thick "scumbles" or rough strokes.
- Use the edge of the knife for fine linear effects.

Layer colors in glazes using acrylic medium. Then try the same thing by thinning your paint with water. With the medium the effect is more brilliant, and you can see the brushstrokes.

Compare between gouache, left, and acrylic. With both you can thin or soften when wet, on the left in each sample, but once acrylic dries it can't be lifted. On the gouache sample, you can see the lifting on the right—there was no effect on the spot of acrylic.

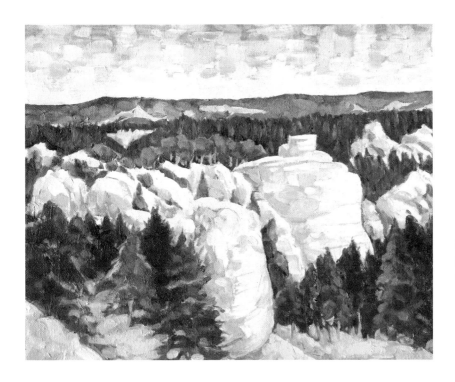

Oil painting by
Keith Hammer—
"Buttes"

Oil Paints

Here, your pigment is suspended in an oil base and must usually be thinned with turpentine, mineral spirits, or other volatile fluids. However, there are now water-miscible oils on the market that may do very well indeed for working on the spot. They certainly would make the process simpler to manage. They still have the longer drying time of regular oils, allowing great workability over a period of time, but they clean up with water.

Greg Albert, my good friend and editor in chief at North Light Books, enjoys these oils and uses the MAX brand. "The MAX paints are great because they work exactly like traditional oils, and I mean exactly, but clean up with water. I keep a big tub of water on my easel and can clean my brushes fast and thoroughly. I really slop and splash, too, which I would never do with turpentine! That way I never put a dirty brush into clean paint, so my colors stay mud-free longer."

Brushes

Oil painters often prefer hog-bristle brushes, with synthetics for detail work, although they also use sables. Bristle brushes have great strength and spring, and work well with buttery oils. Try flats, "brights," rounds, fans, all kinds of brushes for greater control and variety.

Oil-Painting Surfaces

If you plan to paint in oils, most often you'll choose prepared canvas to work on. Look for a fine surface for most uses. Don't let yourself be limited in your choice of painting surface. Anything you use with acrylics would work with oil, including Masonite and wood, which many of the Old Masters used. Gesso can be used to prepare surfaces to accept oil paint as well as acrylic. Some people enjoy canvas boards for their portability. You may even like to do quick oil studies outdoors on paper.

MIXED ON
PAINTING SURFACE

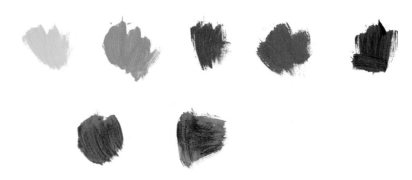

MIXED
ON PALETTE

Again, try out your colors and tools, as you did before, with each color in turn.

BRISTLE BRUSH

SABLE ROUND
BRUSH

MANMADE FLAT
BRUSH

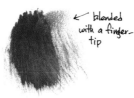

FAN BRUSH

blended
with a finger-
tip

Palette
Knife

- Experiment with applying paint with a bristle brush.
- See how a sable brush differs in handling and effects from a stiffer brush.
- Play with a flat brush and a round one—or try a fan brush to soften an area.
- Use the tip of your finger to blend, too, but be sure to wipe it quickly on a rag so you won't get paint where you don't want it.
- Using a palette knife, try applying paint roughly, with vigorous strokes or scumbles. Again, try linear effects with the edge of the knife.

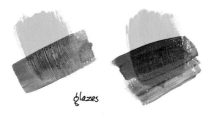

glazes

Layer colors in glazes, using linseed oil as a medium. Then see what happens when you do the same thing but thin your paint with turpentine.

Mixed Mediums

One of my favorite techniques for working in the field involves the use of more than one medium. I am comfortable with sketching and drawing—it's immediate and tactile. Pen and ink, pencil, or colored pencil and wash can make a wonderful painting, and it is freeing to splash color on an already completed drawing. Watercolor, gouache, acrylic—all lend themselves well to this technique, and sometimes the more loosely applied the color, the fresher and more pleasing the effect. This is good news for those who are not used to painting.

You may find it best to work on paper—any good drawing or watercolor paper will do.

Mixed-medium painting—small early fall piece from Watkins Mill

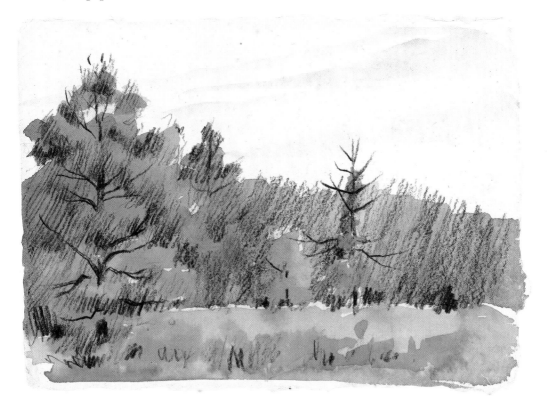

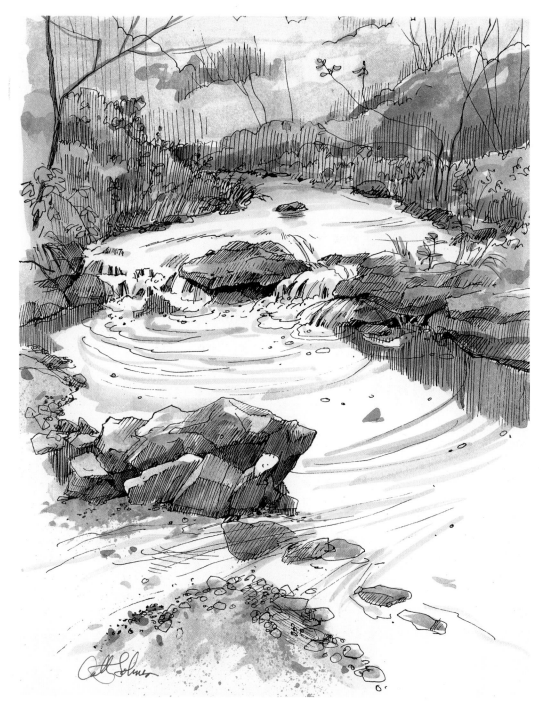

Some ink pens have insoluble ink, and others will lift and smear or blend with water—that can be an interesting technique as well. Try out both to see which you prefer.

Wax-based colored pencils like Prismacolor brand are wonderful for mixed media—you can draw as bold a picture as you like and it

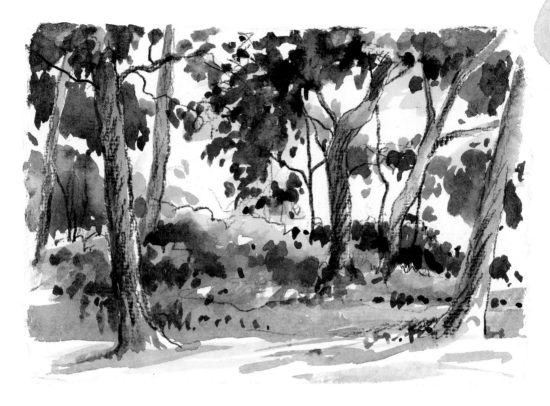

won't lift or smear when you add color. Try a black, a warm dark gray, or a deep brown for your underlying sketch, then lay in color as loosely as you like.

Now that you've tried out the more traditional approaches, play with this one a bit, too.

Gearing Up for Outdoor Work—Beyond Choosing Your Medium

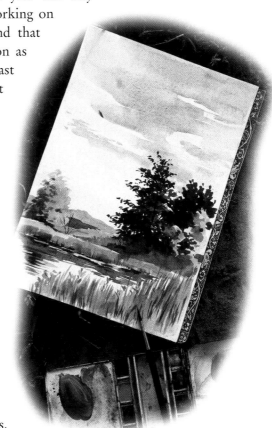

SIMPLE, LIGHTWEIGHT, PORTABLE, PRACTICAL—and even, perhaps, inexpensive. These are the ideas that come to mind when gearing up to paint outdoors. Once you're decided on a medium—or more than one—how you carry it to the field and how you plan to work with it become considerations. Although you can buy almost any kind of a setup for working on the spot, for most purposes I find that comfort is as much a consideration as what I might think I need—at least back in the studio. And comfort means not toting along so much stuff that I wear myself out just getting to the painting site.

Painting on the spot requires a different mind-set. I can't expect it to be just like painting at home, in a climate-controlled environment with unvarying light. Techniques requiring a great deal of extra materials and supplies can wait for when I'm at home. There I can use the hair dryer to quickly dry a watercolor wash. There I may choose texturing agents like salt or rubbing alcohol, plastic wrap or waxed paper with my watercolors, gouache, or acrylics.

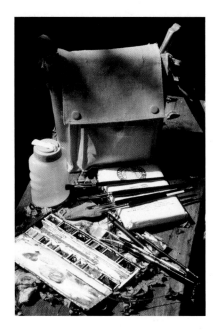

For painting outdoors I follow Thoreau's dictum and "simplify, simplify." This applies to all aspects of the act of painting on the spot, as we'll see later on, but for now we'll consider those things like water or medium containers, carrying cases, painting supports, and so forth.

I like to carry only what I can easily lug a mile or so from my parked car—and preferably, without even noticing it's there. For many such outings, I've made sort of a studio-in-a-backpack, which carries everything I might need, including lunch and a thermos of coffee. Other times, a small waterproof case with a shoulder strap like a purse carries the basics.

It's up to you, and what you feel you need to work best. You can choose to go simple and light, gearing all your equipment to that goal, or create a complete traveling studio. There are advantages to both—it *is* frustrating to be out in the field and suddenly discover a burning need for a brush you left at home, or worse yet, to wish desperately for a source of paint water. But it's also frustrating to lug twenty-five pounds of painting gear up and down a bluff, only to find when you get there that you feel like doing a three-by-five watercolor sketch. Judy Gehrlein solves that problem by being prepared—she carries a large tote bag

Sky painting done with basic materials— water-soluble pencils and wash

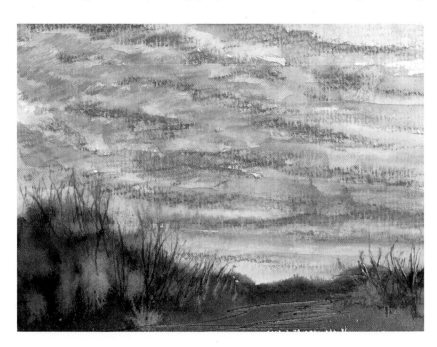

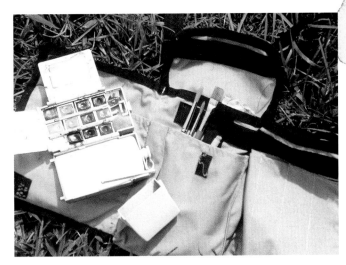

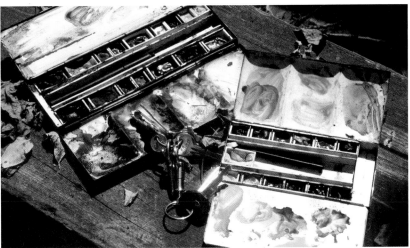

loaded with her more complete painting supplies. When she arrives at her destination, she may take that, or she may just pull out her tiny "field studio" to carry beyond the car depending on her mood, the scene, the weather, or half a dozen other considerations. This neat little kit (shown above) consists of a pencil, a tiny block of watercolor paper the size of a picture postcard, a traveling watercolor set that carries its own water supply, and a small case it all fits in, a setup so light you'd hardly feel it. She's taken this with her to painting locations from Amsterdam to Paris and it's fitted the bill admirably.

If you don't want to work quite that small, you'll need a palette to mix larger batches of color. The metal watercolor boxes come in a variety of sizes, with relatively larger mixing areas, and may be refilled from tube paints or with moist pan colors.

These boxes are similar to the inexpensive kids' sets we all got started with in grade school, but they take refills of pan colors that are carried by the larger art supply dealers. Or you can refill the plastic pans yourself from a tube of paint, if you prefer—just let them dry a bit before closing the lid again.

If you are painting with oils, watercolor, gouache, or acrylic, and not using a field kit or watercolor box, a palette is almost a necessity—of course water-soluble colored pencils or pastels don't require one. For transparent mediums a white palette is best, so you can judge the strength and purity of your mixed colors.

A sturdy plastic palette with a lid works best for travel. Normally, when I want to work a bit larger with my watercolors, I use the same John Pike palette I've had for twenty years or so. There are palettes with lids made for carrying acrylics or oils, to protect the wet paints and keep them pliable.

Some people prefer a white enameled butcher's tray, still available, but you may have better luck in antiques or secondhand stores looking for an old white enameled plate or serving tray. That's what I use with my acrylic colors most often, and when I want a pristine palette I can simply soak the colors off in warm water and start fresh.

The traditional wooden or plastic palette with a thumbhole works fine for oils or acrylics, too. Artist Thomas Aquinas Daly uses a sheet of clear glass over a midtone-gray panel for painting with oils, as it

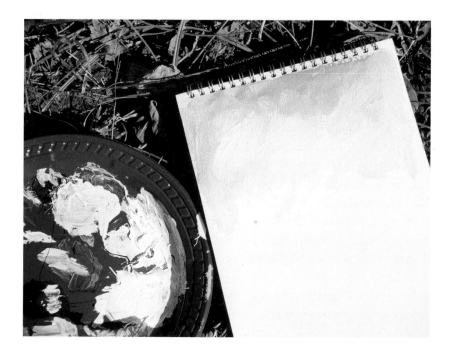

allows him to judge values better, from light to dark. I've even made do with a green plastic picnic plate for acrylics when I didn't have anything else. When you are working with an opaque medium like acrylics or oils rather than a transparent medium like watercolor, it doesn't matter as much what color your palette is.

I generally use a plastic or enamel plate for my acrylics, or the little plastic palette that came with my set—these can all be cleaned up later by soaking in warm water. The paint film softens and can simply be rubbed or lifted away. Or you may want to work with a disposable paper palette for oils or acrylics. These come in a pad and you just tear off the top one when you are done for the day.

Since I am usually working in watercolor, I squeeze out tube paints a few days before and let them dry on my palette or in my refillable metal watercolor box—they rewet quickly and easily and carry much more neatly. The same method will work with water-soluble gouache.

Oils or acrylics dry impervious to water, so you will probably want to carry the basic tubes of color with you and squeeze out what you need when you get to your painting site. And it's probably wise to transport these tubes in a zip-sealed plastic bag in case one leaks or the tubes are damaged; that way the mess is contained.

I sometimes carry my pastels in a similar bag, to keep them all in one place and the dust off the rest of my supplies. Unfortunately, they tend to get quite dirty this way, as the pigment from one rubs off on the next. You can also buy a very nice wooden box for them that not only protects them from breakage but keeps them cleaner and allows you to organize them according to color; there is a slot for each stick of color. Many pastel sets come in just such a box. Small inexpensive sets come in a plastic case molded for them, with a snap-on lid—it works just fine to transport them in it as well.

Water-soluble colored pencils come in their own metal case—a heavy rubber band around the whole keeps it from popping open in transport and spilling my pencils all over. Like the pastels, this case allows me to keep the pencils organized colorwise. Other times I may just grab a selection of individual pencils when I know I want to stick with a limited palette or really plan to travel light, and wrap them with a rubber band to keep them together till I get where I'm going. An old-fashioned pencil box works fine, too, and lets you carry a small eraser if you like.

You will want some way to carry and protect your brushes. If you are using a small plastic or metal kit in box form, there may be a place built in for your brushes, though this usually presupposes you

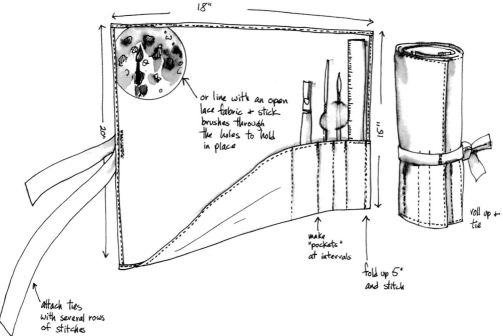

18"

or line with an open
lace fabric + stick
brushes through
the holes to hold
in place

20"

15"

make
"pockets"
at intervals

fold up 5"
and stitch

roll up +
tie

Attach ties
with several rows
of stitches

are using portable folding brushes, not always an option. Some knap-
sacks have narrow pockets for your pencils and pens—they work as
well for brushes. There are a variety of canvas brush carriers on the
market, some of which will fold and stand up so your brushes are held
at a handy angle. I also find a rolled-up Oriental reed brush carrier is
handy and lightweight. It protects the hairs and allows them to dry
quickly.

You can make one of these from an old reed placemat—you may
want to weave elastic in and out of the reeds to hold the brush handles.
Or you can make a brush carrier out of fabric, as shown above.

The most important consideration for carrying your water or
mediums is that the container be sturdy and preferably unbreakable. I
use an old aluminum army canteen when I am taking my whole field
kit—the cup that comes with it makes getting at the water for brush
cleaning or making washes quite simple. A plastic canteen or small
thermos would work as well. I have a little thermos that once came
with a child's lunchbox that works well, too—it has its own little cup.
Other times I use a tiny antique pewter flask when I want to keep
things really compact (it is tiny and quite flat), but then I must plan a
cup as well; many modern flasks intended for carrying a bit of spirits
come with a small cup that slips over the bottom or acts as the lid.
Either arrangement would serve well for field work. An empty mar-
garine tub, lightweight and inexpensive, works admirably for a mixing
cup in the field.

Mediums often come in plastic jars—these are fine to carry to the field. Inexpensive paper or plastic foam cups can be used to contain only the amount you need in the field, though I hesitate to endorse disposables. It's just very difficult to deal with cleanup of acrylics or oils when working outdoors. For the more volatile mediums or thinners like turpentine, you may want to consider a visit to an outdoor or camping store and invest in one of the metal fuel-carrying containers with a good tight lid. They won't leak fuel for your camp stove, so you know they won't leak your paint thinner, either.

Cleanup of oil-painting brushes in the field is a bit difficult. You may find it expedient to simply wipe as much paint out of your brushes as you can, then pop them into an airtight plastic bag till you get home or back to base camp.

Basic and inexpensive, paper towels or tissues are still essential gear for painting—at least for me. I use a paper towel in one hand and a brush in the other—that way I can mop up a quick spill, lighten a wash, pick up a mistake quickly, take some of the moisture out of my brush, soften an edge, or even clean my palette. When I'm working in pastel, the paper towels soften or blend an area quickly. You can use them for that field cleanup of oil-painting brushes as well.

Although it adds a bit of bulk, a roll of plastic wrap with your field kit is handy when working in oils or acrylics, to cover your wet oil painting or to protect the colors on your palette when you are done for the day—and to protect the rest of your gear from *them.* You can just tear off a couple of lengths at home, of course, and keep them folded in a corner of your kit till needed.

If you are working in pastels the plastic wrap might be used to protect your finished work, too, or carry a can of spray fixative with you so you don't end up with a smeary mess.

Auxiliary Equipment

Something to carry your gear in is essential. As noted, I use either a backpack or a small purselike case. Others prefer a pochade—a paintbox of sorts that many outdoor painters find indispensable. If you can get hold of Ron Ranson and Trevor Chamberlain's *Oil Painting, Pure and Simple*, you can see pictures of this carrier and miniature studio close-up and in use; the authors devote a whole chapter to the pochade box alone. You can also see one in Alwyn Crawshaw's *Painting on Holiday.* It holds small boards to paint on, your tubes of paint, brushes, medium, and a modestly sized palette, and allows you to paint

unobtrusively. It is being manufactured again; look for sources in the Appendix.

You may prefer the Jullian French easel. This is a nice item that includes a wooden box in which to carry paints, paper, watercolor block, canvas, palette, drawing materials, and whatever else you deem essential. It will support your watercolor board or canvas vertically or horizontally. It has three sturdy, adjustable legs to allow you to set it up on uneven ground, or even, without legs, on a tabletop. These fine wooden folding easels do carry a healthy price tag for the top of the line—about $425 list price. However, you may find them on sale for $150 to $200 or even less for the smaller sizes. Less expensive copies often don't hold up, I'm told, so if you want to go this way, hold out for the best.

If you don't want to invest so much, don't worry. You can always

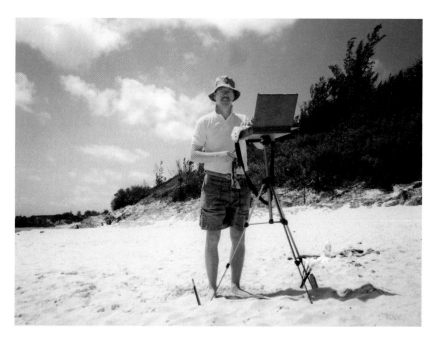

Greg Albert, North Light Books' editor in chief, writes, "The bottom of the box has a hole in the center that was originally designed as a thumbhole, but I'm more comfortable supporting it with a light camera tripod. The box came with a small wooden panel containing a screw fitting that can be mounted right on the tripod head. Both the tripod case and the pochade box have shoulder straps, so I can carry the box and easel conveniently everywhere—and I have!"

Greg is painting on a pink-sand beach in Bermuda, with his brushes kept handy by sticking the ends in the sand!

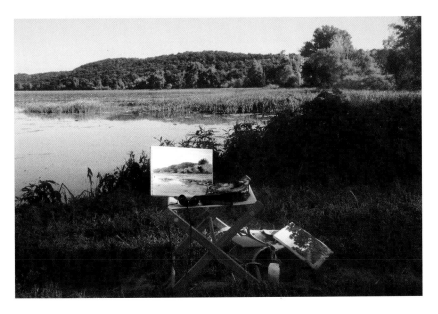

For even simpler seating you can find an inexpensive folding stool without the carrying pack. Some people carry two, one to sit on and one to hold their palette, like a small folding table.

sit on the ground and prop your painting up on a rock or hold it on your lap. I've been painting for thirty years and have managed that way just fine.

A handy tool if you do a lot of outdoor painting is a folding painting stool, especially if your legs are no longer so young. This is made much like a folding canvas camp stool, but below the seat some have a kind of hanging kangaroo pouch, usually zippered, that can hold most of your painting gear. Others are made like a backpack attached to a stool and are tough nylon with aluminum legs. Some have nice little outside pockets to hold brushes or pencils. They're lightweight and easy to transport to the site. Some models have simple hand loops for carrying, some are made to fit a backpack frame, and others have a sling made of webbing to allow you to carry them and keep your hands free. Some even have a back support. (If you can't find one of these from your art supplier, check with a sporting-goods or discount store—on my last visit to one of the latter, I saw a *very* similar item in the camping section.)

I recently received a wonderful catalog in the mail from Duluth Trading Company in St. Paul, Minnesota. It is full of carrying cases intended for electricians, carpenters, and other construction workers, but all I could think of as I thumbed the pages was what wonderful traveling studios these goodies would make. See the Appendix for their address.

When working larger, I like an old-fashioned, economical cardboard portfolio for carrying paper, watercolor blocks or sketchbooks,

and finished paintings. The sturdy cover can double as a painting surface—a kind of portable lap desk. These come in a variety of sizes so you can choose what you're most comfortable with.

You may prefer to use lightweight board with foam sandwiched between paper or resin as a lightweight painting surface for watercolor, gouache, pastel, water-soluble colored pencil, or even oils. When traveling out of town, I cut a piece to fit my suitcase and cut my watercolor paper just slightly smaller—clip the paper to the support and it's protected while adding only ounces to your luggage. You can clip, tape, or staple your paper or canvas to this surface. (When you are finished, you can cover a wet oil painting with plastic wrap and roll it to transport it home, I'm told.)

If you paint in oils and don't want to cover your painting with plastic wrap or try the rolled-canvas method, you will need some way of carrying wet paintings back from the field. Some pochade boxes have spacers in the lid to allow you to carry two or three small paintings without their touching one another. There are special cases available that do the same for larger works; see the Appendix for sources of these.

Still More Auxiliary Equipment

There are a few other things you'll want to consider in addition to your painting equipment, things that may make your excursion safer and more comfortable. Insect repellent is often a given, as chiggers, ticks, mosquitoes, and blackflies are abundant in some of the most beautiful painting locations. I remember working outdoors in Maine and being told the skeeters were especially "wicked" that year. Now, if you've been to Maine, you know that word can mean both good and bad—in this case it was good for the mosquitoes and the dickens for the artists wishing to concentrate on their work! Choose your favorite repellent, be it DEET or pennyroyal oil—just don't expect it to be 100 percent effective.

Suntan lotion or sunscreen may effectively prolong your painting time. I use a gel type that isn't oily so it doesn't mar my painting surface or compromise its ability to take a wash. Sunscreen lip pomade is good, too—when painting near water, sometimes sunlight bounces in odd ways and you can get a burn you weren't expecting, even if you are wearing a hat.

And speaking of hats, that's a good piece of auxiliary equipment in itself. A broad-brimmed straw hat or a baseball cap with a brim can

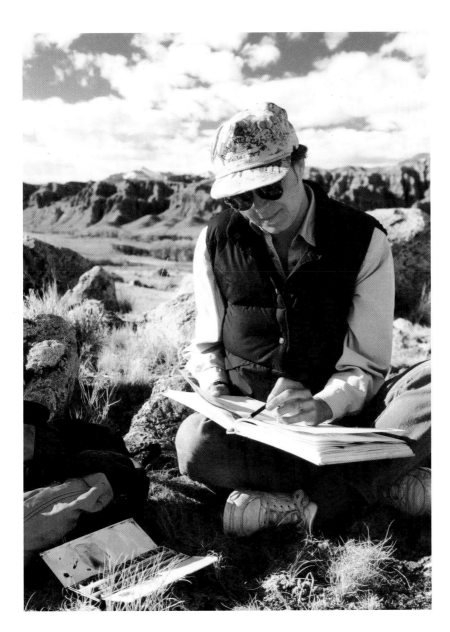

Here, artist and author Hannah Hinchman is working in the American West, her eyes shaded with a ball cap and sunglasses; where glare is likely to be a problem and shade is at a premium, these are both good solutions. Notice Hannah's also wearing a down vest against the vagaries of weather.

help shade your eyes, and even your paper if you position yourself right. It can make working outdoors much more pleasant. So can polarized sunglasses.

A small first-aid kit might be in order, but generally you can leave it back at camp unless you plan on going far up the trail to that perfect painting location. Disinfectant, bandages, and an antibiotic salve are good to have handy.

If you are going into the wild places, especially in the American West, go prepared. Bears don't care much for humans, and will gener-

ally leave you alone and head the other way if they hear you coming—unless you inadvertently come between a mother and her cubs. Carry a bear whistle or bells, or whistle as you work—you may feel like Snow White, but you'll come back with yourself and your work in one piece.

Remember to take drinking water, and, if need be, water purification tablets. It's possible to get so intent on what you're doing that you forget how far it is back to the car, and water is essential.

A light snack is a good addition that may allow you a bit of additional painting time. I throw an energy bar or two into my field kit, or sometimes fresh or dried fruit. A chocolate bar is a great, quick energy boost. Trail mix or a handful of nuts buys me more painting time—if I have to stop painting and go get a proper meal, my perfect light is gone for the day.

You can even buy a painting shade or tent, à la the early Winsor-Newton catalog from the nineteenth century. These are especially useful if you must paint in the hot sun, or if the weather threatens a downpour. A shade umbrella, as in the famous Corot photo, works as well. Living as I do in oak/hickory forest country, I generally don't need auxiliary shade, but if I worked often in the desert, I might consider it. Of course, if you have a van, you can always paint from the side door as though it were a traveling studio.

Locale

Where you choose to paint can affect your equipment, technique—and comfort level. Planning ahead, of course, can alleviate a lot of discomfort and the distraction it can create. Go prepared, if possible.

As Richard Busey says, "When you paint in the desert, finding a spot of shade is high on the priority list!" When I painted with him in March of '98, we followed his advice to the letter, finding a place near Lake Mead that was nicely sheltered but still allowed some wonderful painting opportunities. If you are working in the desert, take drinking water and plenty of it. Use sunscreen. An umbrella for shade can make the difference between a completed painting and a bad sunburn; it will also allow you to see the values better without being blinded by that strong desert light. There have been times that I've had full sun on my paper, and when I looked away to mix a new brushload of paint, I found that everything looked green, as if I'd been looking at snow on a sunny day. It makes it very hard to judge what colors to use and how strong to mix them. If you can't lug along an umbrella, Busey suggests turning your body so it shades your painting surface; you can always

The tree grows from the bank of my creek; I did the pen-and-ink sketch first, then scribbled on water-soluble colored pencils. Since I was sitting close by, I simply dipped my brush in the creek as it ran by to lift and soften the pigment into these interesting and somewhat textured washes. In some areas I used very little water so the pencil lines still show.

turn your head to see your subject. There is more on this in the section on painting in summer.

One of the loveliest ways to work in nature is from a boat or canoe; I bought a small, ten-foot one-person canoe for just this purpose—as well as for fun. You see a whole different aspect from the water. Birds and animals appear less shy, and you can get closer to them. But working near or on the water is a challenge, nonetheless. You can keep your gear safe—at least while moving from place to place—by keeping it in a flotation bag. Even a simple zipper-lock bag will protect

your gear or paper—or even finished works—from an inadvertent bath. If you are working fairly small—say eight-by-ten or less—you can fit your paintings in the gallon size, which are approximately eleven inches square.

In nearly every location you'll still need to take drinking water, since much water in the wild is too contaminated to drink (taking a chance on *Giardia* is not good!), but it is nice to know that when working near water you can use that for painting, without having to carry extra. I've done many a painting sitting on a rock in a stream and dipping paint water right from the creek—as I use only nontoxic paints, this is not generally a problem. (Of course, it you work with oils, that's not an option.)

Getting Started

Now that we've discussed the art of learning to see along with the nuts and bolts of tools and techniques, we're ready to put it all to work—and about *time*, you may be saying! At last, this is the good part, satisfying and wonderful, challenging and frustrating all at the same time. As long as I have been painting, I have to admit there is nothing quite like the moment before you put those new materials to work, the few seconds before you touch brush to paper, or the anticipation of responding directly to nature in this way. The conversation is about to begin.

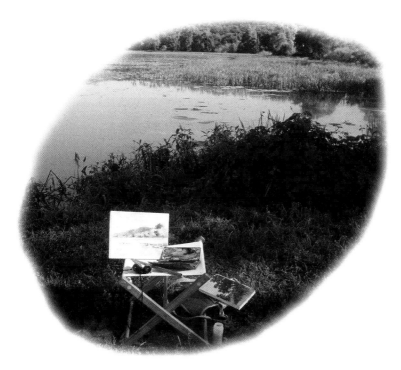

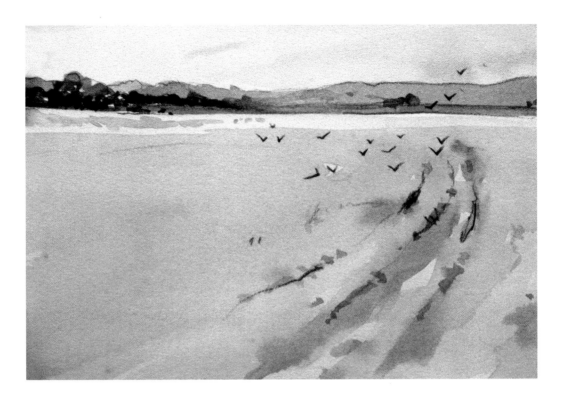

"Early Morning
Beanfield"

Our frustration level in that encounter can be minimal, though, if we remember that we will never capture *just* the effect we're after, that wondrous complexity we see before us, that perfect, glorious light. It's not possible. And as we've noted, we're not painting a flower, or a waterfall, or a gorgeous mountain vista—we're painting a *picture* of it, our *impression* of it. We're using pigment; nature can use light and water and live things.

My friend and painting partner Judy Gehrlein and I do a lot of talking as we work, especially when we take a break to allow our paintings to dry, discussing what painting means to us or how it has affected our lives. She says, "I used to be very concerned about making art, about my painting turning out 'right.' Now I feel like the life you make is the art; making a painting is just one part of that life." I've seen the difference in my friend, and in myself, as that became true for us both.

This realization is liberating in the extreme—because we are the only ones qualified to know what our impression is. *Whatever* we produce is the honest reflection of what we've seen and how it's affected us. We're under no obligation to try to re-create nature with photorealistic accuracy—and in fact, why would we? There are cameras that can do that far better than we ever could. What a camera *cannot* do, however, is express the completely human interpretation of the world

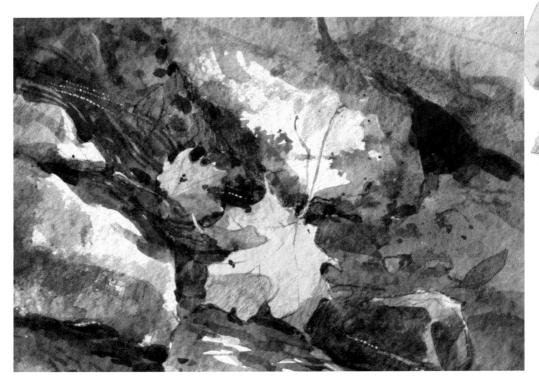

y

Here, the bright leaf caught in the rocks by the little stream caught my eye, after a morning of painting the larger landscape. It was fun to focus on just that.

y

around us. And as much as I love taking photos, I realize that it can't quite capture the immediate, sensuous pleasure of hand/eye/spirit response that we discover when we take time to paint in nature. There are a couple of extra steps in there when we choose a camera to record our experiences—developing film and printing pictures—that don't exist when we paint. Then, we can have a finished image almost immediately, one that develops before our eyes, step by step, and we enjoy a record of our response to keep forever or share with others.

There is a definite tactile pleasure in just handling paints and



GETTING STARTED









brushes, and a childlike joy in using color. More than once in the midst of painting, I've stared in amazement at a sudden serendipitous effect that appears as if by magic on my paper—almost as though I'd had nothing at all to do with it. It's pure gift from the painting gods.

There is something deeply appealing in a landscape; it speaks to us on an elemental level. A heart-stopping sweep of hills or mountains, the pearlescent, moiré-silk light on an autumn lake, a bubbling stream makes us want to keep what we see with us forever. Artists for centuries have tried to capture the soul of nature on paper or canvas; the work of those who succeeded hangs in the finest museums. Think of it: Vincent van Gogh, Claude Monet, Albert Bierstadt, Fairfield Porter, Andrew Wyeth—each has been drawn to landscape, time and time again. So have I. So, I'd be willing to bet, have you.

Nature can be daunting, to be sure. There is so much going on, so much detail. It's so *big*. I've often chosen to paint, instead, an "intimate landscape," a detail of the larger scene. But it isn't necessary to shy away from the big picture, just to be aware of the elements of landscape and how to combine them successfully in your work.

First off, I suppose, this is what I often tell my students—in a practical sense, at its core, painting one thing is pretty much like painting another. We shouldn't let one subject intimidate us while another seems perfectly approachable. Basically, they are all just shapes. *Seeing* those shapes accurately, simplifying them, and then depicting them the best you can is the trick.

It's the bare bones, often, that make the broader landscape successful, evocative. Embellishments can come later—or not at all. Once you've got the basics in place, everything else follows naturally, if you use restraint. (All right, Albert Bierstadt and Thomas Moran and a few others seem to have gotten away with painting every single leaf on every single tree and *still* created landscapes that arrest the attention, but most of us really need to concentrate on simplification—and seeing those bare bones—as a key.) As desert painter Richard Busey says, "What is important is not the motif itself, so much as your ability to imagine, speculate, organize, and above all, simplify."

Choosing a Subject

This can be as simple as setting out into nature, close to home or far away, and letting your eye be struck by something—and there is much in nature that will have this effect. It can also be as complex as having an idea in mind and then setting out to find something that

matches that initial concept—at least as closely as possible. There is a great deal in nature worthy of our notice, whether the smallest, ground-hugging spring flower or a grand mountain vista. What you *don't* want to do is let yourself be daunted by the complexity, or paralyzed by what you see. It can be quite manageable, even if you are a novice painter. There are many tricks to let you zero in on a subject and to simplify it sufficiently to capture the soul if not the detail—in this chapter we'll explore a number of them.

The *best* tool is an open mind and a willingness—or perhaps an ability—to really see the beauty and meaning all around you. Then you can't fail to find something to paint. Don't despair, that ability can be trained and developed.

Let the landscape speak to you. There are days when I'm in the mood for the big picture and other times when some tiny detail catches my eye. Don't imagine that the small vignette is somehow any less worthy of your attention—sometimes that is the thing that really speaks to us. If you are one who enjoys being in nature, and I assume you are or you would not be reading this book, you already know how often it is that the small things catch our eye—the variety of tracks by a lake, a colorful mushroom, a tiny fossil caught in a rock. Paint *that* and you'll find you greatly enjoy the record you've made.

And of course it is not necessary to turn each subject into a completed painting. Use your paints to make field notes and studies as well. That's often how I like to work. When I find a strange track, it is fine to make as detailed a study as I like of just that. In the same way, my studies of a wildflower or weed may help me identify it later. It's these bits of found beauty that can rivet us to a spot and make us instantly aware, as Ram Das said, of "being here now."

Keep it simple, if you like—I had a blue pencil with me on my winter walk, so I just sketched out the tracks with that and added a shadowy blue wash for further definition.

Canada
Goose

Great
Blue
Heron

Chickadee
(songbird)

85

Of course your thumbnail-sized sketches can be more complex if you like, and more colorful as well. My friend Judy Gehrlein did these all on a single page of her European sketchbook.

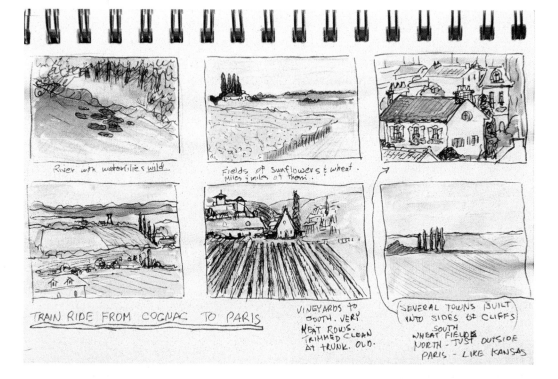

River with waterlilies wild.

Fields of sunflowers & wheat. Miles & miles of them.

TRAIN RIDE FROM COGNAC TO PARIS

VINEYARDS to SOUTH. VERY NEAT ROWS. TRIMMED CLEAN AT TRUNK. OLD.

(SEVERAL TOWNS BUILT INTO SIDES OF CLIFFS) SOUTH WHEAT FIELDS NORTH - JUST OUTSIDE PARIS - LIKE KANSAS

Planning Your Work

For generations, artists have used compositional sketches and value sketches before committing to their larger work, once they settled, roughly, on what they wanted to paint. These can be tiny "thumbnail sketches," as they are called, perhaps one-by-two inch or two-by-three, just to help you decide what you want to focus on and how to best present it. They can be very quick, less than half a minute, if you like—that way you *know* you won't get bound up in detail. Explore the abstract *bones* of what you see; look for the basic shapes, the forms that can be simplified into a pleasing whole. Make several. Just play around with composition and value—it helps you to warm up before painting, too. Add a detail sketch, if you like.

Try squinting your eyes almost shut—values coalesce, forms simplify, details disappear, and you're on your way to finding those abstract bones of the scene—and the aerial perspective. It is easier to simplify values, as well, and go for the big picture rather than being distracted by the thousands of details that often appear.

Yes, trees do indeed have a *lot* of leaves—but your eye tends to read masses of foliage, instead. Paint that and add a bit of laciness at the edge to suggest leafiness. The pattern of a tree's bark does go all around the trunk and from top to bottom—but we only really notice it where we're looking at the time. As it curves away from you it becomes simpler. Perhaps in strong, direct sunlight you can't see all the details—or maybe it's deep shadow that obscures them. The point is that you can paint in the same way your eye sees; use as much detail as you like—where you focus your attention. Let it be simpler elsewhere, because in truth the eye sees pretty much like a camera does— what we look directly at is in focus and everything else is peripheral. It's soft focus—fuzzy, not fussy.

It isn't all just a matter of simplification, of course. Working on the spot opens you to new experience and lets you see things you only imagine back home. Or, more likely, things you *can't* imagine back home. Getting out in nature always brings serendipity—some special sighting, some insight, some bit of peace in a frazzled world.

Try using an empty slide sleeve to look through to isolate a painting subject from the complex and sometimes confusing mix of nature. Or just make a box with your fingers to look through.

Artists have been using similar "viewfinders" since the Renaissance and before.

Don't get too hung up in these little sketches. One of the advantages to making them so small is that you *can't* do much detail. They are only meant to help you plan the big things— composition, placement, value. A graphite pencil is fine for these simple planning sketches, as is scratch paper. Don't worry about them, just enjoy playing with what you see and how you want to present it.

A sketch allows you to work quickly—perhaps only seconds elapse if you are doing a gesture sketch or thumbnail. You don't have all the time in the world invested here; you can move things around as you like. If one sketch doesn't work, if you want *more*, or *different*, discard it and start another—or use it to build on. See my first Sierra Club Book, *The Sierra Club Guide to Sketching in Nature*, for a full explanation of the kinds of sketches you can use to explore your subject.

On the other hand, just because it is a sketch rather than a complete painting doesn't mean the information provided must be *sketchy*. A detail sketch, somewhat larger than a thumbnail, of a plant or rugged rock can be as complex as your subject itself and give you plenty to work with when you begin your painting. You make the decision as to how much time to put into it depending on what you want from the

Gesture sketch:

A quick sketch intended to capture the basic shape, rhythm, or mood of your subject. Take only a few seconds to create a gesture sketch.

This black-and-white gesture sketch took less than thirty seconds.

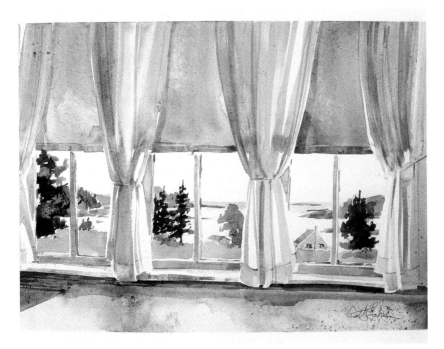

In my painting, I edited out the car and the art supplies that were visible in the actual scene and made the value of the curtains, shades, and window itself a bit lighter so it would not overpower my painting. (And *of course* painting "from the inside out" is still painting from nature!)

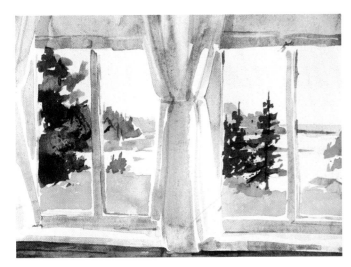

situation, how much time you have to spend, what you are interested in—whatever.

One of the wonderful things about sketching is that you can focus on only what you *want* to. You can edit, add, subtract, move, simplify, or eliminate altogether. If that tree or stone fence adds nothing to your sketch, leave it out. If it's in the wrong place, move it. If it isn't there at all but appears in another sketch and you want to include it, borrow it. It's magic. This really *is* creating; it's in our job description as artists.

Horizontal close-up—the windows make a kind of miniature picture frame. Vertical close-up of same scene

89

Use quick sketches to decide on a format for your work. Vertical, horizontal, or the extremes of either—even a vignetted work can be preplanned in your sketchbook. That viewfinder can help you decide which format looks best.

These are important considerations; they can affect the impact of your finished sketch and the painting that results. A horizontal format may be soothing or pastoral; it may help you best capture what struck you in a panoramic landscape. A vertical format can be dramatic, exciting—or spare and elegant. An extreme horizontal might work best for a midlands prairie; an extreme vertical could help you zero in on the gestalt of a single, towering redwood.

A format sketch, thumbnail style, takes only seconds. Make as many as you like to explore your chosen subject and find just what it was that attracted you to it in the first place—and how best to translate why it struck you.

Plan your composition, as well, with thumbnail sketches. Make them simple or complex; devote only the amount of time you want to them. (The format you've chosen will already have helped you make some compositional decisions.)

Black-and-white
format sketches

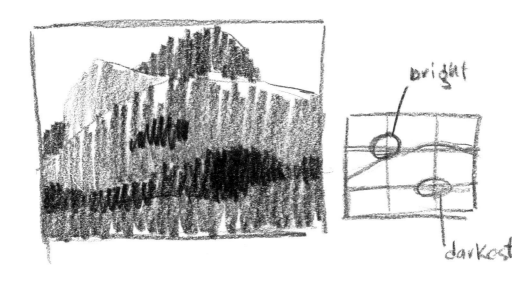

bright

darkest

Consider the Golden Mean—putting your center of interest not *in* the center but one third of the way from the top and side of your composition, as shown. That is, try dividing your paper into thirds horizontally and vertically, then let your center of interest—your main subject—be placed at one of the spots where those lines intersect. You may make it the most interesting, the most detailed, the brightest or darkest—it will catch the eye.

And then consider ignoring that time-honored—and time-worn—rule, and sketch your subject off to the extreme edge of dead center. You may find you like it there; it may express what you're after better than the classical composition. After all, a study of a wildflower

Black-and-white composition sketches

Black-and-white off-center sketch—in this case the isolation of the rabbit in the lower right points up the precarious distance between where he is and the safety of the hole near the tree at upper left.

91

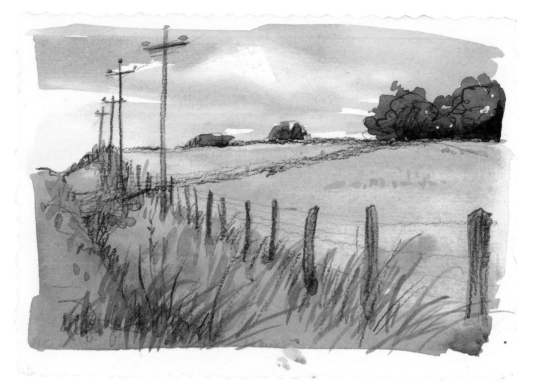

deserves your full attention—why not place it stage front? Some subjects seem to beg instead for the more unconventional placing: a bird about to fly, or an elusive elk that's just caught your scent. It looks natural—*right*—to place them as if they're just about to streak off your page. Such a placement keeps the viewer slightly off-balance—I've seen it work wonderfully with static subjects as well as these livelier ones.

Look for ways to lead the eye into the composition. As you sketch, emphasize the gentle curves of a road that invite you into the

picture plane. Look for S-curves, which are very pleasing to the eye—it's surprising how often we find them occurring naturally in nature. The flow of an S- or Z-line works well to move the eye around within the picture, as at left. Try an arrow-shaped device to work the same way—a clump of weeds, a cairn of rocks, a tree, even a cloud shadow in the foreground can provide this invitation.

Simplify values in your sketches to help you suggest depth, form, distance—and design. There are a thousand gradations of black and white in the world we see—if you try to capture them all on paper, you'll make yourself crazy. Your sketches will help you to define the important values—and to *find* them.

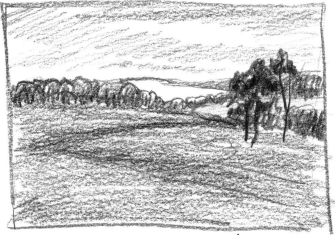

Black-and-white
value sketch

5 values, the med-dark value is
optional, making a 4 value
sketch

I most often use a simple four-to-five-value system. The white of my sketch pad is my lightest value, and a fully saturated dark stands in for black. (If I'm using black ink, fine—black is black. But it's fun to substitute a sepia, dark gray, or indigo for the more expected black—in this case, my darkest value is simply the darkest I can coax from my tool of choice.) I use a light tone for my next value, then a good midtone gray (or sepia, or blue).

Sometimes I add another, darker halftone to bridge the gap between the darkest dark and the midtone value, but not always—the eye and brain do some of the work for me, filling in the values themselves.

These four, or five, are sufficient to suggest the full range of values in nature. Look for ways to use them to the fullest: A sky might be white, when you are sketching on white paper, because it is often your lightest value, with a few pale clouds with midtone shadows; far hills could again be the pale gray value, and the middle and foreground can be a combination of midtone and light. Use the dark for the deepest shadows and sharp details, and as if by magic, you've created a kind of reality in seconds.

And since these are only sketches, I can take the time to play around with my values. If I remember the scene on another day—or another *time* of day—I can make those clouds dark and threatening, or the foreground as bright and sunlit as I like.

Black and white,
one value
dominating

balance

dominate value & high & light

Finding a good balance of darks and lights to make a pleasant composition can be the work of your sketches, too. Don't worry about details—you don't even need to recognize your subject in a quick value sketch, just get those darks and lights down. Vary their shapes and sizes; balance a large dark with a smaller light and vice versa. In most cases, you'll use your lightest lights and darkest darks more sparingly than midtones—but your sketches will let you decide.

You may want to remember some of the basic "rules" of painting, by letting one value or another dominate—let your painting be predominately light, for instance, with smaller areas of midtone and even smaller accents of the darkest dark, or predominately midtone, with smaller darks and smallest areas of the lightest light—or any combination you wish. And keep those lightest-light or darkest-dark accents of varied sizes and shapes—if they become too regular and all-over, your painting will look more like a camouflage jacket than a work of art.

If you have trouble making the transition between the colorful world of nature and the simplification of a black-and-white sketch, use polarized sunglasses, a tinted viewfinder, or, again, try squinting your eyes, which reduces the impact and intensity of the visible colors. You'll suddenly be aware of simplified values and the strength of their patterns. Light and shadow are very dramatic, but it's easy to downplay the drama—values may become too close, making everything look gray. I know; you just can't bring yourself to believe that that light-struck hill could be so high key in contrast to the inky shadows

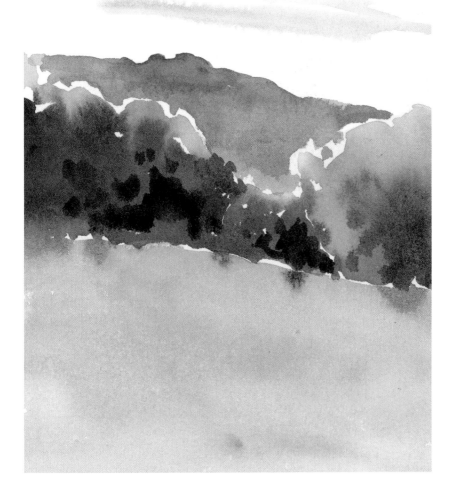

The light was changing rapidly here so I only took time for a *very* quick watercolor sketch as the sun rose over the hill.

beyond. Believe it—the colored glass or polarized glasses will help—and paint it as you see it.

If you're working in color and bypassing a black-and-white planning stage, the same value system applies; practice seeing how much saturation there is in a color, and how much black.

Try out different color combinations—alter the season or time of day in your choice of colors. Go bright, or subtly monochromatic. Again, your sketchbook is the perfect practice ground. And as Apollinaire wrote, "Color is the fruit of life."

Ink drawing of
trees with color
added later

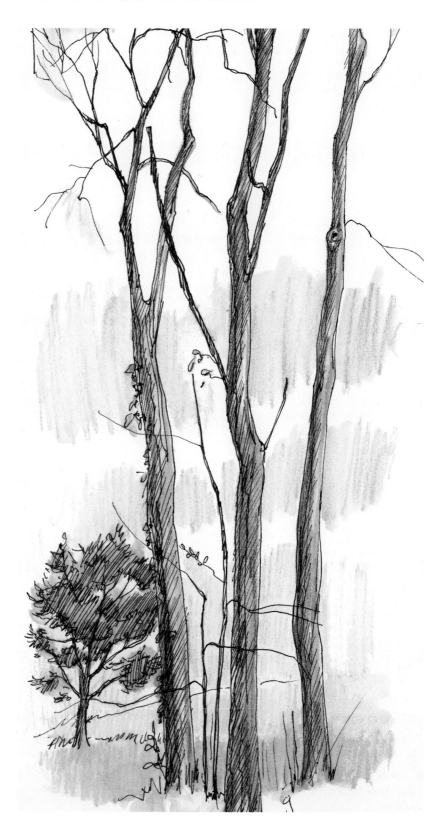

This painting was not particularly successful, as far as I was concerned, but it yielded three other possibilities to explore.

If it helps to get your ideas firmed up in your mind—and to get you over any residual nervousness about jumping in—make up a quick color scheme on scrap paper. Just little swatches of the colors you're thinking about using is enough—try out several if you want. Your initial choices—maybe the obvious ones—may not be the best ones to suggest what initially struck you about the scene, or your emotional response to it.

If you haven't *brought* colors with you into the field, practice training your color memory. Sketch in black and white, then add watercolor washes at home in the studio. Or, make written color notes in the margin or directly on your sketch where they appear. I often like to work this way, usually with results that please me very much. I don't worry so much about exactly *matching* nature's hues as becoming aware of what color impression the scene made on me.

You may not have thought of your studies as a place to dig for possibilities—but they are. Perhaps the scene you chose to capture at the time has a number of other possibilities contained within its borders. You painted the whole enchilada, but you focus on that tree in the middleground to make a new composition. The background shapes may suggest another potential painting. Zero in on these possibilities by putting a piece of tracing paper over your original and drawing rectangles around those areas that seem as if they'd do with further exploration, then upsize them to make a new sketch. Even an interesting pattern of lines or values can be mined out to make something brandnew. Look for the abstract shapes that suggest a pleasing whole.

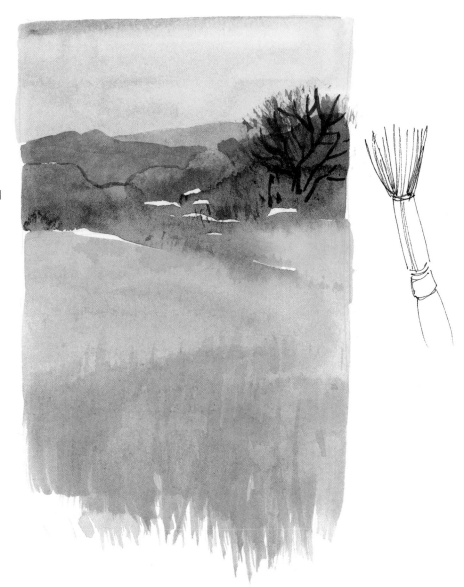

Small watercolor sketch with aerial perspective, from top of Cooley Hill

Other Considerations

Aerial perspective is an important element in landscape; this simply means the way things recede from the eye in nature, whether through simplification, cooling or bluing of colors, or getting higher and smaller. It works as well in middle distance as in the background. Think of the picture plane as a stage set; foreground, middleground, and background are enough to suggest depth. The simple shapes and overlapping forms open your eyes to the graphic forms that may have been lost in detail. A rough black-and-white or color sketch will be sufficient to suggest this effect and fix it in your mind.

Linear perspective, of course, is that trick of vision and distance that seems to make parallel lines converge at the horizon—also an important tool in creating believable landscapes (especially if yours is an urban landscape containing buildings and streets). Of course this also applies to elements of landscape like long, narrow lakes, streams, rivers, country lanes, crop rows—anything that appears narrower as it recedes from the viewer.

If you're going directly for color—a sketch in water-soluble colored pencil or watercolor, perhaps—let colors get cooler as they recede into the distance and keep those background shapes simple to suggest aerial perspective. This is not *always* the case in nature, of course. When the air is particularly clear, distant details are very nearly as sharp as those closer to the foreground, and the bluing effect of atmosphere is limited. Here in the Midwest, as in the South, however, distance is often blued with humidity, especially in late summer and fall. Used

This small country road near Cooley Lake appears to narrow dramatically as it leads you into the picture plane.

99

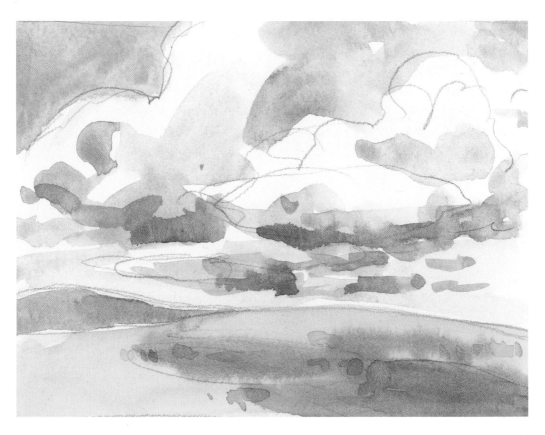

Small dramatic cloud sketch with shadows

judiciously, this is a good trick to suggest a phenomenon most of us have witnessed firsthand.

Things are not always *lighter* in the distance, either, of course. If you have a scattering of big, puffy cumulus clouds, wherever their shadows happen to fall will be darker—be it foreground, middle-ground, or background. If a storm approaches, it will cast a dark shadow under it. Observe these phenomena and use them to make believable—and interesting—landscapes.

Basic Elements of Landscape

It helps to know the basics. That includes the various ways of handling landscape—a rather large and sometimes intimidating subject. It may be easier to break it down into bite-sized portions and consider the separate elements first, then worry about putting them together.

More concrete and tangible elements of landscape include hills, mountains, trees, lakes, rivers, grasses, and buildings, and there are ways to include them in landscape to enhance the effect you're after. Again, it isn't necessary to paint every rock or leaf or blade of grass. By *suggesting* these things, it allows the viewer to participate; the imagination steps in and completes the picture in delightful and individual ways.

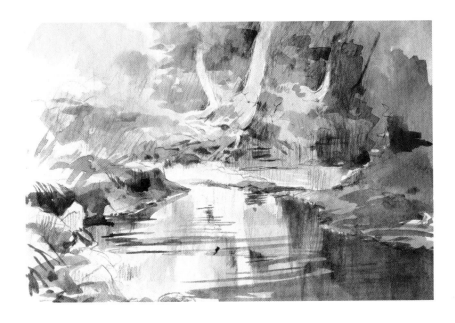

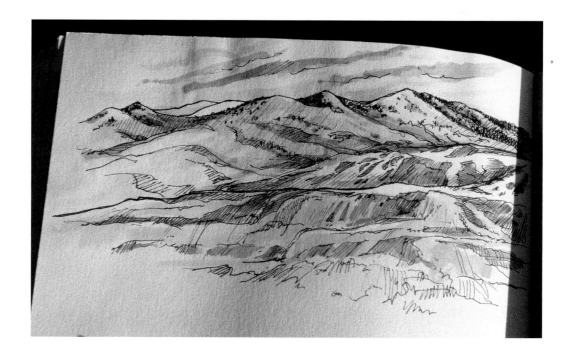

Landforms

Aerial perspective, or bluing and simplifying of distant objects, will help you to capture the illusion of receding hills and mountains, of course, but so will using the illusion of overlapping forms that we discussed earlier. Observe shapes carefully, and suggest one shape behind others.

Murphy's Law applies to painting as well—it always seems that if there's a wrong place for a line to end up, it will! For instance, you will get a much more believable one-hill-behind-the-other effect if you don't let the next rank of hills intersect with the top of the one in front, as in our drawing. It may actually *do* that, in nature—though it usually doesn't—but try to be aware of where your line is going to end up and move it up or down just a bit. When you paint these farther hills, remember to make them lighter, simpler, and perhaps bluer, and they will probably be a clearer mirror of nature itself.

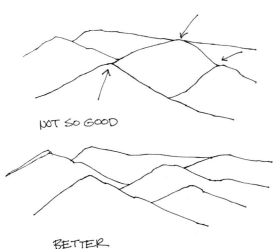

NOT SO GOOD

BETTER

Rocks and Earth

There are all kinds of rocks, of course, and their forms and colors and textures are endlessly fascinating to paint. Here where I live, the limestone outcroppings are mostly silvery gray, but may be encrusted with lichen in many colors. In the desert Southwest, where I sometimes paint, they are more likely to be gorgeous red-brown festooned with ribbons of black desert varnish. Volcanic rock is different from sedimentary rock and can take many forms. Observe closely, and use light and dark to suggest form and volume.

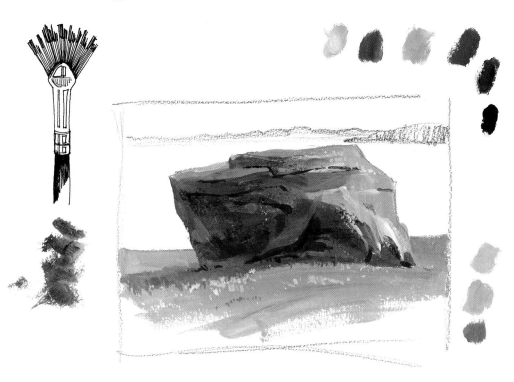

I used acrylics in this quick sketch of a large glacial rock near Smithville Lake—with the opaque colors I could have built up layers of detail until the big pink granite boulder was almost photographic, but I just wanted to capture its monolithic quality as quickly as possible. (Well, it's not like it was going anywhere, of course . . . having sat there for ten thousand years!) The spots of color in the margins show the variety of colors I used in the layers with only a few basic tubes from my traveling kit.

At left is a demonstration of the drybrush texturing used to suggest the ruggedness of the rock, now easier to see against the white paper. I also used a fan brush, barbered to a zigzag appearance, to texture the rock and the grassy foreground.

This was painted mostly "alla prima," all in one go, with very little time between the original layers, which I allowed to blend on my paper, and the final texturing.

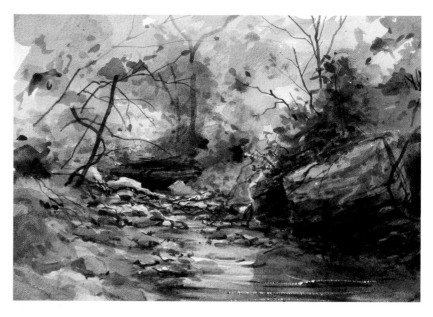

I utilized glazing techniques to unify my subject, with a lovely transparent glaze of phthalo blue to suggest shadows over both the green, leafy sections and over the warm sienna and gray rocks, keeping that one light-struck edge in juxtaposition with the darkest area of the small ledge of shadowy rock just beyond. I paid close attention to the varied, overlapping shapes and planes of the rocks while doing this painting.

Whenever your painting appears to be getting out of hand, or too spotty (like a camouflage pattern), a unifying glaze like this helps.

This is the scene as it appeared the day I painted the rocks in Shackleford Creek.

If it helps to plan out your rocks ahead of time, make a quick sketch— this was very loosely done, just to remind me of the basic composition and position of the rocks, their layering, and the linear effects possible. A tiny value sketch helped remind me where I wanted to maintain the light that filtered through the trees and onto the rocks.

Spatter over a variegated underwash works well to suggest the texture of dirt or sand—that underwash, of course, can be whatever color you see: red brown, almost black, pale, pale wheat.

Remember to vary the size of the spots. You may want to mix up a light gouache with your basic color so some of your spots are light on the darker background, like those shown at right.

Here you can see how varied those spots can be. Blot some so they are lighter than the others for best effect.

Earth may come in many colors, too, from white-sand beaches of the Caribbean to the dark, loamy soil of the Midwest or the red brown of Georgia's fields. Pay attention to these details and you can create a portrait of place. For my purposes, most often I use a variegated wash for the undercolor, then do spatters of a darker color to suggest the earthy texture. When working in gouache, oil, or acrylic, of course, you can add lighter colors as well.

Trees and Bushes

Trees in nature seldom resemble uniform-green lollipops on a stick. Watch for the wonderful variety of shape and color. Your landscapes will be far more interesting—and more lively—if you remember that tree shapes can be as different as poplars and cedar trees. Observe your subject closely. Allow some trees to be more vertical, some to take on a rounder or asymmetrical form. A dead tree or limb here and there adds interest, as do shadows that occur within the tree canopy. Watch for them as you work.

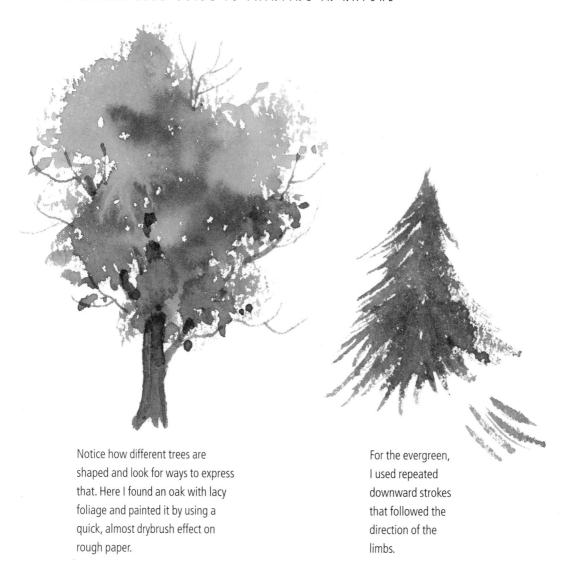

Notice how different trees are shaped and look for ways to express that. Here I found an oak with lacy foliage and painted it by using a quick, almost drybrush effect on rough paper.

For the evergreen, I used repeated downward strokes that followed the direction of the limbs.

Painting trees in the deep woods is different from painting an individual tree, of course, and artists have puzzled for generations about how to suggest that complexity. Obviously, most of us will not want to try to paint every leaf in the forest, even if that were possible. So you'll want to find ways to simplify what you see. I worked my way through this problem a few summers ago in a painting I was quite happy with.

Distant foliage can be handled *very* simply, too. Keep in mind how the eye sees—distances become simpler—and how it focuses on what interests it to the virtual exclusion of other details. You just don't *notice* much detail if that's not where you are looking or what you're paying attention to. Use that phenomenon in your work and simplify madly where you don't particularly want attention.

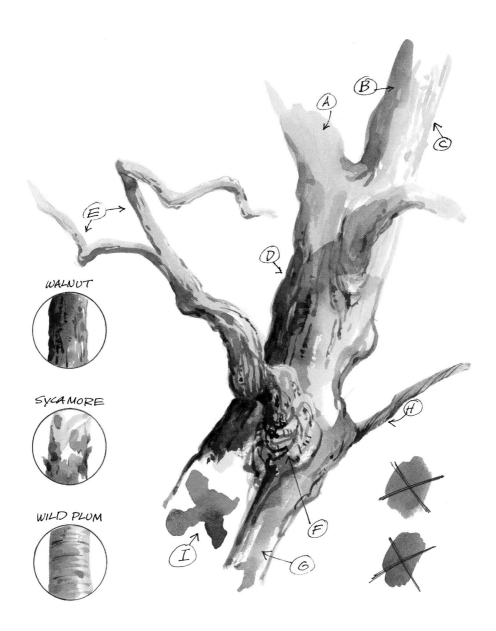

WALNUT

SYCAMORE

WILD PLUM

Like tree shapes, bark is different on different species of trees. Pay attention to color, texture, and configuration. These three display quite different textures—others may be more subtle.

And notice that bark is seldom brown, as we often tend to paint it, but more often a varied gray. This oak was painted with a mixture of cobalt blue, burnt umber, and brown madder alizarin (I) in varying strengths (A, B). The same mix was applied with open strokes to suggest sun-struck limbs (C). In shadow areas I kept the bark much simpler (D).

Smaller branches tend to be less textured (E), but where a large branch leaves the main trunk the bark may be quite rough (F). Notice how cool the mix is at G—the variation keeps it interesting.

(Illustration reprinted courtesy of *The Artist's Magazine*)

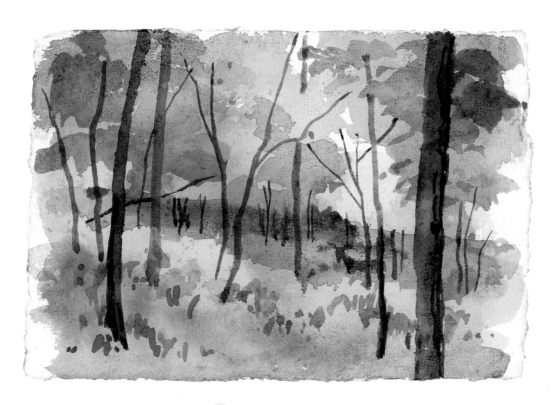

A little color sketch like this only takes a few moments and helps you to solve your painting problems before tackling the larger sheet.

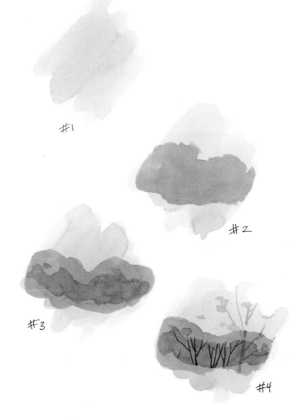

#1

#2

#3

#4

Usually a scene like this can be simplified with a varied underwash. Then add the next layer of glazed color, which pushes the shadows deeper, then another layer, which appears even farther back in the woods. Finally, add dark lines to represent trunks and limbs.

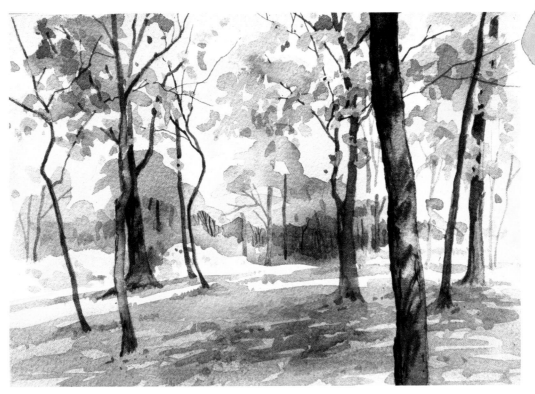

You can see the progression in this small painting done near the Scout camp at Watkins Mill. The warmer foreground trees come forward, partly because of their size, their coloration, and the degree of detail work used.

When you are painting in nature you see all the wonderful variations that tend to get symbolized when painting from imagination or photos. Notice the rhythm of tree shapes, some almost straight, some twisted, some leaning—paint what you see and your work will ring true.

Opaque paints are handled differently than transparent mediums. You can easily work from dark to light, adding small accents, or spatter with lighter colors to suggest foliage, or even punch sky holes through the mass of tree shapes to open up your composition and define shapes. When using oils or acrylics, you can continue almost indefinitely till you are satisfied with the results. If it gets muddy or confusing, scrape it off if you are using oils, or paint over if your acrylic has already dried. In the painting on the following page, the mass of foliage is almost abstract, but it gets the idea across—I was sitting in front of my cabin in the woods and painting the hill across the creek late one gorgeous autumn afternoon.

It was a gray day—overcast, moody, and evocative. So the first step was to lay in the color for the sky. I was using a starter set, so mixed many of my own colors (see Chapter 3 to see all the mixtures I got with a very few tubes of paint). Here, ultramarine blue was mixed with white, a touch of brown to gray it to match the day, and a bit of yellow for warmth. I laid the paint on with loose, rough strokes of a bristle brush. I varied the mixture with additional white here and there to suggest the thicker clouds that were sailing lazily overhead.

Now I added the deeply forested hillside, with a mixture of black, yellow, and burnt sienna applied roughly with a bristle brush. I let the foreground remain smoother to stand in for the hill itself, but used drybrush and rough scumbles at the treetop level to begin to suggest the lacy foliage there. Lighter mixtures of the same colors, and a strong, vibrant red, gave my impression of the fall colors.

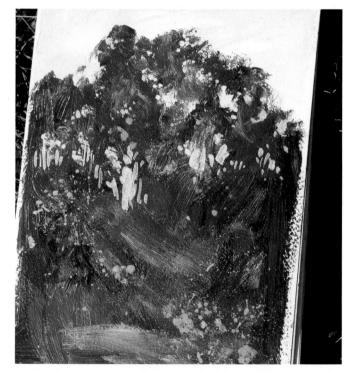

Finally, I used a small sable brush and a mixture of the sky colors to layer lights over the tops of the trees, sometimes just using small dots, other times with longer, more carefully placed strokes as I observed where the trunks showed against windows of sky in the thinning forest. I added some dark verticals for the tree trunks.

Here, I used an almost featureless blue-gray wash to suggest the forest on the far shore of the lake. The sun was just coming up beyond it one hot summer morning, further simplifying the scene with backlight.

Then, when that wash was almost dry, I added a lighter green wash closer to the water level, knowing that it would make backruns in the damp blue gray. It did, and I was delighted with the foliage, best visible just above the light-struck rail of the old fishing dock.

Water

Lakes and ponds occur in almost any landscape—even the desert of Nevada has Lake Mead. Remember to vary the shoreline of any body of water you want to paint. Observe its shape carefully, and allow coves and outcroppings to appear to overlap each other. Remember, too, that the horizon line (and the water's surface) is generally flat—unless you're on the ocean in a heck of a storm, as Winslow Homer depicted so well. Otherwise, it may look as though the lake might be about to dump itself into your lap!

There are exceptions to every rule, of course. If you are coming in for a landing in a pontoon-equipped lightplane, then indeed the surface of the lake might appear to be at quite an angle. (For the adventurous artist, I'd recommend such a sketching trip; try it and see if you can pull it off.) But as a general rule, bodies of water stay horizontal in your picture plane. Paint them like that and you won't make your viewer nervous.

First, I decided where I wanted the sparkle of light on water (B) and used just a bit of white paraffin wax to maintain the white of my paper, then laid in a soft, wet-in-wet wash for my sky (A). When that was dry, I painted the water, keeping the horizon line (C) straight (or relatively so—I didn't have a straightedge with me). Once that was dry, I added the dark shore with its silhouetted evergreens (D) with a variegated wash. A few darker lines in the water (E) suggested the action of waves. I liked the roughly vignetted effect in the foreground (F), which reminded me of foamy spray, so I left it that way. Notice the water turns a bit greenish in the foreground with a graded wash (G)— this also suggests the transparency of water near the shore.

Remember that varied mixtures of color are almost always more interesting than those that are mixed into a completely homogenous tone. Most things in nature seem to have some variation in tone, except, perhaps, for a whiteout during a snowstorm, which is what is happening outside my door as I write this. Allow your colors to mix, at least somewhat, on your painting surface rather than on your palette to approximate this effect.

This is true, of course, whether you are painting water, a grassy meadow, or a forest canopy—variation is not only more interesting on your painting surface, it is more likely to be seen in nature. Look carefully; take your time.

Generally speaking, because of that trick of aerial perspective, again, the water in a lake or pond will appear more detailed closer to you and quite simple at a distance. A flat or graded wash with drybrush work in the foreground can suggest that with great believability, with watercolors. When painting with oils or acrylics, blend the background water more smoothly, then let your brushstrokes or swipes of a palette knife suggest waves closer up.

Rivers, streams, and creeks are also frequent landscape elements. These are often subject to the laws of linear perspective as well as aerial perspective, if in a more random and lively way than a city street. Like a street, however, a stream or river looks larger in the foreground, then appears narrower and narrower as it recedes into the background. It will also be simpler and usually lighter in the distance, too, but water reflects the sky's light. It may appear like a silvery ribbon winding away into the background.

This small sample was done on a canvas-textured sketch pad, using ultramarine blue, yellow, white, and a touch of burnt umber to deepen the color in the foreground. Though it was done in only a minute or so, it manages to capture the effect of the waves, with the smoother water in the background.

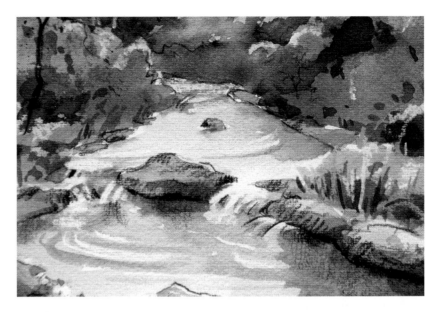

Here, the chuckling sound of the gently moving water that fell over a tiny waterfall tempted me to try to capture it on paper. When you try a subject like this, pay attention to the way the stream recedes into the background. Note that there is more detail in the water, as always, as it is closer to you. I used a white crayon to maintain the white water where it curled over the tiny falls, as well as yellow and a bright yellow green to suggest the light-struck grasses and foliage and a few light sycamore trunks in the background. I used wet-in-wet to suggest the reflections and shadows in the pool, and a bit of spatter in the foreground to suggest the small gravel and sand closest to the viewer.

The old lake, which was formerly part of the Missouri River, reflects the subtle, pastel color of the early morning sky and follows the rules of perspective in the background. I liked the pale colors of this morning scene; only the trees just past the field were dark and mysterious.

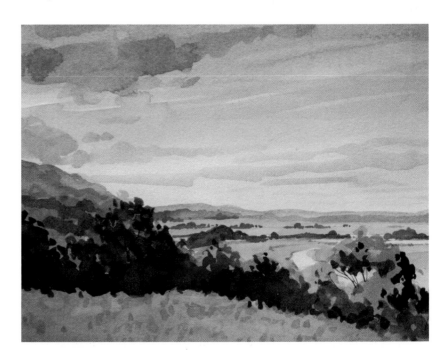

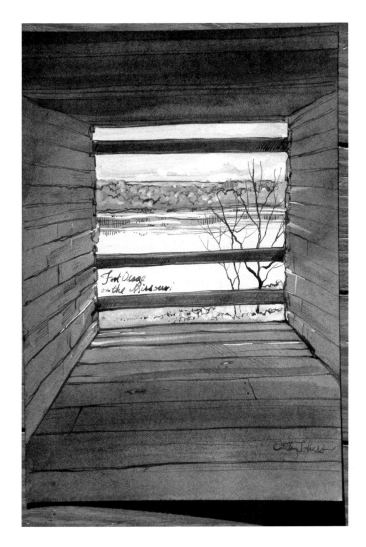

This is an unusual handling of this subject, but I loved the dramatic effect—I was at Fort Osage, a Lewis and Clark site on the Missouri River, and noted the light-struck scene beyond the log walls of the dogtrot cabin. Looking across the river, linear perspective was not in effect at all, only aerial perspective. I used an underwash of burnt sienna and ultramarine blue over my whole sheet of paper, added the ink lines that defined the scene, and then used opaque white gouache to light up the river, the far bank, and the sky. Finally, I used a bit more ink when that was dry, in the water and for the bare trees on this side of the river.

Watch for negative shapes surrounding the stream itself to help you place it within the landscape, that is, the shapes of the banks. Seeing those shapes correctly will help you to keep the stream from spilling out of the picture plane.

If your little stream runs chuckling over rocks, you may have quite a bit of detail in the foreground: foaming water, miniature waterfalls (or big ones), ripples to suggest water direction as it flows around the rocks, plus the rocks themselves. The stream becomes simpler as it recedes into the picture plane, again making use of aerial perspective.

Soften some areas so the stream doesn't appear pasted on, and let some shapes overlap the shoreline, and you'll find your stream well integrated into its environment.

Sometimes when painting moving water, it helps to graph out the

Negative shapes around the water

Graphed-out water movement

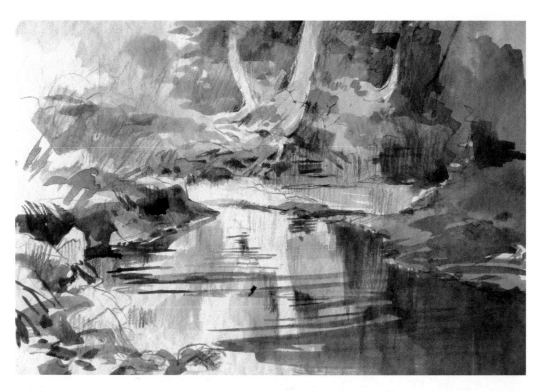

Stream painting

action. Just sit and observe for a while. Look for the logic—what's causing the turbulence you see? Try sketching the basic elements—the stream within its banks, the rocks that affect its flow. Use arrows to mark where the stream divides, how it splits to go on both sides of that partly submerged tree, how it rides up over an obstruction, how it drops into a little pool and then makes ever-wider ripples on the flat surface. Let your pencil point or brush follow your graph's lead and you'll find you have a very natural-looking stream indeed. Then, when you paint your subject, you'll have a good grasp of what's happening and how to suggest it.

The size of the river you are drawing or painting makes a difference in how you depict it; you'd never see the effects of a single rock in a river the size of the Missouri, but you do find wonderful patterns of turbulence on its surface caused by invisible obstructions beneath the water's surface. These, too, can be suggested with aerial perspective, more pronounced and detailed close to the viewer, flattened and simpler as they recede.

The author painting by the Missouri

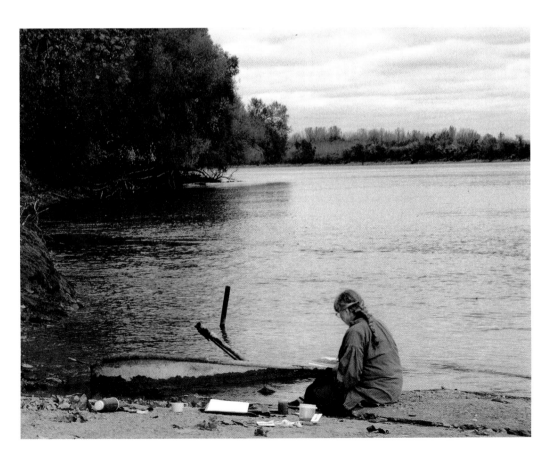

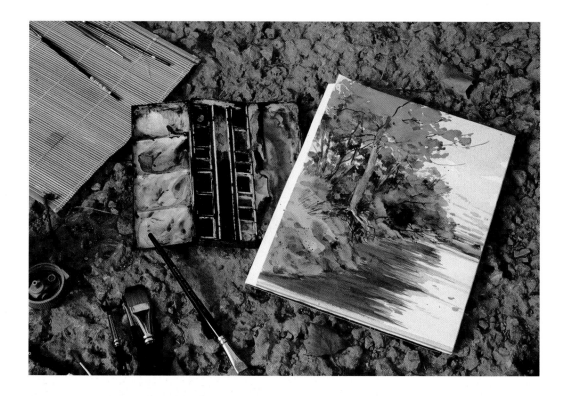

Painting of the
Missouri and the
trees on the bank,
plus art supplies

Scene at the Missouri

Grasses, Weeds, and Other Small Foliage

Grasses and weeds are useful foreground elements. You can get quite complex and botanically accurate, if you like, and imagine what Albrecht Dürer might have done with such a scene, or suggest a scattering of rough grasses for texture. Generally, a few grass blades with a weed or two suggested for variety and textural interest—and a few leaves here and there—are enough to give your foreground dimension and presence. Brushy areas can also be suggested in the middleground, using foliage-like shapes and shadows and a few twigs. Try using the tip of a round brush to suggest these effects.

Clouds and Skies

You may never have thought of focusing on the sky for your painting, but look up—there are some beautiful things happening above us. Clouds appear in all shapes and sizes, and a wide range of color and value as well. Rainbows and sundogs, those short bursts of prismatic color that appear close to the sun when atmospheric conditions are right, can add a glorious touch of color. If you find yourself observing a lovely one, don't be intimidated. Try to capture what you see. Use fresh, clear colors, but don't go too strong—just a bit bolder than pastel should work. Blend a bit to soften—a common mistake in painting these prismatic sky effects is to paint something that looks cut out and pasted on.

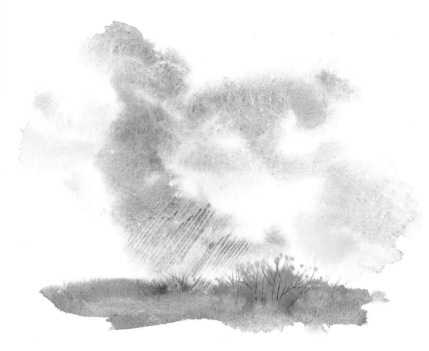

I used wet-in-wet washes in nice varied colors (phthalo blue, ultramarine blue, brown madder alizarin, and raw sienna) to suggest this stormy sky (lines scraped into the wet wash with the end of my brush caught the effect of falling rain and the tree branches at the horizon). In order to focus attention on the sky, I kept the ground simple and low in the picture plane.

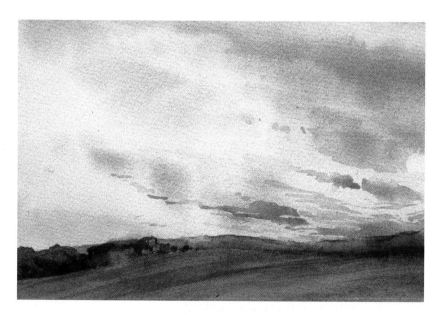

This painting was done right before the clouds opened up. I was able to paint the large wet-in-wet rain clouds over the dark field, using aerial perspective—the higher clouds were lighter and larger. I laid in the low foreground earth and distant trees, then made a run for my car and the rain began to fall in sheets. The first washes dried under cover, and then I added the small, dark glaze to suggest the distant clouds—smaller and darker.

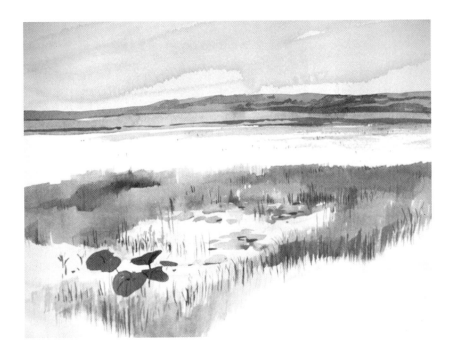

Clouds may be handled very simply, as here in this watercolor of the lake near my home.

Even when you're not painting something as colorful as a rainbow or sundog, notice how much color is present in the clouds. Often it's more than you think, as the sun peeps through or the clouds catch some reflected light. Paint what you see, or push it a bit for dramatic effect.

Clouds themselves follow the "rules" of aerial perspective, but in mirror image. That is, the ones highest in your picture plane may be the most detailed, becoming simpler and lighter as they recede into the background, close to the horizon. Pay attention as you prepare to paint, and think of how best to suggest what you see.

The Human Element

Sometimes including something man-made in your paintings of nature can be a poignant reminder of our own relationship with landscape. You may wish to include houses, greenhouses, garden sheds, wellhouses, and the like, to the same effect.

Houses can be quite varied, from a four-square Amish home in spanking-white paint to a rugged Appalachian log cabin that blends into its surroundings as though it grew there by itself, sprouted from the soil like a mushroom. An old mine provides interesting building shapes, geometric but angular; I've seen many in the West. Consider a

Here, I paid special attention to how the light and shadows fell on the old well—I liked the effect of the man-made form in the lush green landscape, enough to paint it twice—the fairly finished sketch, left, and the final painting.

Finished painting, "Mineral Water Well, Excelsior Springs"

gazebo or, where I live, in an old spa town, an old mineral-water well. Even an arbor fits the bill in the larger definition of "building" (somebody built it, didn't they?).

In a landscape context, buildings and other constructions are usually minor elements, but ones that add a human resonance. They invite us in; they can be included (or introduced) to suggest relationship. We focus on them, in a painting, because they are visible reminders of our humanity and our place in nature. They make a statement we can understand almost instinctively.

You may find that working small helps when capturing very fleeting light effects. There are only a few minutes during the day when fingers of light reach in just that perfect way through a thick canopy of leaves. For this tiny painting I sketched in the bare bones with a fiber-tipped pen and then laid in the color, maintaining the path of light that just clipped the edge of the little gazebo in a neighboring park. I love this place at just this time of day—it is so inviting. There are times when a man-made element like this just works hand in hand with nature to make a perfect painting subject.

Barns are the most obvious landscape buildings, and perhaps for that reason they can become clichés—except with very careful handling. Try focusing on less predictable buildings that exist in landscape. Silos were often attached to barns, but not always; hereabouts I drive by one made of rugged old terra-cotta tiles and concrete. Its circular shape catches the light in interesting ways. You may want to practice painting cylinders to see how best to suggest this effect.

Bridges are also man-made landscape elements that are often overlooked. From the simplest footbridge to an Oriental moon bridge to the swinging bridge overlooking the Royal Gorge, these add a nice touch to a landscape that can otherwise appear a bit sterile.

Sketches, cylinders

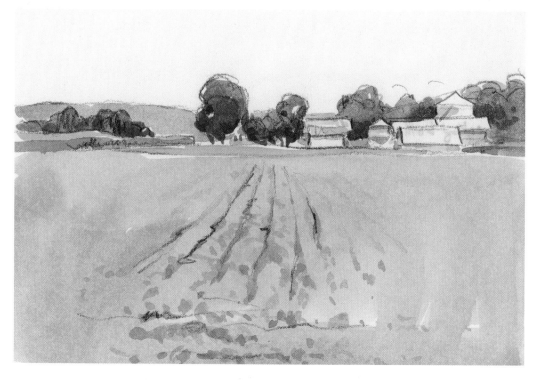

You can include buildings very simply and almost coincidentally, but they still have power to focus your attention.

The light changed rapidly as I painted this little bridge. I was glad I had sketched my subject using a Prismacolor dark gray pencil, because that foundation allowed me to slap the colors on quickly as they changed position.

This technique is very useful for painting in nature, as you can do the basic drawing any time you want, then utilize your painting time working quickly to capture that elusive light.

Funny, I didn't like this little painting much when I first did it. I was too aware of its shortcomings. But after two years I find it brings back the day in my mind very well indeed—and sometimes that's the best thing of all.

But whatever elements you choose to include, remember that *feeling and response* are among the most important of landscape elements. If you don't care about your subject—if it doesn't excite you in some indefinable way—you might as well go out for a malted. Wait to paint until something moves you; look around with fresh eyes. No matter where you live, there is something worthy of your time and talents. As you paint more, you will be able to respond more intuitively, and painting subjects will leap out at you.

Keep an open mind and a fresh spirit. Imagine you're an eagle and sketch from that perspective. (Draw from an airplane window if you get the chance—it's a different world looking *down* on the clouds.) Then paint from your sketch when you are able.

Go prepared, as I've said elsewhere. By this I don't mean just taking along all the things you need to make the painting or drawing you plan, but take care of your own needs as well. Ensure a pleasant and safe excursion. Pack water, if you're going to be out long in summer's heat. Take sunblock to prevent sunburn; wear a big hat to shade your paper—and your eyes—from the sun. Use insect repellent if biting bugs are a problem. And, yes, that *is* a lot more hassle than painting safely tucked in your air-conditioned studio. The trade-off is worth it.

Enjoy the adventure, even if it's only to a local park—or your own backyard. Though working from nature is indeed good practice and a learning experience, it's also sheer luxury. (I'd call it *necessity,* for myself—at least part of the time.) Artists need to fully experience life in order to translate it to canvas or paper or three dimensions. Working on the spot, learning as you go, gives you the experience to put feeling into your work, to suggest a few telling details, to discover the world beyond your studio door—and to begin to own it and allow it to own you. Let it become a part of you. As Zola wrote, "Art is nature seen through a temperament."

Size It Up—or Down

It's a funny thing that we each of us have a creative comfort zone. There is a way of seeing and working in a particular size that seems to suit us best—whether small, large, or in between—that just plain *feels* better to us. There are times when it is good to break out of our comfort zone and explore that far edge of creativity—we may find satisfaction in doing the exact opposite of our norm. Creativity thrives on an edge of unknowing, a promise of possibility *beyond* the norm. Use this

section to help you find *your* comfort zone, or to break out of it, if you like.

What size you want to work may depend partly on *where* you are working, of course—it is much easier to use the larger sizes back in your home studio. That doesn't mean you can't work large, on location, only that you must be prepared.

It depends as well on what supplies are available to you—if you live in a small town as I do, and have only one nearby outlet as your art supply store (here, it was a corner of the local paint and wallpaper store for many years!), you use what you can find, if you don't want to take the time for mail order. That meant that I got used to using modest sizes for most of my work and was quite comfortable with them.

But comfort, as noted, is not always the best thing for creativity. Using a new and unfamiliar size can open the door to a new way of seeing. Years ago when I discovered the small postcard-sized watercolor blocks, I also discovered a new way of seeing—and of working.

It was very liberating just to be able to tuck my painting surface into a pocket with a tiny watercolor set and *go*.

It was also great fun experimenting with these little pads, trying out different techniques. I didn't have a major investment in either time

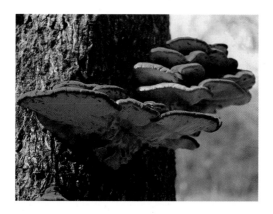

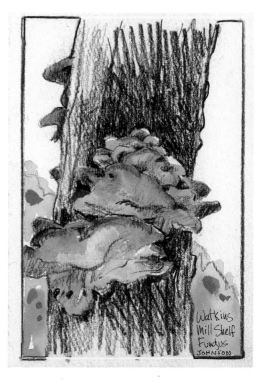

If you feel the need, take a reference photo of your subject. Though I did the shelf fungus, right, on the spot, I still decided before I left that I'd like a photo, because its complex shapes had eluded me.

I did the barest of small value sketches, along with a larger composition sketch, before beginning to work. This is, of course, an actual working sketch, not an illustration.

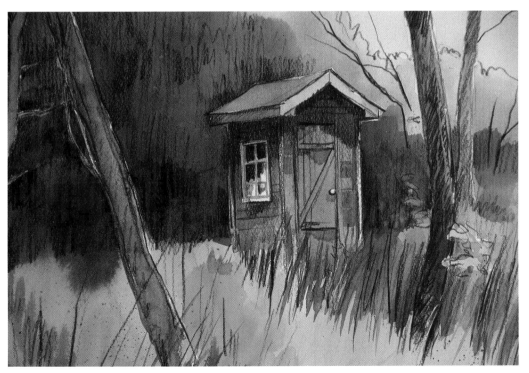

I used a favorite technique for freshness here, the underlying drawing done fairly loosely with a dark gray wax-based colored pencil. Then I laid the washes in freely to maintain the fresh feeling, with lots of color as well.

or expensive paper. I felt free to simply *play*. My favorite approach, as it turned out, was to use a dark gray colored pencil to capture the basics of the scene, then add a loose splash of color. I could either do this directly, on the spot, if I had taken my tiny field kit of watercolors, or I could take the pile of sketches back to my base camp and add the color there, from memory. In ways, I often preferred to do that, since I was able to distill the impression down to its essence and not get lost in the details, and to train my color memory as well.

It is often just the hues of the day or the landscape before us that engages our imagination and makes us want to paint. Learning how to capture what you *feel* as well as what you *see* is part of becoming an artist. California plein-air painter Camille Przewodek, who offers workshops on painting out of doors, says, "My use of color is inspired by color relationships actually perceived under many varied light schemes. I am continually humbled and inspired by the magnificence of nature when I am outdoors trying to capture the light."

I still use the technique of the colored-pencil sketch and loose washes now, even when I am working much larger. One of my best paintings, lately, has been a half-sheet of watercolor paper of the outhouse at my cabin, using this same method. To me it has an undeniable freshness and vigor.

Working outdoors has its special challenges, as we have noted. Wind, weight, and convenience all play a part. What size you choose to work can affect your enjoyment and your ultimate satisfaction in your results, as well. It's a personal decision, and there are ways of learning to work either way, depending on the effect you are after and what makes you happiest with your work.

When you work small, it's easy to be unobtrusive. You can sit with your painting on your lap—or in your hand—and work just about anywhere. An artist working in a larger format is a lot more visible. You'll attract more attention from passersby, as well as the birds and mammals you may want to include in your painting. If you are the shy type, you may want to consider that unavoidable attention. If scaring your subject is the issue, you can make a blind to hide you from the animals you are painting.

An Intimate Approach—Working Small

Traditionally, artists have preferred more modest sizes when working out of doors. You may decide to follow their lead on the trail—you need fewer supplies and less water or medium when you are

working small. Smaller works are lighter (so if you like you can carry more of them); they are easier to transport, easier to work with in the field.

It's also easier to work quickly when you are covering a smaller physical area. You may come home with more impressions of your day in the outdoors, more memories to treasure, more ideas to mine for later works.

A large painting surface can act as a sail in a stiff wind and be difficult, if not impossible, to control—and for that reason a smaller painting has the advantage of being less obtrusive as well. Not only will you draw less attention to yourself from the human contingent, but you are less likely to scare the birds and mammals you may be trying to capture. That large flash of white paper, particularly if it is a watercolor pad that catches the wind in a wild flutter of blown pages, can frighten away anything in sight.

Small paintings may be less daunting, especially if you are just getting started—there's not all that white paper to fill. It's much easier to make a big enough mix of pigment to cover your paper. There's excellent precedent to working this size; Karl Bodmer's wonderful watercolor paintings and sketches are often quite tiny, perhaps seven by ten, as are the atmospheric paintings of Thomas Aquinas Daly.

There's even a group of artists dedicated to working small—the Whiskey Painters of America.

Small is a relative term, of course. Some would consider a quarter sheet of watercolor paper—eleven by fifteen—to be a small painting. Most gallery paintings seem to be considerably larger. But I've seen some wonderful paintings that certainly stood on their own that were eight by ten or smaller, even postcard size.

You don't need to consider these smaller works inferior, or mere sketches, however. Throughout the centuries artists have filled museums with tiny works like bright, perfect jewels. It's not size that makes the painting—that appears to be a modern misconception. Proportion has nothing to do with importance, or even, usually, emotional impact. In fact, sometimes these smaller works virtually force us to make an intimate connection, have great power to connect with us deeply. We are more concerned here with satisfaction and responding to nature than with anything else—work with the size that makes you most comfortable.

You may find it easier to transfer a thumbnail sketch to this smaller format for your finished work—it seems to translate more directly. Perhaps it's just that the connection between the eyes and the mind doesn't have to work so hard to make the transition. And often you can skip a thumbnail altogether unless you want to explore values or composition more fully, and just sketch directly on your paper with a graphite pencil—then paint. If you like, the graphite lines can generally be mostly erased, if you're working in watercolor, once your washes are dry. Acrylics, of course, will seal them under a layer of dried polymer even if you are using them as water media, so they can't be removed.

A Monumental Vision

Many people like to work quite large—at *least* a half sheet of watercolor paper (fifteen by twenty-two), a full sheet (twenty-two by thirty), or even larger. This "feels" more like a finished painting to them—and sometimes it does to me, as well. It's a nice size to mat and frame, should you decide you want to. It may seem a bit more impressive, if you will, than a tiny work.

Some *subjects* may strike you as needing the larger size, almost insisting on it—a huge, simple landscape works well with this monumental scale.

It isn't impossible to translate the fresh, vigorous sketch you love

to this larger format. You just may want to make a grid of lines on your small paper, then lightly mark matching ones on your paper or canvas. You can work freehand here, no need for precise measurements. Simply transfer to the large sheet only what is in each of these small rectangles—this approach seems more manageable to many people than trying to sketch out the entire vista. Before you paint, erase the grid lines with a gentle white vinyl eraser so you won't end up with these too-mechanical lines showing.

It is also possible to incorporate proportionately more detail, should you choose to work larger—if that's what you want, though the illusion of detail may be just that. I was amazed a few years ago when I visited an exhibition of Andrew Wyeth's work at the Nelson-Atkins Gallery of Art in Kansas City. Many of the paintings were quite large—four or five feet wide or more—and not really very detailed at all, as I discovered when I could finally get close to them. When you see Wyeth's work reproduced in a book, that same painting is likely to be reduced to fit a page width of somewhere around eight and a half inches—no wonder it looks incredibly detailed!

It certainly isn't *necessary* to make a larger work appear terrifi-

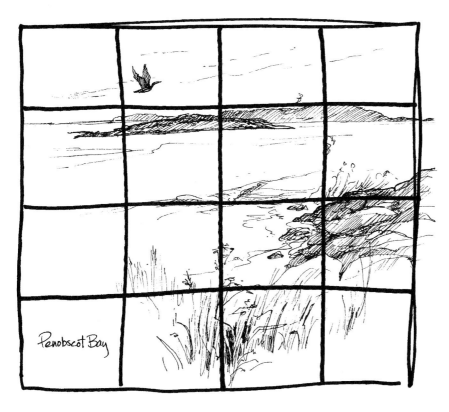

Transferring by grid

cally detailed—it's perfectly fine if you want to fill that large expanse with simple landforms, and if done well, it will look wonderful.

An alternative approach is to make most of your large painting simplified to an almost abstract degree, then zero in on that part that most interests you and use as much detail as you like, just there. Sometimes that approach works very well when working on the spot. You may have a limited amount of time, and focusing on what most interests you in the scene lets you get that down in the time available while making a rather interesting point/counterpoint between carefully delineated areas and large, simple areas. It's a wonderful effect and one used by a number of outdoor painters.

Logistics

Some things to take into consideration when working large are simple logistics. How do you transport a large work? How do you mix large enough puddles of paint? How do you support your paper or canvas?

If you are working with oils or acrylics on stretched canvas, that last question is fairly easily answered, because the painting surface more or less provides its own support. You can prop it up against a tree, or the side of a building, or a stone wall, or take along a portable easel. Just be careful of a sudden gust of wind! If you are using an easel you'll probably want to find a way to weight it down, even though many have sharp metal points to drive into the ground—it's not always enough. Some artists supplement this by suspending a heavy rock from a crosspiece.

If you are working with watercolors or pastels, you will want some way to support your paper. A large pad of paper, available at any art supply store, works fairly well with pastels because it has a heavy piece of cardboard as a backing. One with heavy enough paper can work with watercolors, too, but it is not optimal. Even with cardboard backing, water-medium paper that large will tend to buckle when wet, unless you work very dry indeed, and probably for that reason most pads of paper don't come as large as a full sheet of loose paper.

It is best to have a rigid support for your paper—a Masonite sheet, a piece of foam board, or the like. Simply tape or staple all four sides or use bulldog clips and paint. (You still need to watch those wind conditions, though. A large wet painting, whether watercolor, oil, or acrylic, can become a mess very quickly if it blows away at the wrong

time—once it's thoroughly dry, damage will probably be minimal, but mine never seem to blow away then.)

If you are working larger, mixing enough paint is sometimes a problem. This is the time for your whole traveling studio to go with you—a backpack or toolbox with tubes of paint, a palette with a large mixing area, and plenty of water and/or acrylic medium if you're working in watercolors or acrylics, or linseed oil, turps, or other mediums if you're using oils. Don't try to do a larger painting using a small, compact watercolor box or pochade meant for sketching, or you will drive yourself crazy!

If you need *really* large amounts of color, you may want to try a cupcake tin, spray-painted with white enamel, for mixing. You can find similar plastic palettes in the art supply store, as well. If you are working with a transparent medium, test these large washes on a piece of scrap paper to make sure you've gotten them as strong as you want them—in larger amounts they tend to look darker until you put brush to paper.

My large John Pike palette fits inside my backpack for these more generously sized works, and I can still zip it shut. This is a good time to squeeze out fresh paint, or wet your mounds of paint well before beginning to paint if you're using watercolor or gouache in a large format—you won't want to take the time to scrub up a decent amount of color from those dried mounds to make a large enough pool of liquid paint. Spraying them down with clear water a few minutes before you plan to start, or even pouring a little water from your canteen or water carrier directly onto each mound, will let them soften sufficiently to use with some speed.

Take big enough brushes, too—here's where your one-inch or larger flat brush comes in handy, and a number 12 or better round brush. Some look almost like house-painting brushes and work very well for big paintings. Again, as a general rule, don't try to paint a large work with tiny little brushes unless you are very patient or plan to return more than once to complete it. It's perfectly possible to work that way, of course, and many people, including Wyeth, do just that— but usually in the studio, where conditions can be controlled. Working outdoors with changing light and weather conditions, it's best to let yourself work as quickly as possible. That means large washes and big brushes. You can always graduate to the smaller brushes for that detail work.

Working with a larger format generally requires a different physical approach, too—here quite often you need to stand and let your

whole body work with you. Paint with your arm and shoulder, not just your hand. You get a wonderful spontaneous sweep that way, rather than tight little niggling marks. Your paint may drip if you are working upright, but even that lends spontaneity and can look wonderful. If you absolutely must, catch the drips with a rag or tissue, but consider leaving them where they are. You may find your larger works are just as fresh as the small ones.

Catching the Changing Effects of Light

GORGEOUS, BUTTERY, RICH—THE late afternoon light was beautiful and intense, and I *had* to paint it as it gilded the tops of the trees and threw lengthening shadows across the brilliant green haymow. Colors seemed almost to vibrate in the raking light—fully saturated, impossibly rich, and overlaid with a transparent golden glow. A short while later and the light had changed to pale orange, then coral, and finally a radiant salmon. Tree shadows, by a magician's trick of light on retinas and brain, appeared cobalt blue and lavender at that time of day, deepening to ultramarine as the sun dropped lower in the sky. It was lovely, and fleeting as first love. I hit the brakes and got out my painting gear with hands that almost shook with excitement.

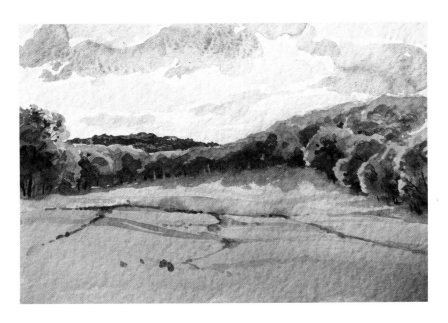

"Late Afternoon, Howdershell Woods," watercolor

That day, I produced a quick little painting that did not begin to do justice to the scene—but that surely reminds me of its beauty, and how irresistibly drawn I was to try to capture those moments before the light faded.

Remember that light contains all the colors of the spectrum—think rainbows, or prisms. There are times when you may want to suggest that quality with very pale, subtle wet-in-wet effects—if you are painting a snowy day, perhaps, or a day when the clouds seem particularly pearlescent. If you are working in watercolor, you can just wet down your whole paper with clear water, then drop in pastel washes made with good, clear yellows, blues, and reds and swirl them around a bit; don't mix thoroughly or you'll end up with a gray—a nice atmospheric gray, but still a gray. Just blend the edge, let the whole dry, then paint as usual.

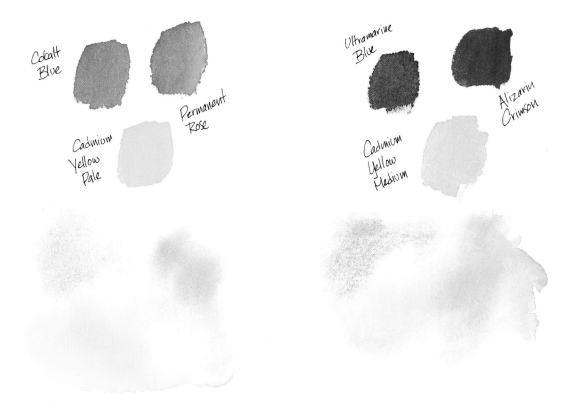

Prismatic effects are created with the primary colors—in these cases, ultramarine blue, alizarin crimson, and cadmium yellow medium on the right, and cobalt blue, permanent rose, and cadmium yellow pale on the left. Below each sample is what happens when you mix all three together on paper that has been wetted with clear water.

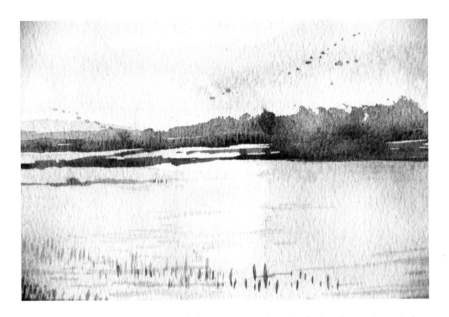

Here, I wanted the effect to be very subtle—it was mostly a cloudy day, threatening rain, but with light breaking through behind the clouds every once in a while and turning them to pearl. In order to capture that effect, I wet nearly the whole of my paper, then dropped in very light washes of yellow, red, and a cool blue. I left an open spot of dry paper in the area that would be the water, where I wanted to suggest the reflection of the sun's light. While everything was still quite wet I dropped in a little grayer mix here and there to suggest the soft clouds.

Then I let the whole dry completely and added the landforms, flying ducks, and foreground weeds.

With oils or acrylics, or even watercolor pencils or pastels, you don't have the transparency of watercolor to work with, unless you are using your acrylics thinned to a watercolor consistency. You can still achieve wonderful effects with soft pastels that are really quite similar. Try introducing a subtle bit of pearly color in the clouds, if nowhere else, and blending it with your finger or a soft cloth.

There are many ways to suggest the prismatic effect of light. I've seen paintings where the artist suggested that, particularly when strong light was coming from behind the subject, by outlining whatever his subject was with a line of lovely primary colors. Wayne Thiebaud often used this technique to wonderful effect in his California landscapes—

A multicolored line around your subject captures some amazing truth about how light works on the retina. This little watercolor pencil sketch is an exaggeration, of course, but it gets the idea across.

The light changes rapidly. Pastels work quite well to capture that transience, since you don't have to wait for them to dry. Here, the brilliant winter sunset was fading as its source had dropped behind the curve of the earth, and I relied on memory to suggest the color of the earth—I was too interested in capturing that gorgeous coral sky while I could!

This is a good time to stick to a very simple technique rather than try for a great deal of detail, because if you are working from nature you won't have much time before the color fades completely from the clouds.

the first time I saw one of his paintings I just stood there in awe, thinking, Why have I never noticed that before! It sounds bizarre, but it can look wonderful, and records a visceral impression of what your eyes are actually perceiving.

Fleeting Effects—Sunset and Other Phenomena

Once I had gone out to paint in the late afternoon and it became obvious that the sunset that day was slated to be absolutely stunning; the clouds were puffy and broken and already wonderfully varied colors. I couldn't help it—though I was on my way home, I had to try to catch it on the fly, difficult though it was in the gathering dusk. I stopped in a parking lot at the edge of town, where the view was uninterrupted by houses or electrical wires (the same place I choose every year to go to see our community fireworks), and quickly called my husband to tell him I'd be a bit later than I'd expected.

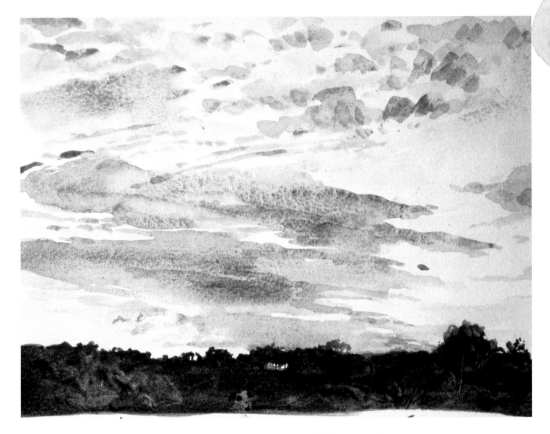

The paper I had with me was a pad of tinted watercolor paper—to help capture that warm sunset glow I chose the warm, creamy-tinted option.

I was more concerned with getting the dramatic cloud shapes and the deepening colors than I was with the land below—it was fairly simplified in the fading light and considerably less important in the composition, so I left it alone to begin with, but noted in my mind where I wanted it to be, where the horizon should go.

I mapped out where I wanted the blue sky bits to show between the clouds, noticing that they looked darker higher up and faded to peach at the horizon, and painted them in quickly with manganese blue and an orange mixed with cadmium yellow pale and cadmium red medium.

The warm sunset orange touched the edges of some of the clouds with bright color, so I added that, then mixed a strong blue gray with ultramarine blue, alizarin crimson, and a bit of burnt sienna for the major cloud shapes, and painted them fairly wet-in-wet.

When that was dry, I added a few of the overlapping cloud shapes with a slightly darker mix of colors and painted the landforms below with a strong mixture of phthalo green, phthalo blue, alizarin crimson, and burnt umber, touching it here and there with the side of my hand for texture and scraping out a few lighter tree trunks with the end of my brush while it was still damp.

Trust your vision; rely on memory when you have to. A scene can change in moments if the setting sun drops behind a low cloud bank.

"You can't paint *now*," he protested. "It'll be dark in a few minutes!"

"You bet I can, and I'm going to do it!"

And did, too—the fact that I still had my painting gear out on the car seat in disarray from my last attempt a few miles away made it easier to set up quickly, sketch in the basic cloud shapes, and start slapping the paint on with feverish haste. There was no time to let things dry in between—the light was fading fast. Of course, that worked to my advantage as well—the soft shapes of clouds blended where I wanted them to, and I just left dry paper here and there where I wanted to suggest crisp edges.

It was one of the most exciting painting sessions I've ever had, a race with light and beauty, and one that would not have happened if I had given it up as impossible to begin with.

When you choose to paint is a matter of inspiration, opportunity, and convenience. You may be able to steal a block of time after you get the kids on the bus, at your lunch hour, after work. Morning and late

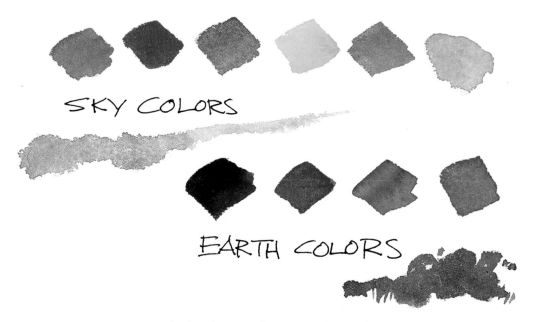

In a sunset sky, the colors are as fleeting as the light itself during that brief period. We need to learn to work as fast as possible, perhaps making small color sketches or even just tiny swatches with notes to help us remember what it was that so excited us. This might be a good place to work smaller and cover that painting surface quickly. As Nevada watercolorist Richard Busey suggests, "Get a sketch, or at the least a photo, of what you are painting before you start because in the course of painting the light and shadows will change quickly." That's as true in my part of the country as in the desert.

afternoon light are often considered the most evocative, as they make luscious long shadows that help delineate your subject, describe the shape and texture of objects, and provide wonderful contrasts of light and dark, warm and cool.

But if high noon is what you have, *work* with it. Perhaps the shadows aren't as interesting and useful as they are in the morning or late afternoon, but the pastel, sun-baked vista can be exciting as well, in a whole different way.

The colors lasted for the better part of a half hour, plenty of time for a tiny, simple painting like this, but just to be on the safe side I made color swatches to remind me. Also, because of the transient nature of light, I chose to do a very quick pen-and-ink sketch to provide the basic skeleton of the piece, then I'd be free to lay the colors in quickly without worrying about composition, etc. Those decisions were already made.

In fact, if you plan a specific locale or subject, but know you want to try to capture it at a time when the light will change rapidly, you may want to make your composition sketch much earlier. You can do that, of course, at any time, and it will free up those precious few moments to get down to what it was that you want to capture—*color*.

Right before the sun sank below the horizon, I suggested the lovely red ball, somewhat flattened by a trick of atmosphere.

When you paint something like this, make special note of the subtleties of color—the far hill had become quite purple the later it got, but directly below the sun, it was warmed to sienna. I used manganese blue and phthalo blue for the sky and water, cadmium orange and alizarin crimson for the sunset colors, and ultramarine blue, burnt sienna, and alizarin for the landforms, in various mixtures.

Even if you have almost unlimited choices of working times—if you are self-employed, say, and you can rearrange your work schedule to take advantage of the best times to paint, or on vacation—if a subject suddenly delights you, don't wait for the perfect light. Don't lose the excitement. *Start.*

Morning Light

Because the sun's rays are slanted through Earth's atmosphere, the light is different now than it is at noon. If it is very early, the light is subdued and gray blue with just a hint of color. Hills and trees may be dark simple shapes with no detail at all. As soon as the sun rises higher you'll begin to see the more intense, fresh color of morning. If the day is overcast, you may find beautiful pearlescent grays lit by the sun just before it hides under the bank of clouds again. Paint that!

I love the view of the morning sky out my dining room window—this too is painting nature. Because I knew the changes are rapid at that time of day, I sketched in the bones of the composition with ink. I kept the colors relatively flat to mirror the flattening effect of low light. Where the smoke from my neighbor's chimney rose against the sky, I just blotted with a bit of tissue while the sky and hill were still damp.

The colors were ultramarine blue, phthalo blue, phthalo green, alizarin crimson, and a bit of brown madder alizarin.

Out in the Midday Sun

Painting in the middle of the day does require a little forethought. That strong, midday light on your white painting surface can be blinding, until you get it nicely covered with the first few layers of paint. This is a good time to try a tree, a shelter, your car, or even a wide-brimmed straw hat—anything to shade your paper a bit. Polarized sunglasses might be a good idea, too—they are not as likely to distort colors as the strong-hued ones, but help simplify values, as noted, and save your eyes from the glare. This is important not only to keep you from getting eyestrain or a bad headache, but for the good of your painting as well—glare distorts your eyes' ability to discern color or value. Try it. Stare at that white paper a moment, then look away—everything is darker and greenish.

Notice how the shadows fall at midday—you may get a kick out of doing a painting that helps tell time!

Deep-Forest Light

Sometimes a special trick of light is what rivets our attention to what is actually a fairly simple scene—a shaft of unexpected light on a forest path, a glow at the horizon, a vignette through light-struck leaves to deep, cool shadows. It was that effect that made me want to paint this little scene beside my creek, where I often read in the old wooden lawn chair. The light was magical!

The view from my deck looking down toward the creek is often quite lovely in the summer—that's one reason I built the cabin where it is. This day I especially noticed the effect of strong summer sunlight in the woods that surround the little stream.

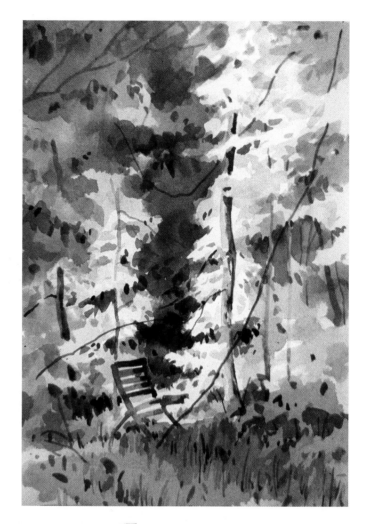

For this painting, I tinted my watercolor paper all over with a wash of pale yellow to suggest that lovely filtered sunlight. Then I waited till everything was dry and added successively darker washes of blue, blue green, and green to shape the trees, suggesting the trunks that were in full sun as well as the ones in deep shadow. In many areas, the green was created by making glazes of pure blue over yellow for an especially transparent depth. Finally, the dark accents and the chair itself gave the scene humanity and depth.

Note how the glazing of these colors makes a variety of lovely greens. I let each layer dry before adding another.

A Haloed Light

There are times throughout the day when you may find your subject beautifully backlit, with a brilliant, almost otherworldly haloed effect. I painted this smallish scene in the middle of the day, with the sun just behind my subject, which was a small sapling that had grown from a dead tree stump. The edge of the forest beyond, in the small park near my home, was cast in deep shadow, and the effect was too gorgeous not to try. The hardest part was mixing the darks dark enough to provide the necessary contrast, but the effect was a success, I think.

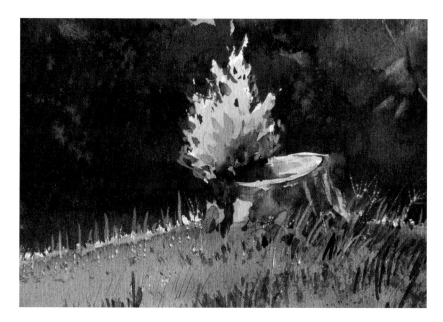

For this small painting, I decided on where I wanted my main subject and did a quick sketch of it, just off-center. I mixed a strong green for the far trees and laid it in quickly, wet-in-wet. While it was still quite damp I scraped in the lighter limbs, spattered the whole with clear water to suggest foliage, and lifted a few places with a sponge dampened with clear water.

When that was dry, I went back and painted the much paler greens of the little sprout and the medium green of the grass, using mostly sap green modified with blues and browns. When that dried, I added the cut stump in a couple of washes, with ultramarine blue and burnt sienna—which I used in a very weak wash for the sunstruck areas. A little scraping on the right side while the paint was still damp suggested bark.

Then I added a suggestion of grass as well as individual leaves on the sprout itself. And finally, I scratched out the strongly lit grasses and weeds with a sharp blade once the painting was thoroughly dry and utilized a little wax-based crayon work to further capture that strong, haloing light.

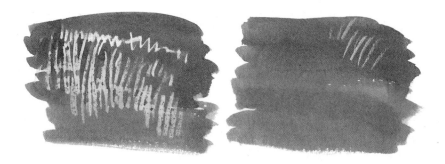

You may want to add a bit of sparkle to your darker paintings by introducing mixed-medium effects like good old Crayolas or pastels. On the sample at left, I used wax crayons, firmly applied, before painting—the wax repelled the watercolor wash, leaving light marks. On the right, you can see what happens when you use crayons over a dry wash—not much! The light marks at upper right were done with pastels instead, which became slightly darker when sprayed with fixative.

Painting in the Evening

This too requires very quick working and a good memory—try only the simplest subjects here, as the light fades far too rapidly to try anything else. The lovely colors of the sky once the sun has set are good only for a very short period of time, and it is very difficult to see your painting surface as well—likely as not you will be finishing this one from memory.

It is often difficult getting your colors dark enough when painting in the evening—if you are working with an opaque medium like oils or acrylics, it's a bit easier. Try mixing enough to do the whole area and

Allow each layer to dry before adding another, and make each application light and quick if you're working with watercolors. Notice how much darker the area is that has three glazes of color over it.

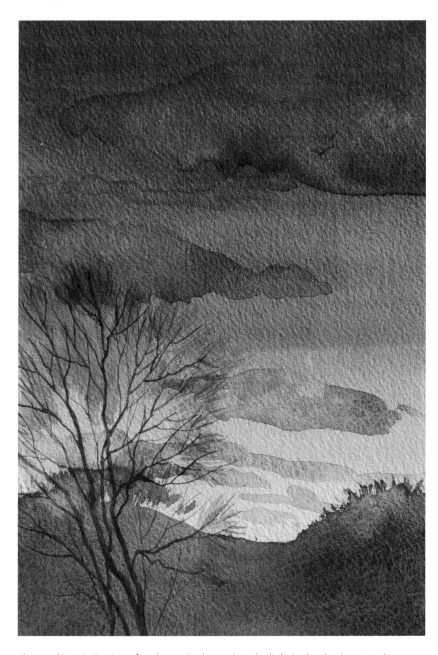

I began this painting just after the sun had set, when the light in the sky closest to the horizon had just turned to that intense greenish color. I did the deep sky color, fading to the lovely transparent green, then let the painting dry and finished it later, in better light. I added the clouds and the simplified foreground shapes of the trees at home to complete the impression of dusk.

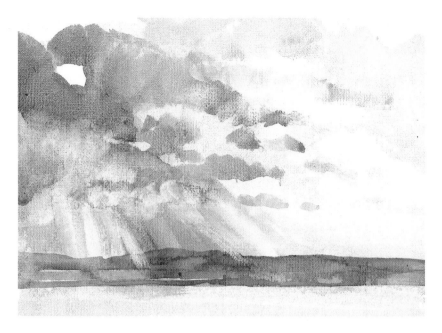

This is a beautiful effect we notice when the sun breaks through clouds—it always seems to symbolize hope to me. This was just a quick sketch on paper meant to be used with acrylics—the paper is already primed to use with that medium, and I had only watercolors with me. It didn't matter, I wanted to suggest the scene, so I grabbed what I had before the light changed.

Because of the completely nonabsorbent nature of the canvas-textured paper, the paint just kind of sat on the top without soaking in at all. This proved to be a benefit to my planned effect, because to suggest the sun's rays, all that was necessary was allow it to dry and then lift the rays out with a damp tissue.

then test it on a piece of scrap paper for color and value. If you've gone ahead and painted directly and don't like the effect, don't despair, though. You can always add more glazes of color to deepen the effect. This is easier if you are using a nonsoluble medium like acrylic, of course, even if you are using it transparently like watercolor. But if you use a quick, light touch you will be able to lay on additional glazes without lifting the color underneath, even in watercolor.

Light and Shadows

Even when painting natural subjects, shadow is often what helps define our subject, and sometimes what catches our eye in the first place. The shadows on the trunk of a gnarled oak, for instance, tell us

This simple little sketch shows the effect of light direction—low side light makes long, raking shadows that are darker closest to their object, then become lighter and less distinct as they fall away from it.

Light directly from behind is called backlight and can result in a halo of lighter color around the edge of the subject. Again, the shadow is darkest closest to its object.

Finally, direct overhead light, like what you see at midday, makes a pool of dark shadow directly below your object.

that it is round, and emphasize the texture of the bark right where light and shadow meet. Shadows can tell us which limb advances toward us and which recedes, because the more forward limb will cast a shadow of its own.

As Richard Busey suggests, "If your painting is about an interesting shadow shape, on a house, for example, paint that first before it changes." And sometimes shadows *are* the subject themselves. A rather unobtrusive clump of grasses growing from a sand dune may be suggested through gorgeous, complex, calligraphic shadows as the sun sinks lower in the sky. That becomes what your painting is about.

Reflected light

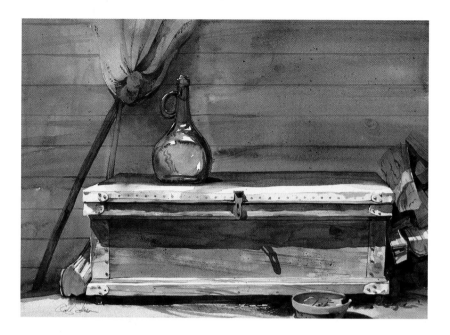

I loved the play of light on the edge of the old wine bottle and the trunk that holds charcoal and cooking equipment on my deck—the raking light that made interesting shadow shapes out of the lock hasp was too good not to try. Because the shadows would change rapidly, I drew them in first, and painted the top of the trunk and the front before anything else. The progression was still too rapid, so I finished the painting the next day at the same time—that's usually an option unless the weather changes to overcast or rainy.

Shadows may be depicted with subtle or strong blues, atmospheric grays, lavenders, and a wonderful range of other subtle hues, because light and color are often reflected back into them. Look carefully, with your mind and heart as well as your eyes. Let yourself see what is there; you can push it a bit, emphasize a bit more than actually appears in nature in order to get that idea across. If an apple in full sun is close to a dark shadow, you will nearly always find some of the bright color itself in the shadow. The same is true of reflected light in architectural subjects, as in the old barn on the previous page. It's a gorgeous and magical effect, and it breathes life into your work. You just have to be able to see the magic in the first place.

Light and shadow are delightful aspects of painting in nature; that's what I was after when I painted this arrangement on the deck of my cabin in the woods. It's a found still life with light as its subject.

Shadows can tell us something about the character of the ground they fall on, too, as they follow the terrain, be it rough or smooth. Use shadows to suggest that truth; you'll notice them more and more often.

Planning Ahead—or Analyzing What Went Wrong

Normally, if a light effect strikes you as dramatic, you may want to do a small value or color sketch before beginning to paint. Then you can capture just what it was that caught your eye. In this case, however,

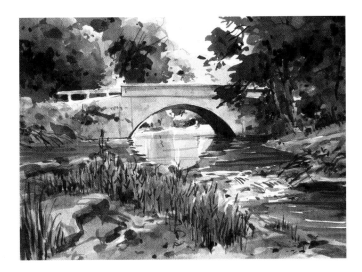

Bridge,
painting one

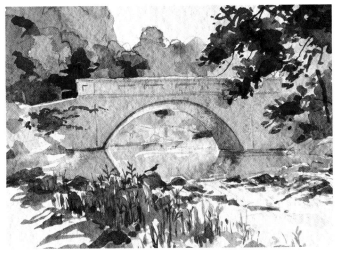

Bridge,
painting two

I tried my subject three different times—two small paintings, *then* the little sketch that helped me figure out where I'd missed the mark. It was a gorgeous summer day, and the old arched bridge cast beautiful reflections in the still pool just beneath it on the Fishing River—I ached to paint it as I saw it.

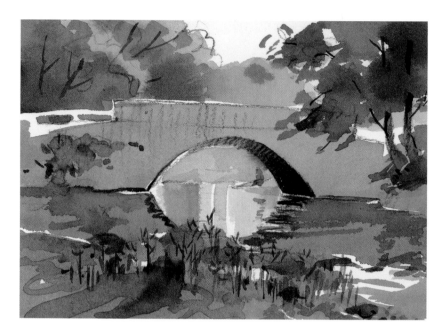

I should have simplified more—the effect that struck me was the window of light beyond the bridge's arch, and its reflection in the pool. By starting to paint directly on my paper without planning first, I managed to confuse the issue with too much detail—though I did really enjoy the fisherman who briefly appeared on the gravel bar beyond the bridge, adding a touch of color with his red shirt, in my second attempt. I still suggested him in the small, simplified sketch that finally came closer to the initial impact of the scene, and helped me to realize that what had really struck me was the strong contrasting values—and if I were to try again, it would be with this little sketch, in reality much smaller than the previous two, as my guide.

8

Painting Through the Seasons

I can't turn the urge to respond to nature off and on like a switch. It's not as fleeting as all that, nor is it like a flower that wilts in the first frost. Creativity and response last all year long, or they can if we're open to the possibility. Of course it's wonderful if we can swing a painting vacation or a nature journaling workshop during the sweetest seasons, and we have several listed in the Appendix. But it isn't necessary to stop there. Painting on the spot is an opportunity to learn from our environment—and to respond to it—that presents itself throughout the year. It's an open invitation that knows no season and requires no RSVP.

This was done outdoors, in my cabin sketchbook, on Christmas Day. The preliminary drawing is pen and ink on tan-toned paper. The color was added with watercolor washes to the purplish-red buckbrush berries. Finally, I used opaque white for the frost that had formed on the berries and on the long spiderweb that hung there. Though it was very cold, I was able to work without too much discomfort, then duck back inside to the woodstove.

Granted, there are challenges that go along with that invitation. Painting in spring rain is quite a bit different from painting on a dry fall day, and even the *colors* of autumn are a challenge—they can get garish far too easily. And too, in the spring and into the summer, the mosquitoes and blackflies will begin to distract us—painting in the North, in Maine, or in bayou country is often syncopated with the sound of slapping at biting insects.

In the summer, the heat can be almost unbearable, and sometimes even dangerous—if it's humid as well, weather conditions can retard drying time considerably. Winter painting can be very chilly indeed, and we need to take precautions and make allowances. Frostbite is no joke, and even if things don't get that dangerous, simply *painting* in inclement weather has its drawbacks—watercolors can freeze right on your paper.

This is definitely *not* to say you should give up painting till the weather is more cooperative, because if you do that you'll never find the perfect time. And when you do, the competition with other outdoor activities will be fierce. Take the opportunities offered, but take them wisely and with the kind of preparation that will not only allow you to be safe—and far more comfortable—but will ensure you will bring home a wonderfully evocative and meaningful painting as well.

There is so much that is worthy of painting, all through the year, you will be glad you took the chance—and made the effort. With a bit of planning and mental preparation, you can enjoy painting through the seasons. Just accepting the fact that you're not going to be as comfortable as you are back in the climate-controlled environment of your studio is a great help.

Winter Work

Winter means snow in many parts of the country, an austere and beautiful landscape made up of blue shadows on white, and the prismatic sparkle when sunlight hits that snow. It is also the thunderous darks of evergreens, and the flash of a cardinal's wings. It is fields of sprouting winter wheat in shades of acid green against rich black earth, or grasses dried to platinum blond and warm, tawny sienna, the colors of a lion drowsing in the sun. It's a wonderful time to paint.

Sometimes when the weather is really chilly you may prefer to work in a small size, with a very portable medium. This little sketch was done with watercolor pencils, which are simply dry pigment in pencil form. Once back to the house, I touched the right side of the drawing with a wet brush and clean water (keep rinsing your brush often if you want to keep the color relatively unsullied) to turn the drawing into a painting.

The white of the paper itself stands in for snow and the ice-covered lake. Note how much color there actually is, though, even in a winter scene. It's anything but dull.

It can also be miserable! Be prepared—an excellent motto for Scouts, it will make your work outdoors in the winter much more enjoyable. It almost goes without saying to dress for the occasion. Layering seems to work well in various working conditions—that way you can take off outer layers if you get too hot, or add if the sun goes behind a cloud. You have a good deal more flexibility. It's difficult to paint all bundled up like a kid in a snowsuit—but not impossible, so if that's how you are most comfortable, *do* that. Wool and silk plus down-filled outer garments are excellent choices for winter warmth, but so are fabrics that are the product of modern technology, like Gore-Tex and PolarTec. If you've spent much time outdoors in the winter, you'll have your own favorite combination of outdoor wear—but remember, when you are painting you are immobile for relatively longer periods of time. You're not as likely to get warmed by exercise, so either get up and move around occasionally to keep the blood flowing, or dress accordingly.

There are a number of products that will help keep you warm—people who attend outdoor football games may know about cushions that can be heated in the microwave, but there are also chemical hand-warmers and other devices to keep your fingers warm and flexible. You can even buy liners for your boots that provide extra warmth, and electric socks! Look in camping supply stores or outdoor-sports departments of your local discount store.

If you need to, find a place to paint where you can build a small fire—it's amazing how that small bit of warmth can help. Take a hot drink with you, in a thermal container, but you may want to avoid alcohol. Once the initial warmth wears off you are colder than before because your veins expand and expose more blood to the chill.

As noted, in really cold weather, water can freeze on your palette and on your paper. Your mounds of paint, if you are using watercolor or gouache, are not as likely to freeze because they are made with gum arabic, which tends to keep them at least reasonably pliable. Watercolorist John Pike always talked about painting in winter with a bit of vodka in the paint water to keep it—and himself, I suspect!—from freezing. I've not tried it, but it seems as though it ought to work.

Look for someplace to work where the terrain works *with* you instead of against you. A sheltered spot in the sun works well—the temperature can feel many degrees higher. And it's always possible to paint in your car if you work relatively small; just remember to leave your windows open if you keep the engine running for any length of time. Warmth and even the chance of bringing home the best painting you've ever done are not worth dying for.

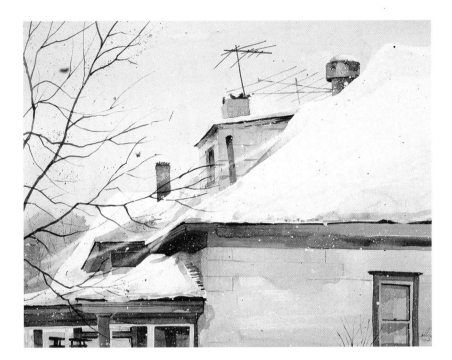

I had plenty of time to do this one—it was obvious nobody was going to be getting out for a while. I carefully drew the shapes of my neighbor's house and the deepening caps of snow on everything, then began painting with watercolors, laying in the pale sky first, then the house itself, and the shadows on the snow—since the sun was not out the shadows were very soft and subtle.

It was funny to see the starlings perched on the chimneys for warmth—opportunistic creatures! So I drew their shapes very carefully and painted them in with a small brush.

Where the snow was blowing off the roof, I lifted off dry color with a bristle brush wet with clean water, blotting often to remove the loosened pigment. Here and there, when that dried again thoroughly, I used an ink eraser for more control in taking off just a bit more blowing snow from the eaves at lower left.

I added small details like the antennas and the tree branches; then, when everything was dry, I used opaque white paint spattered on to make the snowflakes. Looks cold, and it was!

One of my favorite winter paintings was done right out of my dining room window during a raging blizzard—those conditions would have been a bit too harsh to work outdoors, but it was fun to sit at the table all warm and comfortable, hot coffee at hand, and paint the storm as it made huge drifts on my neighbor's roof. That's still painting nature.

These techniques will work fine with watercolor, water-soluble colored pencil, or gouache, but not with acrylic or oil, since both of those, when dry, are insoluble.

Ways of lifting color to suggest blowing snow

The wide, top streak of blown snow was done by briskly scrubbing the pigment loose with a stiff brush and then lifting immediately with a clean paper towel. The lower two just off the edge of the roof were done with an ink eraser, carefully and patiently applied so as not to damage my paper's surface. The lighter lines against the side of the house are water-soluble colored pencil in white—subtle, but nice. If you wanted, you could also use white pastel lines for this, but then it would be necessary to use fixative to keep the chalk from rubbing off.

Many artists like to use a bit of salt in a damp watercolor wash (A) to suggest snow or icy effects—you could carry some small packets of salt from your local fast-food place in a small plastic bag if you liked, or a traveling camp salt shaker. Below, opaque white was spattered over a blue undertone (B). This would work well with watercolor, gouache, acrylic, or oil. Then, liquid mask was spattered into a wet watercolor wash and allowed to dry (C) before removing it carefully by rubbing it with a finger for softer effects.

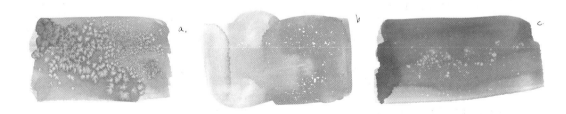

Falling snow, mixed media

April Showers

Rain can occur any time, not just in the spring, but this is often the time that we get the unpredictable showers that you will need to be prepared for. You may want to paint from a handy shelter (shelter house, automobile, natural overhang) if the weather looks threatening. You can also just take an umbrella with you, or at least a piece of waterproof cloth or plastic to throw over your painting to protect it. If the surface is wet, don't let the covering come in direct contact or it will smear.

The weather was so incredibly damp it took forever for the intermediate steps in this painting to dry. The skies opened more than once and it just *poured.* Good thing my painting buddy and I had opted to begin working under cover of a handy shelter!

Setting up in a park shelter is always an option when painting outdoors in bad weather. Here, my painting buddy Judy Gehrlein paints in relative comfort.

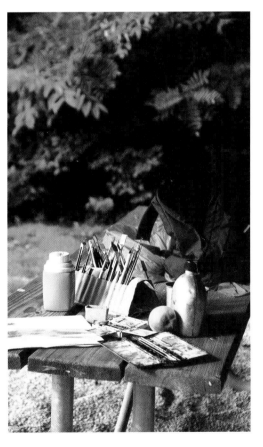

This is my setup, including a small blue thermos of coffee.

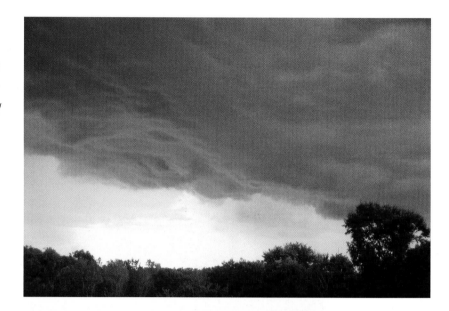

This is a picture of what the weather looked like as Judy and I prepared to paint. Not likely we'd choose to work without cover.

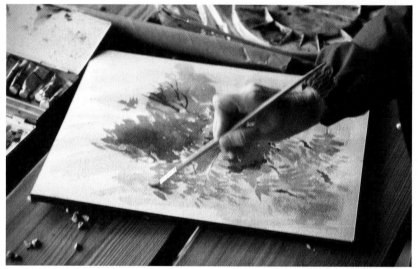

You can tell my partner's chosen perfect colors for such a gray day—just the right combination of subtlety and color.

The air was almost completely saturated—step one of my painting was painted fairly wet-in-wet and took forever to dry.

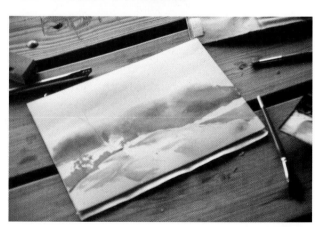

Then I began laying in a suggestion of foliage.

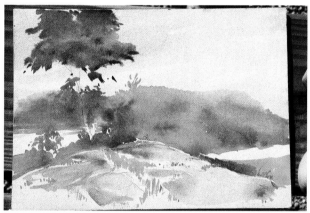

When that dried I was able to add a few more details.

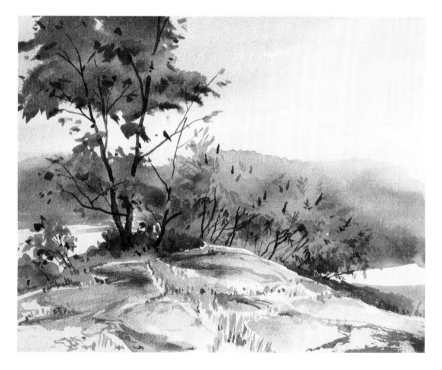

And finally added just enough additional details in the form of trunks and limbs that it seemed sufficiently finished. By then the rain had begun to fall in earnest. We had our peanut butter sandwiches and coffee, waiting for it to let up, but finally called it a day.

Spring Paintings

I like to paint in the early spring. It seems as though the world is awakening after a long, well-deserved rest; many cultures have celebrated just that, from the Celtic Beltane to Easter. Painting outdoors in spring is just another way to celebrate renewed life. The colors are so tender and subtle, when many of the trees are still bare and their twigs are just beginning to take on a palette that mimics autumn's varied hues. They are paler and less obvious now, but look closely and you will see yellow-green willow sprouts among the reddish twigs of some of the understory trees. Shadows may appear almost lavender. Young leaves may be a pale primavera green, or even have a red cast at this

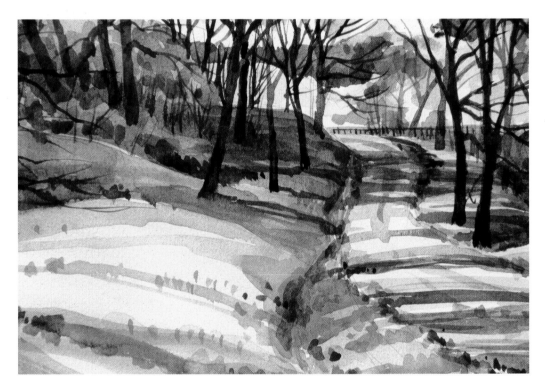

Colors here in the Midwest in early spring are lovely—poignant, subtle, and always a challenge to capture on paper. The grass is almost acid green, especially when the sun shines through it, and flowering trees of the understory add their colors, both bright and pastel, to the scene. Here, redbud trees light the old park road. Permanent rose and alizarin crimson work well to capture these blue-toned rose reds.

Notice, too, that the long shadows cast by the still-bare trees serve to describe the terrain—you can tell where the hill drops down, where the gully beside the road is, and where the ground rises again to crown the road.

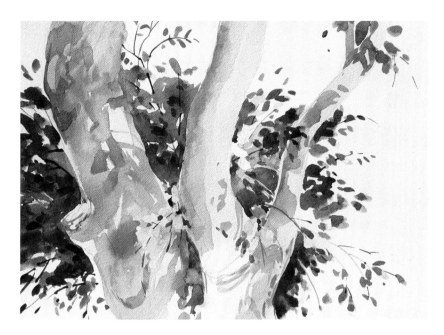

I was interested in exploring format for this painting of a desert tree, so I tried one vertical and one horizontal. I decided on the horizontal form to allow more room for foliage and the play of those strong, lavender shadows. I also tried out a palm in that clear light, and was quite happy with this little sketch, left.

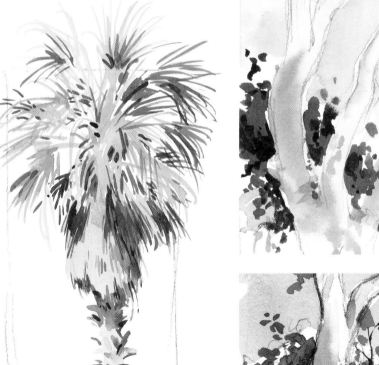

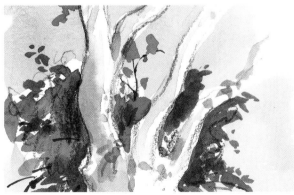

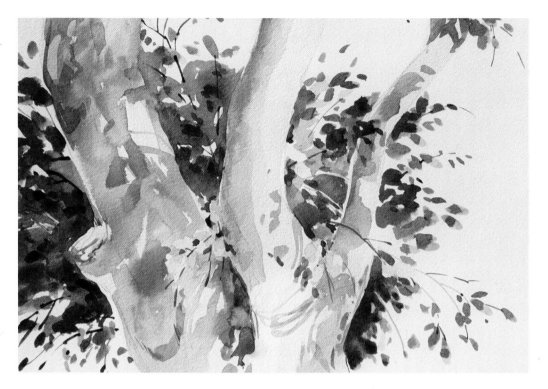

I was excited by the warm and cool colors and the quality of the light on this tree. We ran out of time before I was able to finish, but every time I look at the painting I remember what it was like out there by the lake, what a lovely day it was, what the gulls sounded like and how the desert smelled. You can't ask for much more from your work.

time of year, as many do, as protection from sunburn—it is as though the leaves' tender cells are wearing sunglasses.

And it's a lovely time to be out and about. Cool breezes, wonderful working conditions (barring rain), birdsong—in the desert it is especially lovely. I visited Nevada in March and sketched or painted nearly every day before breakfast. We visited Lake Mead and sat painting near a shelter house, just drinking in the scent of a desert spring and the sounds of gulls trolling for dinner over the water. Waves lapped the shore, making sweet counterpart to their cries.

It's the only time you see much green in the desert—and the colors are quite different here, clear and intense, even in the early spring. It got hot while we were out painting, even though it was only March. I tried to incorporate that feeling in my sketches and the quick painting.

The painting above and those on the previous page were done in March, even before the redbud bloomed in my native Missouri.

Hot Weather Painting

It can get very hot indeed in some parts of the country. My brother-in-law, Richard Busey, lives in the desert, and goes out most seasons to paint on the spot—except in midsummer, when temperatures can soar to 120 degrees and higher.

Even the heat of a Midwest early morning can be a bit much—but normally that's my solution of choice in the summer. It beats giving up for the season. I get up early, having packed everything the night before, and hit the road almost before full light. I can usually get in two to four hours of reasonably comfortable painting time before I need to bag it for the day—and that's about the time sweat starts dripping onto my working surface!

Remember to take along plenty of drinking water when it's hot out, and your insect repellent if you are in mosquito or tick country. It helps to find a shady spot to work, not only for your own comfort but to keep the sun off your work surface—that glare, as noted, interferes with our ability to see colors and values correctly.

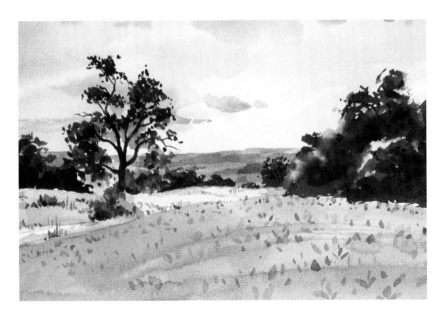

This painting was one of a series done from the top of the loess bluffs overlooking the Missouri River. The sun would make the day uncomfortable soon enough, but it was great fun painting in this early morning light, sitting in the middle of a farmer's soybean field and listening to the birds wake up.

Just remember that, if you set up someplace like this, you need to ask permission and be very careful not to damage the crop.

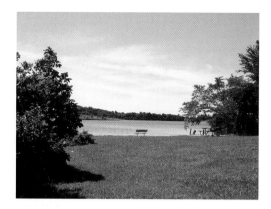

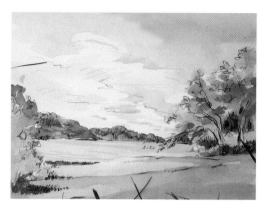

This was one of those days when I was in the mood to paint but nothing really struck me—it was getting hot, and getting near noon, too, when the shadows are less interesting.

It seemed like a good time to use one of my favorite mixed-medium effects, a quick drawing with a black or dark gray colored pencil with watercolor washes laid in. You can see the underdrawing and the first pale washes in this step.

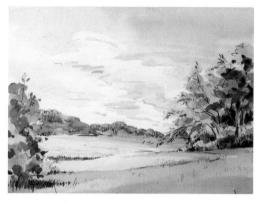

Here, I added the next washes to define shapes once the first ones were dry. You can see the blades of grass where I had the painting propped to shoot the slide.

I put in a few dark shadows to suggest volume in the trees, shadows on the ground, and a little texture in the grass with short strokes of a small brush.

Dress accordingly—lightweight natural fabrics like cotton or linen are probably the most comfortable. Experts often suggest tucking pant legs into socks, and keeping long-sleeved cuffs securely buttoned when in tick country to discourage these small creatures. They have been known to carry Lyme disease and Rocky Mountain spotted fever, so watch for them, remove them promptly, and disinfect and wash the site.

Don't overexert—and don't try to carry too much, or move too far, too fast. You may even want to work fairly close to your car so you don't have far to walk if you get overheated.

If it is very humid, you may find that your paint dries much more

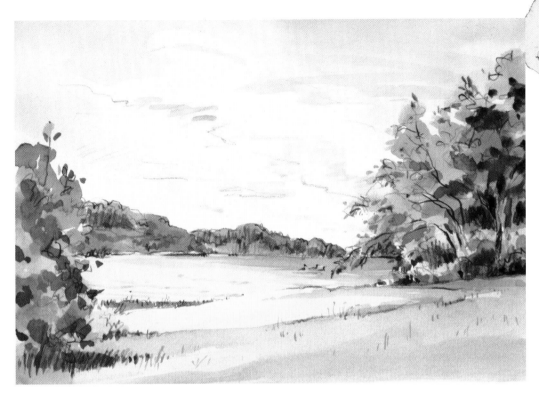
Finished painting

slowly than normal. Be aware of this tendency and compensate for it. Back in the studio you may use a hair dryer to hurry drying of an area, but out in nature you have no such amenities. It's necessary to develop patience—or a diversion. What I sometimes do is work on more than one painting at a time, so that while I'm waiting for one to dry I can be working on another. I may take a short walk and come back to find my painting has dried enough to continue working. Other times I'll simply take out my pennywhistle and entertain myself (and the wildlife) to overcome the urge to jump back into my painting too quickly. This also gives me the opportunity to get away from it a bit so I can assess with fresh eyes what my next step should be. Sometimes I realize I don't need to do another thing. I'm finished.

There are times, in the endless green of a Midwest summer, that I think there's nothing interesting to paint, that everything is exactly the same shade of green. It isn't, of course, and I may just need to look a bit harder to find the lovely variations in a small plant's reddish stem, or the wonderful colors of limestone and shale rocks along a riverbank, or the many bright disks of the myriad species of sunflowers that appear in August. There is always plenty to paint if we go at it with an open

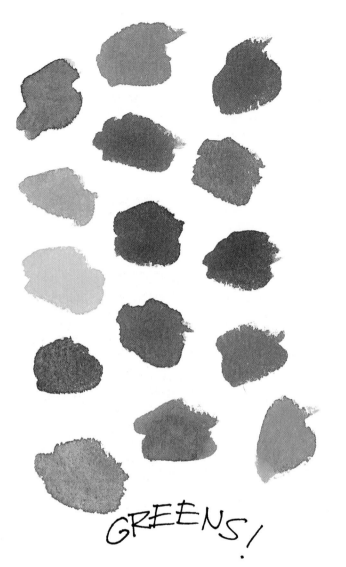

As an exercise, try a color swatch of all the greens you actually see—this is not only an excellent exercise, but an eye-opener as well. How can I become bored with that wonderful variety that exists in nature? I think that too often we intellectualize, or make judgments based on something other than on-the-spot reality. We forget. We think in shorthand. We generalize.

Nature will not allow that when we meet her on her own grounds. There are layers of complexity here we can only begin to perceive. Boring? Not by half!

Incidentally, these were all mixed from the blues and yellows on my palette, not from tubes of green pigment.

mind, and the early morning light tends to make colors much more varied and interesting.

Be aware, too, that sunlight is strongest in summer, no matter where you paint. It can almost bleach out the colors you see; when it strikes your painting surface full on it can affect your ability to see colors and values. Find shade or wear a broad-brimmed hat as suggested. Any time of the year, of course, full sun can cause problems in perception as well as comfort level. In the desert light, artists are particularly aware of the need to adapt to strong light, and Richard Busey says, "Set up so the sun isn't shining right on the paper, or you'll go 'snow blind'!"

Autumn Colors

Working in the fall is extremely pleasant, usually—the air is winey and cool and refreshing, the autumn haze is beautiful, subtle, and evocative, the colors are dizzying. Some of the insects are gone, which makes working easier as well. You may need to simplify madly to make sense of the tapestry of colors, or focus in on what I call an intimate landscape—the microcosm at your feet.

Here, you get an idea of the actual size of these little "postcard paintings"— just right for a small field study like this one.

Finally, you can see how successful this little sketch was. Judy didn't feel the need to paint every leaf on the forest floor, but just enough to make the brilliant little berry pop out.

Though it looks complex, this is basically a very simple painting and took only a very short time to complete. I suggested the autumn hill full of red-brown oaks with a mixture of burnt umber, ultramarine blue, and cadmium red, varying the mix to darker and bluer for shadowy areas. The sky was mixed with white and ultramarine, with only a little bit of brown to gray it. I "punched" sky holes in the tops of the trees to suggest lacy foliage and faraway limbs.

Then I added the tree trunks and limbs, and mixed up some yellows, greens, and oranges with a little opaque white. Spattered here and there, it suggested the fall colors and leaves. Finally I mixed cadmium red and white for the warm-colored leaves on the small dogwood trees in the understory—their leaves turn the most gorgeous pinkish color.

Color is often almost overpowering in the fall. Sometimes it's best to take it in small doses and do a close-up, as Judy has done, or concentrate on an area where one color tends to dominate—a golden aspen or pawpaw grove, for instance.

A different medium may help, too. I found that painting autumn colors in acrylic rather than my usual watercolor allowed me to simplify more easily. The opacity of the paint film lent itself to a flatter, simpler handling that worked well with the subject.

When faced with autumn's varied palette, it's easy to produce something muddy and confusing like this painting I did on the spot at Cooley Lake, opposite—if I were to try it again I would simplify madly, as shown in the color sketch on page 172.

This is the scene as it actually looked—a beautiful day to paint but a subject that could easily get confusing.

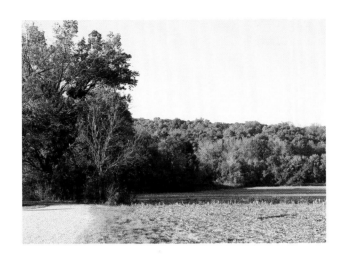

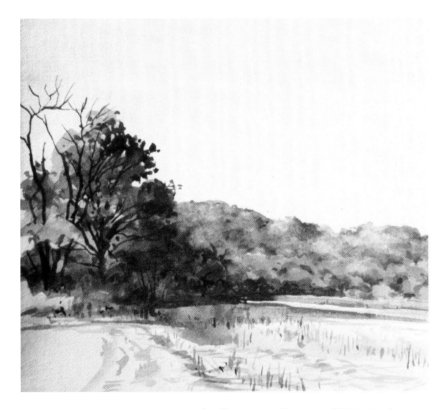

This is one I feel just missed the mark—it's still a nice record of a beautiful day, but the colors got muddy. I tried to do too literal an interpretation of what I saw, and because of that the background hill appears too garish. The bright colors seem to pull it right into the foreground with the trees at left, when in fact it was at least a quarter of a mile away. I tried to lift and simplify the area by softening it with a damp brush and clear water, then removing some of the color, but it was not really a successful attempt.

A quick sketch, months later, gave me some ideas about how I might have simplified what I saw and kept the background where it belonged. You will notice that the far hills are much lighter and simpler in the rough sketch—and the rest of the painting could be a little simpler as well. Problem solved!

This is much more successful as a painting—it's fresher, cleaner, less confusing. I used my favorite mixed-medium technique—black colored pencil drawing with watercolor washes laid quickly over the top. The colors were kept much purer, with less mixing on the paper, and allowed to dry. A bit of gouache added last worked well for the bright poison ivy vines.

"Storm Over the Lake," watercolor pencil. It was alternately raining and clearing, so I sat in my car to do this little painting of the late autumn showers over the water. Most of the color was gone, and it was late in the day, as well, but it was still fun to do a quick sketchy painting just to see if I could in the time left before it got too dark. I laid in the colors with the water-soluble pencils, then softened here and there with clear water from my canteen. When that dried, I went back and added a little additional color, then softened it to blend.

Flora and Fauna

DETAILS ADD THE SPARKLE of life to your work. And sometimes it is that very thing that catches our eye in the first place. A small flower, a butterfly at rest, a mayapple pushing its way out of the damp spring soil, a bird among the twigs—all sorts of lovely things that make us aware of our relationship with nature.

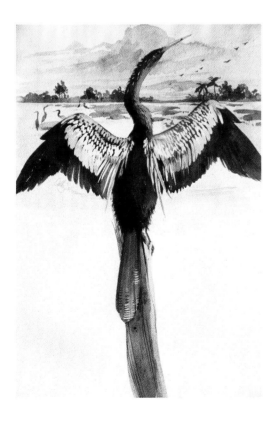

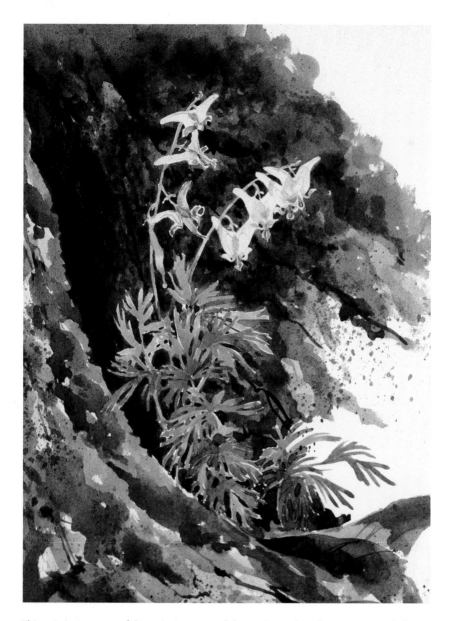

This painting was one of the series I attempted that spring—I love these interesting little flowers and enjoyed the attempt. Instead of using a masking agent to protect the white of the flowers and their lighter-colored stems, I just drew my subject carefully and painted around the areas that would remain lighter.

Getting down the complex shapes of the leaves was perhaps most challenging. I paid special attention to the negative shapes—that is, the shapes made by the background rather than the leaves themselves.

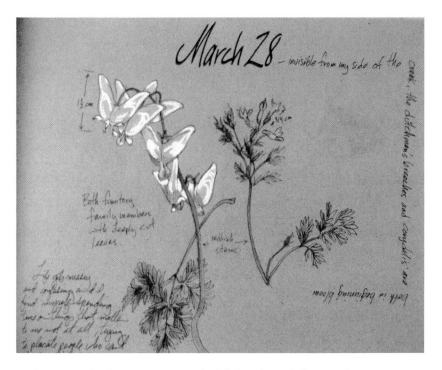

Just because you've done a subject once, don't feel you've said all you need to. Five years or so after the first painting was done, I found these lovely flowers across the creek from my cabin and took my tan sketchbook and paintbox of gouache colors over to paint them where they grew.

Gouache works very well on this toned paper, allowing you to pop lights out of a darker background very easily. I drew the basic shapes with a fine-tipped pen, then added whites and color with a small brush and gouache. You can see it is a very different effect from the first attempt.

Plants are of course somewhat easier to paint—they don't startle nor do they run away as do animals. We can study them to our heart's content. We can sketch and paint them at our leisure—as long as they are in season, that is. One year I set myself the task of painting each of the spring flowers as they bloomed in the park near my home. Well, at that season, the plants are a calico riot of shape and color that bud and bloom and fade at lightning speed, and I quickly had to abandon all hope of keeping up. Still, it's lovely to make a study of all those flowers blooming on a specific day (or just one of them), or the mushrooms you find after a rain, or the trees growing in a particular environment—perhaps one you don't get to visit often. Your painting, no matter how simple or complex, will let you preserve your memory of the subject, the day, the place—and teach you a bit more about it as well.

Learning How to See: Plants and Flowers

Part of the pleasure of learning to see is the ability to lose ourselves in beauty. Flowers have caught the eye of poets and artists for centuries; they evoke a whole range of feelings. Even their names tell a story. Lady's slipper. Dandelion. Queen of the mist. Jacob's ladder. Old-man's beard. Their Latin names are as expressive—we've always had a special relationship with plants. Little wonder we want to spend time exploring them, and capturing their image on paper or canvas.

With plants, we can take our time and look for relationships between their parts. We can observe whether leaves are alternate or opposite. We can see if the shape is basically a disk, a cone, a globe—what have you. We can ask ourselves questions, either those based in botany (does this plant have smooth or lobed or toothed leaves?) or ones of a more personal nature (what does this color remind me of?). These questions, and their answers, help fix the details in our minds, and we can create a truer picture.

Sometimes those personal questions produce the best work, somehow capturing more of the soul of the plant than do the botanical observations—those are quite useful for making botanical illustrations but less so for catching the sense of life and connectedness. Light striking a mushroom's cap, the eerie pale glow of Indian pipes in autumn woods, the complexity of Dutchman's-breeches, the sweetness of violets—these are things more easily understood with the heart, not the brain. But both work together to make a work of art.

And the most important thing is your response on paper, not the result of your efforts. It's the time spent in the trying.

Sometimes seeing the geometrical shapes and simplifying forms helps you to understand how everything follows the rules of perspective. These disk-shaped flowers do—note how the disk is a circle when it is turned toward you, then becomes more of a flattened oval as it turns away.

Practical Considerations

It may be necessary to reduce what you see to an almost mathematical or geometrical formula in order to capture it on the page. This doesn't necessarily kill the magic or turn what you see into something boring and sterile. Consider fractals, those consummate mathematical formulae tracking chaos theory that seem, somehow, best to express the magic in nature. This is simply a way to get a handle on what you see.

Don't feel as though you have to finish a painting to have

Many wildflowers follow a very simple design, roughly circular with petals rayed out from the center. Wild roses, daisies, and these marsh marigolds all follow the same basic pattern; you may want to count the ray petals and paint what you see.

Notice here that I included the whole plant to better show its growth pattern. Also, note carefully the shapes of the leaves you are painting—that's what may help identify your find. Marsh marigold has large rounded leaves that are vaguely heart-shaped. This plant grows from a simple root structure rather than a taproot, bulb, or rhizome; I included that in my painting.

accomplished anything. The time you spend is more important than anything else. And don't discard a half-finished work; sometimes it preserves your memory of a time and place as well as a finished work. If you want, you can use it later to complete a more formal painting back in your studio.

I like to keep sketches and studies from life—done on the spot— on hand. It's easy to record over a season's time or a life cycle of a given plant what it is like from bud to blossom to fruit. Although I use mine for commercial illustrations at times, they are beautiful, fun, and informative as botanical paintings as well. I have a large cache of these drawings, studies, and small, impromptu paintings from life, and often enjoy putting them together in a completed work.

Not every detail needs to be completed when you paint a floral. Sometimes it's very effective to let some edges be "lost and found" and some areas only partly painted. It seems to invite the viewer into the

Here, you can see perspective in effect in many directions. Basically globe- or oval-shaped, these tulips still are rendered with the rules of perspective in mind. Notice how these subtle differences in plane make the flowers appear to lean toward you or away.

Here, I ran out of daylight before I ran out of subject—I intended to return the next day and finish, but it rained for several days, and I got busy. The mayapples opened and blossomed before I ever got back to the place where they grew. I still like this little unfinished study and would never discard it—it helped me to see how the early spring wildflowers emerge from the ground tightly to unfurl like tiny green umbrellas, and serves as a record of the plant community they grew in. Here, wild ranunculus, ferns, and grasses appear in the same ecosystem.

Judy Gehrlein's studies of poppies of rural France suggest that it's not necessary to complete an entire painting—or even a whole flower. These simple watercolor studies capture the freshness and immediacy of her subject and are wonderful for rendering the delicate, almost transparent petals.

Later, using this study Judy was able to create a finished piece back in her studio.

Brown Madder
Alizarin

Burnt
Sienna

Ultramarine Blue

Studies done in the early spring, when the pawpaw flowers are young, were combined with leaf studies and a much later one of the fruit itself to make this botanical painting.

This is one of those plants with flowers of such unusual coloring—almost a mahogany brown—that a study done from life, and on the spot, is invaluable. The color was approximated with a mixture of brown madder alizarin, alizarin crimson, burnt sienna, and a bit of ultramarine blue. Notice the pale yellow-green bud that appears between the two blossoms.

The large, elongated oval fruit that appears later in the summer was rendered with wet-in-wet watercolor washes of a light sap green and burnt sienna to capture the variation in color. Like bananas, pawpaws tend to get brown spots on them—they indicate ripeness.

This botanical painting of a wild rose follows roughly the same progression, from bud to flower to fruit, and again field studies helped to create the finished illustration. Careful observation of details helped me to notice that the thorns were slightly darker in value than the stem they were on, and that the young stem that bore the bud and flower became greenish brown with age; that's what the rose hips grow on.

I paid special attention to the graceful shapes and gestures of this bouquet of flowers, rendering part of it wet-in-wet and adding details as it dried. Notice where perspective applies to the planes and shapes of the flowers.

picture plane. It's restful, in some cases; it sets up an interesting tension in others. It also invites the viewer to become involved, because the brain invariably imagines what is not there as well as seeing what is. The viewer, in other words, completes the painting in his or her own head.

I was asked to do a flower painting for a book cover for North Light Books during the winter season—there were no wildflowers to paint, but my local florist took up the slack. I consider any painting of living things to be painting from nature, and was delighted for the opportunity.

Unfortunately the fax machine that sent me their layout (the rough sketch of format and proportion they needed) distorted what they sent, and so the painting at left was unusable for the book cover. I had to do it over, but that meant I got to keep this as a lovely reminder of the beauty I brought into my home in the dead of winter.

It's not necessary to work in full color when working in the field, of course. If your subject warrants, or if you just prefer, your painting can be done with a very limited palette. Consider carrying a few water-

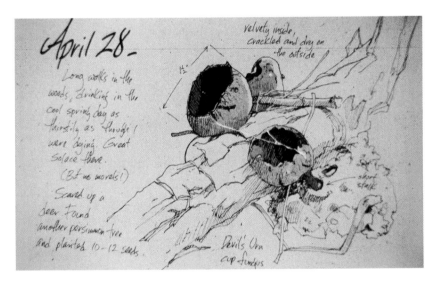

I found these tiny cup mushrooms near my cabin and brought them back to paint comfortably while sitting on my deck. The paper in the sketchbook that I keep at the cabin is a natural tan color, so I decided to work with that and the fungus's own shades of rich brown, plus a bit of opaque white to capture details like the tiny thread of spiderweb.

This is a mixed-medium painting with an ink underdrawing, watercolor washes, and gouache details. Apply gouache with a tiny brush for paintings like this. It's absolutely fair game to use any combination of mediums you like, to paint what you see, if that's what it takes.

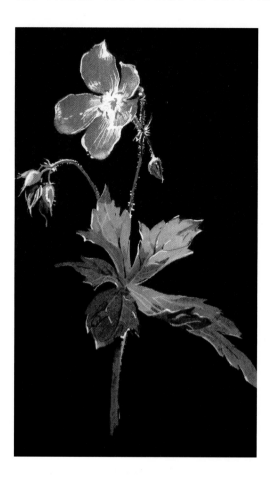

Tiny details of stamens, leaf veins, striations in the delicate petals, or the tiny hairs along the stem are easy to render with gouache, an opaque medium.

First I drew the flower shape in with a pencil—a bit difficult to see on a black background, but not impossible! Then I added the first layers of color, relatively thinly applied—that is, with more water mixed with the pigment than in later layers. This resulted in the pink petals looking almost transparent, which I liked a lot, so I was careful not to let the later applications of color lose that effect.

Once these first, thin layers were dry, I added more paint to my mixture and less water, and added a bit of definition to the petals—and a good deal more to the leaves and buds.

I allowed that to dry and defined the veins in the leaf with a darker green, then picked out highlights along the veins with a mixture that had more opaque white in it. The red at the center of the flower was easy to do with a small brush and a mixture of cadmium red with just a touch of white. Finally, details of the edges of the leaf, where the light seemed to etch a narrow border, the fine lines in the petals, and the tiny hairs along the stem were added with a very small brush and white paint.

In a case like this, careful initial observation is more of a challenge than the application of paint, which is actually quite straightforward, as indicated.

soluble colored pencils into the field with you, or look to see if there is an overall color family that best suits your subject. Cool blues and greens work well for some flowers, and fungi may lend themselves even better to a monochromatic handling, as they often appear in tones of white, gray, tan, sienna, and brown. (This is discounting the lovely apricot chanterelles or the bright red fly agaric!)

Gouache has been traditionally used to paint flowers; it makes it easy to add tiny details that appear in lighter colors and seems sometimes to capture flowers' delicacy better than any other medium. The English painters especially seem to have gouache down as a medium; it is in fact very European and only beginning to become popular here for anything other than illustrating. Since it is water soluble, like water-

color, it is excellent for field work, cleaning up easily and transporting well.

It can be used for a more abstract handling of very tightly detailed works, where it really shines. Use a toned background for unusual results, either a light pastel that captures the overall mood you are going for, a traditional tan, or black for dramatic results.

Painting White Flowers

This is sometimes a bit of a challenge if you work on a white background. Rather than end up with a harsh, dark outline, you may want to render a darker background behind your subject and let your flower pop out of that.

If you model it carefully, a white flower can have as much detail and depth as any other. You just may need to push the color a bit. A bit of prismatic or pastel shading can make a more interesting painting

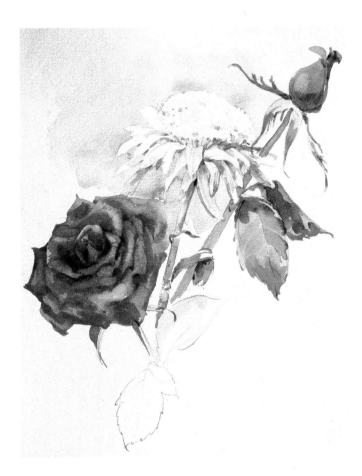

This painting was purposely left unfinished to show the progression of steps—the leaves in the foreground were rendered fairly simply, the upper one just the basic shape and the lower one with its toothed border and a suggestion of veins. As begun in the upper leaf, you would simply put a light wash on for color, then start adding additional layers to suggest shadows, veins, and other details, like the one at right.

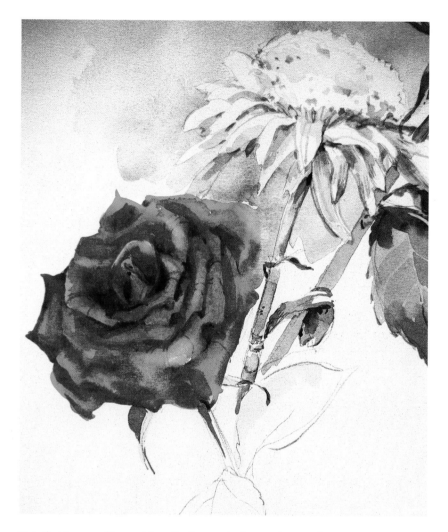

Note that there are "lost and found" edges on the large red rose—that is, some are hard edges and some are softly blended. This helps keep the flower from looking pasted on, and it approximates the way your eye works—what you are looking at is in sharp focus, the rest is not. I wanted the center of the rose to really stand out, so that's where I did the most detail.

And for the white flower itself, I used a permanent rose to do the lighter, warmer shadows, and a mix of that and ultramarine blue for the darker values.

To make it pop out of the background I laid in a wash of what is known as "palette gray," but don't look for it in the art supply stores. That just means it's a mixture of whatever colors have found their way to the mixing area of your palette. It often makes a very luminous, lovely gray, unlike anything else you can use. I just painted around the flower, but if you wanted you could mask it out with a liquid masking agent, lay on the background wash, let it dry and remove the mask, then paint the flower as usual. Not necessary, of course, if you are using one of the opaque mediums. Then you can just lay a white flower in over whatever color you've chosen as your background.

than one in which you simply use gray or an unvaried blue for the shadow areas. Look carefully at your flower—there is a great deal of dissimilarity in value in the whole, even if the parts, if looked at individually, are as white as a sheet of paper.

Gouache works well in a painting of an entire scene, too. Use it alone or combine it with watercolors, water-soluble pencils, pastels, inks, what have you. I was heading home from a morning of painting and was struck by the bars of sunlight and shadow between the trees on the hill that seemed to emphasize the beautiful blue chicory flowers. The colors were stunning, but it was a more difficult subject than I was willing to try in a transparent medium. I gathered my opaque gouache paintbox, my watercolor box, and the rest of my gear the next sunny morning and headed back to the spot. It was already hot, that July morning, but it was worth it.

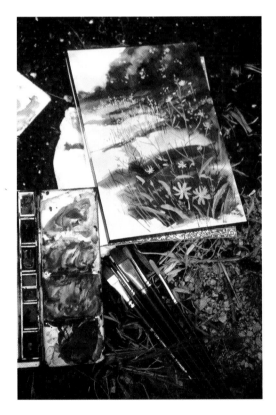

Here you see the painting and my gear, nearby, with both paintboxes.

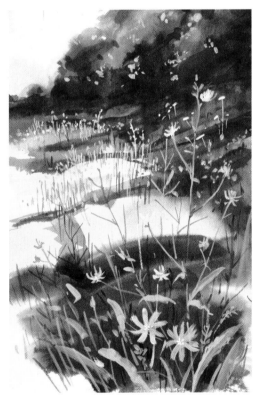

I eliminated the road for my composition and used a fairly loose, almost abstract watercolor underpainting to suggest the thick trees on the hill, the blue sky with the big fluffy white clouds, and the lights and shadows of the area adjacent to the hill.

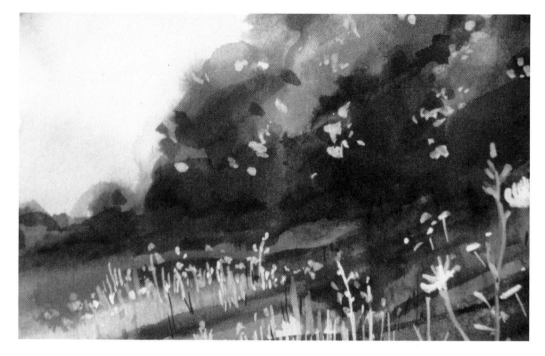

I let the sky and the far hill blend a bit, softly, wet-in-wet, to maintain the feeling of distance, and painted in the foreground quickly with a flat brush.

I mixed gouache in the hues I needed, and in the background applied them with a small brush using dancing strokes that I hoped approximated the growth pattern of the tall chicory. I used lighter mixtures where the colors would be silhouetted against a dark area, and darker mixtures where they would appear against a lighter background.

The foreground flowers were done straightforwardly, from direct observation, but are not a slavish reproduction of reality—I was not going for a botanical rendering, just a quick impression of the morning. On the largest flowers, I used a quick stroke of my brush for each blue petal, lifting quickly at the end to approximate the fringed appearance of the chicory's petals, mixing ultramarine and cobalt blue and a bit of opaque white so they would stand out against the dark background. The leaves and stems were done in a similar fashion.

In the middleground were some lovely yellow flowers that offered a little contrast—I added them with a mixture of cadmium yellow and cadmium orange gouache—and a few white Queen Anne's lace nearby.

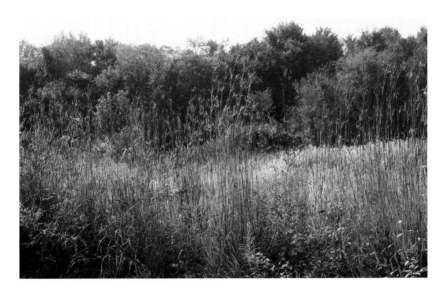

Prairie

I sketched in the roughest of guidelines for myself, using a wax-based colored pencil, and added the ironweed's purple flower with a mix of ultramarine blue and permanent rose. I emphasized the contrasts of light and dark on the flower to suggest the fact that the light shone on it from above.

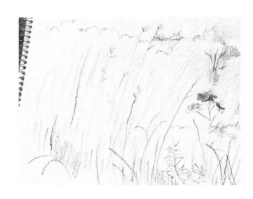

Here, you can see the very simple wet-in-wet washes in watercolor that suggested the far hills and the prairie grasses. I used a combination of greens from the tube and those I mixed myself, with phthalo blue, cadmium yellow, yellow ocher, and a touch of burnt umber in the shadowy areas. Because I knew I wanted the closer flowers and grasses to stand out against that area to suggest aerial perspective, even on this small scale, and a kind of intimate distance, I kept the grassy areas fairly light.

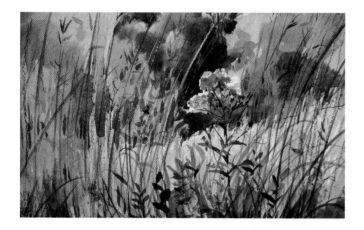

Finally, I painted in the wonderful variety of grasses, weeds, and wildflowers with long strokes that used my entire arm and shoulder, just so I could keep the lovely sweep of the tallgrass prairie. Direct observation is good in a case like this—if I had resorted to memory instead, the foreground shapes would not have been anywhere near as interesting.

Detail

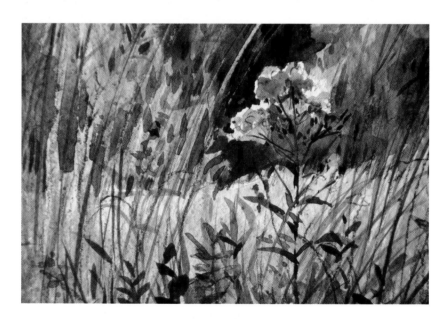

Sometimes a subject is not immediately apparent to you, or perhaps you like the scene but at first don't see anything to focus on. Richard Busey writes, "You can wear out a set of tires looking for the perfect place to paint. And don't jump right out of the car and start painting. Better to relax awhile and get in tune with where you are."

Sit still awhile and let it soak in—there's no need to plunge right into your work, as Busey notes. This hazy summer morning at the Martha Lafite Thompson Nature Center in Liberty, Missouri, I wanted to have my breakfast in the shelter house that nestles into the tallgrass prairie. As I sat with my coffee and yogurt, I noticed the lovely ironweed flower among those graceful, leaning grasses and decided that would be my subject.

Animal Kingdom

Wildlife has become a popular subject among artists; as a naturalist and environmentalist, I'm delighted. What we draw or paint, we learn more about; what we share with others, we want to protect—and wildlife needs our protection as habitats shrink from overuse. The birds and mammals that find their way into our paintings have the power to touch our viewers and invite a response—perhaps even initiate a more active role in conservation and habitat protection.

But first we have to get close enough to these creatures to capture them on paper or canvas. We have to be able to suggest their gestures and shapes with accuracy and life. To do those things, it's necessary to become a bit of a naturalist yourself. You have to put in your time in the field, as they say. You have to have firsthand knowledge of your subject.

It's not enough to work from pictures in a book or magazine—it's not enough, and it's not nearly as satisfying. Learning about these creatures yourself is where the fun comes in. Getting close enough to them to sketch or paint is a continual challenge, but one you'll remember all your life. And as our goal in this book is painting in nature, this is essential—at least for quick studies we may use later.

There are a number of methods of getting close. Easiest, of course, is your own backyard bird feeder. I've done countless studies and sketches there, and many of them have ended up in finished paintings or illustrations. Find out what the various birds need—ground feeders, platform feeders, suet eaters, nectar drinkers—and provide a

If you feed the birds you may get a chance to do many quick sketches and studies; don't hesitate to add paint if you have the opportunity. This chickadee had come to visit my feeder along with the juncos and titmice, and my original sketch was very quick, more a gesture sketch than anything. Later, when other chickadees returned, I was able to get out my gouache and add a bit more life to my little study.

Work fast, as you need to, but note that often a bird or animal will return to the same or very similar position, allowing you to finish. Be patient and trusting and you'll get the chance you need. Repeated and prolonged observation will help you fix details in your mind's eye.

F
L
O
R
A

A
N
D

F
A
U
N
A

191

variety of options. If you have a comfortable and somewhat hidden place from which to observe, your painting opportunities are endless. Often the birds will become used enough to your presence that a hidden place is not even necessary; it all depends on how much time you have to devote.

Some wild animals may be attracted by feeders or salt blocks. Their actions still won't be totally natural, but it's a great chance to study their antics from close range. At my cabin, I have hanging feeders in front of a big bay window and a platform feeder just beyond the edge of the deck. I've had the chance to paint more birds out here in the woods than I'd ever seen in my life—goldfinches, purple finches, and grosbeaks have all joined the common feeder birds. Some of the birds I've gotten to paint or sketch aren't even seed eaters but seem to come just because the other birds have accepted my presence; they forage for grubs or worms on the ground nearby. Carolina wrens aren't interested in the feeders, but they flock here just the same, as do summer tanagers, bluebirds, and indigo buntings.

And, of course, where there's free food you're likely to see squirrels, chipmunks, and raccoons. I don't resent the animals that make their incursions there in the least. Some of my most enjoyable painting and sketching experiences have been when I hurry to capture that sense of life on a two-dimensional surface.

Your own pets are a wonderful source of study material. Though not what many people might think of when considering "painting from nature," they offer good practice and a basic understanding of the common anatomy. I paint my cats just to keep in practice.

Another option for getting close is the local zoo; many are less jails for animals now, and you may be able to observe the animals going about their activities in more or less normalcy. If you are interested in the smaller animals, a petting zoo might be the place for you, though these feature baby or pygmy farm animals like goats and cows rather than wild creatures. Still, it is good practice and helps you to fix details of anatomy in your mind.

Make yourself useful around your local wildlife rehabilitation facility; your help may be needed, and it is a way to get close to the animals and learn more about them. At the very least, let these people know you'd like the chance to see, sketch, or photograph their charges. Your local state conservation agent may be able to let you know when he or she has access to an animal before returning it to the wild; move quickly and you may get the chance to be closer to a woodchuck than you'd ever dreamed possible.

This great horned owl was in the care of my vet until its wing healed; he brought it to my place to acclimate for a few days before release, and I had the opportunity to draw and paint it more than once while it was there. Here, I did a drawing on my paper to act as a guide, then painted the eyes first—with any living creature that's often the most important.

An underwash of body color was the next step; I knew that I could sit and add the details of feathers and markings as a final step, and that even if the owl moved or I tired of the job, a partially finished painting would still be effective. Sometimes more so, because it allows the viewer's mind to interact with your painting, completing what is not there.

Many veterinarians double as rehabilitators. My vet calls me whenever he has an interesting creature in his care, recovering from the effects of a close encounter of the human kind. I've had the chance to draw everything from a relatively rare short-eared owl to a young, wobbly-legged fawn. (It's important to *go* when someone lets you know about a sketching opportunity; pass a few times and they'll figure you're not really interested. They won't call you again.)

As is often noted, however, animals don't behave in a normal fashion behind bars (would you?). They lose that wild alertness, they get bored, fat, lazy, and complacent. It's best if you can meet them on their own ground—best for them and for you.

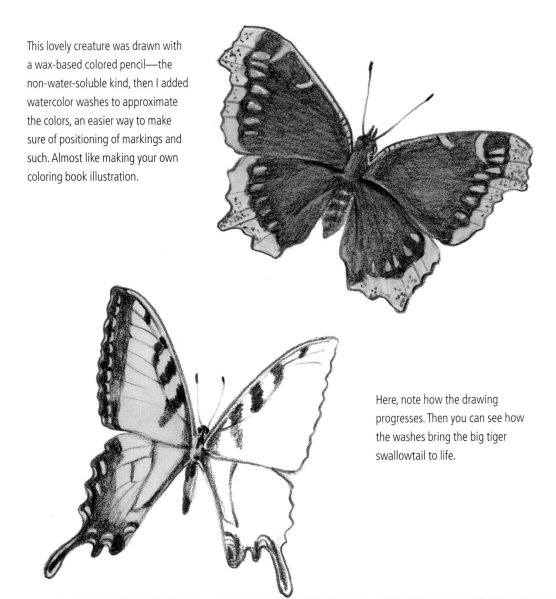

This lovely creature was drawn with a wax-based colored pencil—the non-water-soluble kind, then I added watercolor washes to approximate the colors, an easier way to make sure of positioning of markings and such. Almost like making your own coloring book illustration.

Here, note how the drawing progresses. Then you can see how the washes bring the big tiger swallowtail to life.

Leave wildflowers or weeds around your property to attract a wide variety of butterflies and other insects, or get out in the field where they bloom. One day when I went out to photograph flowers, I discovered I was seeing ten different kinds of butterflies while I was at it, from tiny blue hairstreaks to the spectacular black swallowtail; they've shown up in a number of my paintings.

I often see mourning cloaks in the early spring, and tiger swallowtails seem to like the varied habitat nearby. It's fun to take the time to paint these lovely bits of color, alone or as adjuncts to a larger landscape or botanical painting.

Check with the National Wildlife Federation or the Xerces Society for suggestions on turning your backyard into a miniature nature sanctuary. There are a number of specialized flowers and bushes you can plant to attract these beautiful creatures, providing yourself with subjects and the wildlife with habitat at the same time. You might want to look for *Butterfly Gardening: Creating Summer Magic in Your Garden,* by Xerces Society/Smithsonian Institution, published by Sierra Club Books, San Francisco, in association with the National Wildlife Federation (Washington, DC, 1990).

Nocturnal moths may be attracted by a porch light or by a source of sweetness like honey or sugar water; the graceful luna moths seem especially plentiful in the woods around my cabin. It is more difficult to paint at night, to correctly judge values and colors, but close to that porch light it is not impossible. If you just can't, don't let that stop you—make a sketch, like this one, and use it for reference later. I found a luna's wing on the ground a week or so after the sketch, and saved it so that when I have a chance I can combine it with the sketch to make a painting.

Drawing of luna
moth

Become proficient at tracking to discover some of the more elusive mammals. Read Tom Brown's books on tracking in the wild, or the classic *Peterson Field Guide to Animal Tracks* by Olaus Murie. Be willing to be out early and late; many animals are nocturnal or crepuscular (appearing at dusk and dawn). To capture them in your work you have to meet them on their own terms. I have tracked muskrats, beavers, woodchucks, badgers, and other creatures, just for the pleasure of seeing them; several have ended up in my paintings. Winter's a great time to do it; not only do their tracks show up easily in the snow, but the animals themselves stand out against the simplified background. Bundle up and go for it. Take your field kit with you and take a shot at winter painting—but be aware of how cold you're getting, and guard against frostbite.

In the wild, you need to be as unobtrusive as possible to get close enough to work. Don't wear scent—perfume or aftershave lotion. Don't smoke in the field. Spicy foods may taste great, but that garlic breath is even more detectable by an animal than it is to your seatmate at the local theater. Camouflage clothing is as useful to the artist as it is to a hunter. Or make yourself a portable blind with a poncho and wide-

Sometimes it's fun to paint just the animal's tracks; other times I include the creature that makes them as well. In this case this small rabbit had been injured by a predator and was in my care for a few days. I studied its tracks and enjoyed doing this small watercolor.

Take every opportunity you reasonably can to observe an animal and you'll find that when you have the chance to do a painting in the field, you will have developed the understanding necessary to capture it on paper or canvas, quickly and accurately.

This little fellow adds a touch of life to the landscape. It was really there, but not for long—
it helped to have drawn and painted its cousins many times before.

I drew the rabbit's simple shape in place when I roughed in the guiding sketch for
this quick painting, and rather than worrying about painting around it when I did the
foreground grass, I just used a paper towel to blot up a tiny lighter area where the animal
was. Then when that was dry, I went back and painted it in with a light wash of a pale
brown. If I had used a darker color, the little bunny would have looked pasted on rather
than a part of the scene.

brimmed hat—often it's our bold eyes that frighten or alarm an animal
or arouse the fight response. (Grizzlies don't care to be rudely stared at
and will challenge you in a heartbeat; that's one animal to avoid if at all
possible.) Position yourself at anything but normal human height;
above or below eye level works well. And appear to look anywhere but
directly at your subject—steal glances from the corner of your eye.

And most important, sit still. Be patient. As long as you're bum-
bling through the brush, most self-respecting animals are going to turn
tail and run. By sitting unobtrusively—and silently—nature will get
back to normal and you'll be surprised what you may be able to see.

Now What?

Now that you've discovered how to get close to the animals, how
on earth do you capture those quick, lively creatures? There are a num-
ber of ways. Try gesture sketches. If it sticks around longer, then you
can develop your drawing as long as you're able, or even translate it
into a quick painting.

Keep moving. If your subject moves before you get a chance to finish a particular drawing, move on yourself—to another sketch on the same page. Watch for repetitive action. One summer a young gray squirrel visited my deck to feed on a rainy afternoon. His tail acted as an umbrella, draped up over the animal's back, and though it was dripping wet the rest of the little creature looked perfectly comfortable. I sketched him that way, and each time he moved I started a new drawing. When he returned to a previous position, I went back to the sketch that most closely approximated this pose and added new details. The result was a happy pageful of squirrel sketches, one of which ended up as an illustration in one of my books and as the subject of a small painting. Another squirrel amused me by hanging by his back feet from the eaves to reach my bird feeder; each time he reached out to grab at it, I did a little more on my drawing until I had the entire animal down on paper. He's not yet appeared in a painting—but he might one day!

Detailed studies. If you get the chance to really spend time with your subject, do so—work as long as you can. In some cases that will be enough to do a completed painting, and other times you will get only a part done. That's fine; it's still invaluable both to your understanding of that creature and as a work of art on its own.

I never got the chance to finish painting this turtle that found its way into my care—I was holding it with my left hand and painting with the right, and the creature was busily making hamburger out of my hand with its claws. I would not recommend working in this way, either for the animal itself—I now know it probably caused it more stress than was good for it—or for you, either. Turtles can carry salmonella, and if you neglect to wash your hands after touching one, you can get sick.

Nonetheless I enjoy this small study, which turned out to be very little more than the reptile's head, with the barest indication of a shell and its patterning. It was a male turtle—you can tell by the red eye.

If you are of the carnivorous persuasion, there is yet another opportunity to paint a creature up close. This painting of a crayfish was a respectful nod to the remains of a Cajun feast. I was interested in the rich coloration and the shiny nature of the hard carapace, which I rendered by painting around the highlights rather than masking them or scratching them later with a sharp point. It was painted with a mixture of transparent watercolor and gouache, which I used to pick out details of the claws and carapace.

Memory sketches are invaluable when dealing with wildlife. Train yourself to remember what you've seen, and trust your responses. If your drawing is not picture-perfect, you can develop the details later from research photos or field guides. Your own memory of what you've seen is what counts here, giving a sense of reality to your work.

The Finished Product

To render animals and birds believably, you need to get from here to there the same way you get to Carnegie Hall—"practice, man, practice." Get to know their skeletal makeup. Make a hundred pictures of the same animal. Keep trying.

Try not to be squeamish if you get a chance to paint an animal that's recently deceased. It's one of our best opportunities for close-up study. Of course, it's best not to touch roadkill, which may be a carrier

This tiny painting is only 4¼" by 5⅞", but it is one of my favorites done for this book. I kept the colors low-key and muted to mirror the damp day, and felt the little thing needed a touch of life. Nearby, great blue herons fed in the shallows, occasionally catching my attention with a loud "scronk!" Just as I was about to call it a day, this heron flew from one side of the lake to the other, directly in front of me.

Obviously I was not able to paint it as quickly as it flew, so I just observed it closely and, as soon as I could, drew it in, just where it would balance my composition, and painted its reflection in the water below. Because I've watched and drawn herons many, many times, I was able to paint him fairly believably.

August 1 —

Looks as though this little tree frog was intended as someone's meal, but dropped him — the fire...

A bird had caught this hapless frog and deposited it near my deck at the cabin. The bright yellow and green creature blended into the small landscape at my feet at first, being the colors of so many of the flowers that were blooming just then, but as my eyes focused I saw it was a frog instead.

I sketched it with a fine fiber-tipped pen and then added washes of fairly thin gouache to capture the colors as best I could, affording me a better understanding of the anatomy and coloration of these small amphibians.

of rabies or other disorders, or be crawling with fleas. If the creature has been dead for some time, the smell will be unbearable, as well. Use prudence and caution, but do take the opportunities afforded you.

Notice the direction of the light, and let light and shadow suggest shape and volume. Reflected lights add a sense of roundness. The very shape or position of the highlight on an animal's eye can spell the difference between a portrayal that feels right and one that falls flat.

How best to express fur or eyes is up to you; there's no "right" way, just what *feels* right. I've covered a bit of this in my book the *Sierra Club Guide to Sketching in Nature*—anything from a careful rendering of each hair to a quick squiggle works, depending on your goal.

Techniques for painting fur

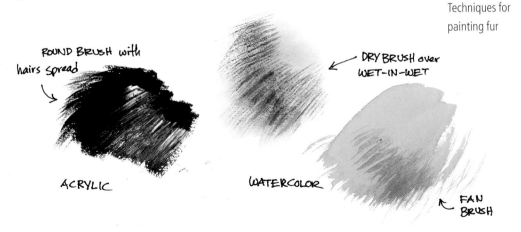

ROUND BRUSH with hairs spread

DRY BRUSH over WET-IN-WET

ACRYLIC

WATERCOLOR

FAN BRUSH

Study the masters of wildlife art (especially their sketches) for firsthand insight into how the artist thinks. My favorites are Bob Kuhn, Keith Brockie, Charles Tunnicliffe, Francis Lee Jaques, Gordon Morrison, Charles W. Schwartz, and Robert Bateman. Look at how they handled fur or feathers or the shape of a beak. Notice how they incorporated their subject into its environment with accuracy and feeling. Of course you'd never want to copy another artist's solution, but these guys can give you subtle hints on how to find your way out of the maze. Once you take a new road, you'll find your own way. Working directly in nature will answer a lot of questions for you, as well.

And that is one real advantage to choosing this kind of subject matter—it gets you out of the studio and painting in nature, beyond your own four walls and out where it's really happening. It's surprising how refreshed you'll feel when you come back in after a long, hard day of tracking, sketching, and painting. I guarantee you'll remember the experience longer than just another day in your studio, even if you don't come back with a single painting.

Finding a Special Place: Relationship Between an Artist and Landscape

MONET'S PASTEL LILY PONDS. Gauguin's island paradise. Wyeth's Brandywine River country. O'Keeffe's spare, austere desert. As long as there have been artists, people of special vision and their special places have been woven together inextricably, and together they form some lovely tapestries. We see more than a *place* in their works. There's a *sense* of place, as well, a hint of the give-and-take, the object and response—the love—between the artist and his or her subject.

It's not just a simple matter of painting what you see—what's available, familiar, and accessible—but painting what *speaks* to you. What calls your name. Therein lies the power to touch—and to be touched, to interact with your subject, to experience it as intimately as breathing.

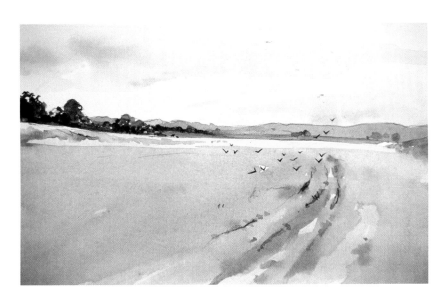

Another of my favorite places . . .

It's not so hard to do. Follow your nose; follow your leads; follow your inclination. As Joseph Campbell writes, follow your bliss. And be ready to *stop* when you see something that interests you. It's fine to have an agenda, a plan—but don't hesitate to deviate from that plan if something comes along that sings to you.

If you want to form a relationship with a special place, it should, of course, be reasonably convenient. You need access under a wide variety of conditions. But that's not the primary concern. Be aware of what it is that touches you, in mind and heart. Is it a majestic seascape or a "found" still life? Open prairie? Deep woods? Moving water? An unspoiled wilderness? Or, as is often the case with me, some poignant reminder of our own relationship with landscape? A tumbled stone wall or a meandering fence-line heaved by the frosts of many winters moves me; it has a power.

There's another advantage to this kind of discipline, of course, other than the obvious one of just that: discipline. Forming such an intimate relationship with one specific place teaches us to look beyond the surface; it teaches us to *see*, period. I have no excuse for getting bored once I've discovered the layers and nuances of meaning in this one small place—it teaches me that the world is full of possibility and holds within it the power to enchant us. All *I* have to do is see it. Taking time to find these places and to form a relationship with them can't help but benefit us as artists—and as human beings.

Some time back—during a summer of drought and blast-furnace heat in the Midwest—I decided that if I were going to call myself an artist and believe it, I'd *have* to take the time to paint. For myself. Whatever I wanted to. No assignments, no agendas, no concern for upcoming books or shows, or for what sells, or the "in" colors. Just what *spoke* to me. And 105 degrees in the shade or no, I went out every week, daypack bulging with palette and paints, sketchbook and containers of water, lugging a stack of watercolor paper and my half-sheet-sized Masonite support.

At first, I thought I'd paint all around the state park near my home—the long, blue lake with its prehistoric-looking cormorants and resident flock of Canada geese, the oak and hickory forest, the little creeks, and the deer and wild turkey and muskrats that congregated to drink. I'd paint the troll tree with its

odd, grinning face formed by an old gall. I'd capture the octagonal schoolhouse and the old wool mill, restored nineteenth-century buildings that are part of the state historical site. (As you've probably guessed, Watkins Mill was *already* something of a special place to me.) The possibilities were endless.

Maybe the possibilities were *too* much, a kaleidoscope array that daunted as much as it tempted. Or maybe it was just that I let myself be open to what really spoke to me. After months of intermittent showers or no rain at all, I was drawn as if magnetized by the lake. Wet! Cool! It was mecca.

There was an ancient wooden fishing dock that reached crookedly out into the water like an arthritic finger, casting its delightfully angular reflections in the water. It had been there as long as I could remember, a great place to dream away an afternoon, a lovely vantage point from which to watch the sun come up, a human contrivance that had mellowed into its place until it was as much a part of the landscape as the killdeer that ran along the beach and the mussel shells that shone like huge pearls, the remainder of a raccoon's meal. In the midst of pell-mell "improvements" at the park, I was afraid this bit

Dock painting number one

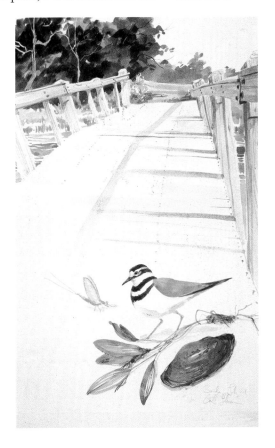

of cockeyed and rickety rusticity was not long for this world. It was bound to be deemed dangerously outmoded, and replaced by some streamlined and featureless limestone gravel spit.

And so I started there. The heat was stifling, hot as an oven; I felt like a gingerbread man. The wind was gusting up the lake at thirty-five miles per hour, catching my watercolor board like a sailplane and almost tearing it from my grasp. A huge husky came to brush against me, paddle at the water's edge, and then return to shake himself dry with a shower of droplets. People came and went, asking the usual odd questions ("Oh, are you an artist?" Well, today I am. Or, "My niece/ son/cousin/mother likes to paint. Should she/he keep it up?" Uh, why on earth not?). Meanwhile, the shade kept shifting and the chiggers kept munching.

They were not the optimum conditions.

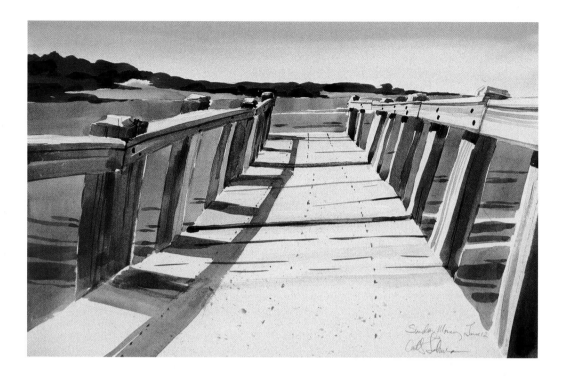

Dock painting
number two

I loved it.

I did one of the best paintings I'd done in a long time, fresh and immediate—it was too uncomfortable there to stay long enough to overwork it! (One of my favorite reasons for working on the spot, actually; I usually get tired and reach a reasonable stopping place at just about the same time. I can always polish later, if I need to. I seldom do.)

But the old dock still sang to me. I had chosen to paint it from the land, looking out into the lake. But what about the lovely calligraphy of shadows and reflections under it? What about a distant vantage point? What about the small vignettes formed by the weathered timbers themselves, as if small landscapes were framed with old wood, ready to hang on the wall? What about close-ups, and looking back to the land from the end of the dock, and the little incidentals that made up this small ecosystem? As time went by, these new possibilities presented themselves: endless variations on a theme. One painting wasn't going to get it, not by a country mile.

So, week after week I returned to explore another aspect of the dock. Sometimes I waited my turn at the popular spot; occasionally someone would have slept there, after fishing most of the night, and I'd have the remains of his or her breakfast to pick up before I could paint. Once I came early, before the sun—no one else was about. Sometimes I included the fishermen that worked the shoals nearby, sometimes not.

Often, I'd do one large half-sheet painting plus two or three small color sketches of the environs of the dock—the view down the lake, or the shoreline that stretched away from its base.

I became something of a Sunday fixture at the dock. I'd be included in family conversations like an old friend, or ignored completely—or I'd realize that someone was taking quick, surreptitious glances at my work, pretending not to be interested at all. And each half-sheet painting I completed, I dated to track my summer at the lake. Each one recalls that specific time.

Week by week I returned to the same spot, amazed at the continuing mine of possibilities. I still am, though other things intruded on my discipline. I missed the warm mosaic of autumn color and the fallen leaves that must have swirled around the dark, leaning pilings. I didn't see the deer drinking at the water's edge, safe in the park through hunting season, though their tracks on the muddy shore gave them away. I saw the ice beside the dock only in passing; thrown up in great, groaning plates, it was like the North Sea in microcosm. The planes and shadows and forms were fascinating in juxtaposition with the dark, wet wood; the blues and browns were endlessly subtle. But I wasn't hardy enough, at the time, to sit in snow and paint with rapidly freezing water—and hands! And I'm sorry I don't have a living record of the year in this one special place. There were a hundred things to see and paint, just here.

Dock painting
number three

Dock painting number four

Dock painting number five

My "dock series" isn't for sale—though I produced some of my best work as a part of this experience. And the reason is that I have a one-of-a-kind record of a time in my life, a time in which I felt secure in who I was and what I was doing. I was disciplined, and knew it. No "lost weekends" here. I can see the progression of days; they're preserved on paper. No need to wonder what I did Sunday, July 17; I *know*. And now that the old dock is gone, torn down when it became decrepit and unsafe, I don't feel that familiar pang—"I *wish* I had painted that before it was too late!"

Demonstrations

THIS SECTION OF THE book is a gallery of paintings, some step-by-step, some explained with close-ups and sketches. They are of subjects and concepts and mediums that appear elsewhere in the book and are intended for inspiration as well as instruction. They focus on details or distance, light and shadow, untouched nature and man-made subjects in landscape. They are certainly not meant to suggest that this is the only—or even the best—way for these particular subjects, but how they appeared to me or to the artist who painted them, and how they worked out, on a particular day, in a particular place.

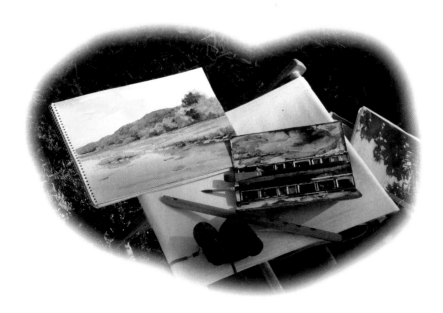

Enjoy the adventure, even if it's only to your own backyard. Though working from nature is indeed good practice and a learning experience, it's also sheer joy—and I'd have to call it necessity, for myself—at least part of the time. Artists need to really experience life in order to translate it to canvas or paper or three dimensions. Working on the spot, learning as you go, gives you the experience to put feeling into your work, to suggest a few telling details, and to discover the world beyond your studio door.

Water-Soluble Colored Pencils

I often carry only the pencils with me to the field rather than a whole painting kit that includes brushes and water—there's no real need to risk spilling or breakage. I can wet the whole drawing or

This lovely golden tree caught my eye, and I decided to try it with water-soluble colored pencils.

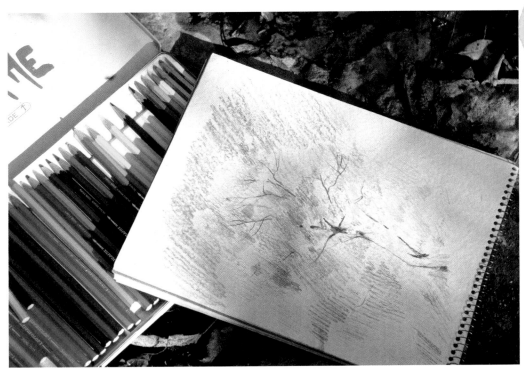

The technique worked well to keep me from being too concerned with detail. I layered strokes for more complex colors. This is the dry drawing, before I softened it with water.

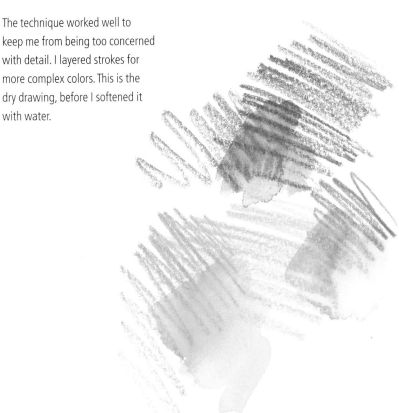

I decided on a loose, sketchy effect, and used repeated, open zigzag strokes, like those done here.

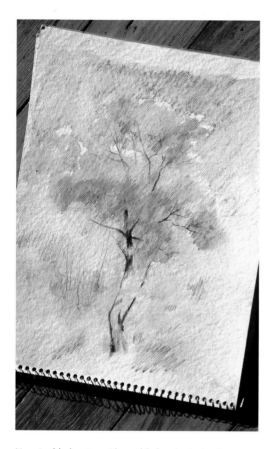

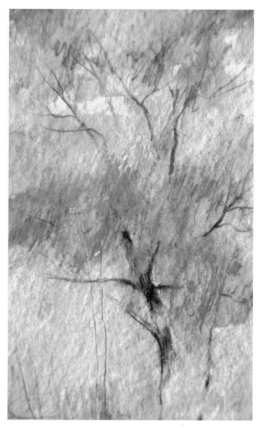

Now I added water with a sable brush, rinsing it often in clean water to keep the work from becoming muddy. I was careful to use the tip of the brush judiciously to maintain fine details of twigs and branches rather than just slop water indiscriminately over the whole painting.

In this close-up, you can see that I didn't slavishly copy nature's colors, but used a strong lavender and purple in the shadow areas to make a nice vibration with their complements in the gold and orange foliage. I was happy with the effect!

selected areas when it is convenient—minutes later at the campsite, when I get home, or five years later. I can also dip a brush into a convenient water supply, the lake or stream I am painting, if I want.

These pencils can be tricky. If you expect the dry color to be as intense as that same color once wet, you're in for a surprise. Some colors become vibrant, brilliant, and exciting, but some border on the garish. Some cross the border, heading south.

The water added to the pencil dilutes the original pigment, frees it from the static state, and allows the white of the paper to shine through, often in very exciting ways. You may want to test the color—wet and dry—on a piece of scrap paper to make sure that the color you've chosen is what you really want in the end.

Painting Nature's Details

I spent a long morning on this painting of the roots of a sycamore tree that grows by my creek. It took on a contemplative nature, as paintings sometimes will, and I enjoyed taking my time and painting it as slowly and lovingly as I wanted.

Zeroing in on a subject like this automatically helps you to simplify it. Painting this much detail and pattern in an entire forest would be difficult indeed, but settling on the roots of this stubborn tree made a lovely subject for close study.

Here you can see how much was actually going on around the tree root that had caught my attention. I decided I wanted to eliminate the background and vignette my subject in order to focus on the roots and rocks themselves.

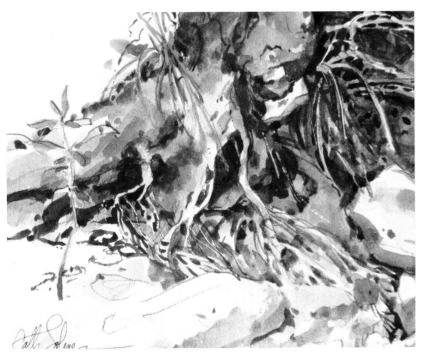

I didn't have my camera with me when I did this painting, so I wasn't able to do step-by-step slides, but here you can see a detail of the area to the lower right, where I concentrated on the negative shapes between the little roots that suggested their complexity.

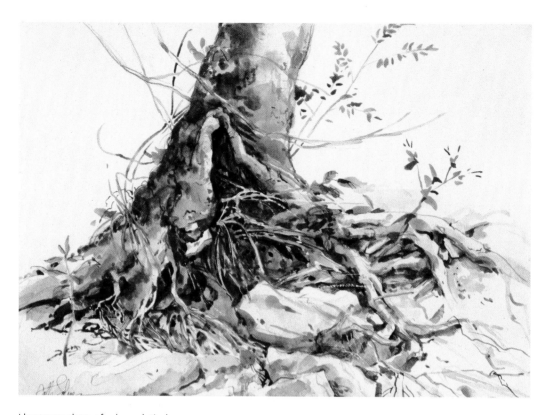

I kept my palette of colors relatively simple, using mostly subtle grays and browns, with sap green to suggest the richly colored grasses and moss on the side of the tree. Brown madder alizarin lent a bit of warm color to the fallen leaves that were caught in the rocks and between the roots. Notice that for unity I used a subtler mixture of the same color on the vines and branches around the trunk itself.

It isn't even necessary to complete a detail study if you don't want to. Judy Gehrlein spotted a small clump of mushrooms in the damp upland forest overlooking the Missouri River and decided she wanted to do a quick study with her lightweight and simple traveling studio.

She concentrated on the negative shapes of the earth and forest duff around the small, pale gilled mushrooms to make them pop out of the background. That was enough; no more detail was necessary.

Light and Shadows

This effect is so fleeting that sometimes it's best to use a very simple, quick approach. My painting buddy and I had walked quite a ways, and the day had started to warm up. We found a bench beside the trail at the Martha Lafite Thompson Nature Center in Liberty, Missouri, and decided to rest a bit under a huge cottonwood.

I was immediately struck by the small sprout that grew from the side of the tree, and decided quickly to capture it on paper before we quit for the day.

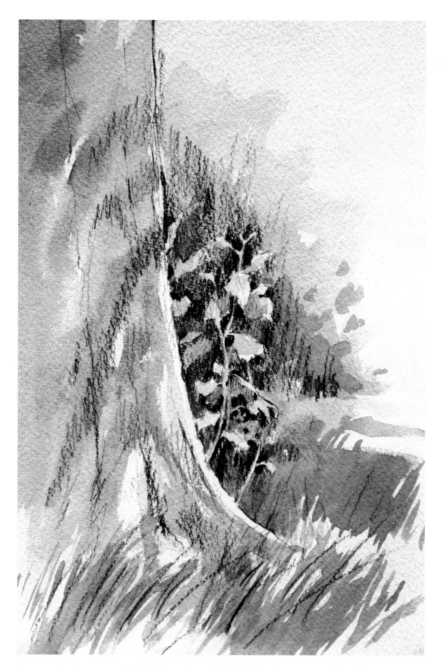

It was a simple matter to lay in the washes quickly, letting the painting fade off into a rough vignette on the right. I used wet-in-wet work to suggest the muted shadows on the side of the old tree trunk, and strokes with the edge of a flat brush to suggest the foreground grasses.

One of the fastest ways to work is to do a sketch using a dark wax-based colored pencil, then splash on washes. That's what I chose to do here, before the light changed too much.

360 Degrees

Consider all aspects of the place in which you find yourself. If you can, return to it over and over; make it a special place, forge a relationship. I found a spot to paint on the high loess bluffs overlooking the Missouri River and never did get bored with the possibilities. I looked north, south, east, and west from that windswept place and enjoyed many a morning there, painting before the day became too oppressively hot.

This painting was done looking to the east in the early morning; the colors are pastel except for the dark green of the trees, which were almost in silhouette.

Another early morning. This view down across the old oxbow lake caught my eye.

I decided to try that same vista a bit later in the day. Though the light was not conducive to very good step-by-step pictures, you can see the progression of steps.

Looking westward toward Kansas City, the view was one of receding hills. The trees became softer and simpler-looking in the distance and I decided to try to capture that effect. This step shows the basic drawing and the first, light washes, done wet-in-wet.

When that was dry, I added somewhat darker washes to define the shapes.

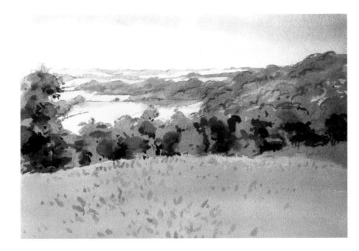

A third layer, with deep shadows and simple details, completes the scene.

In this detail shot you can see how tiny lines and dots applied with the tip of the brush suggest the rounded leaves of the soybean field where I worked.

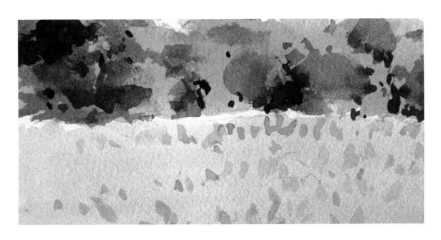

Simplifying What We See

Sometimes a scene is so complex it just gets away from us—it happens to all of us. There may be just too much detail to take in—leaves, shadows, reflections—and if we are not able to simplify the scene we end up with a confusing mess. Don't feel you've wasted your time or materials, though—you've still had time outdoors, alone or with a friend, and you've responded to nature.

In this painting, that's exactly what happened. The details got away from me. I wanted to capture the leaves, grasses, foliage, branches, twigs, and roots—but I was also taken by the shadows on the small sandbar and on the water. And then of course there were reflections, and the motion of the water itself. It was simply too much, and I was overwhelmed—and so was my painting. The pattern ended up being so overall that it looks like a hunter's camouflage jacket!

Don't despair when something like this befalls your work—it's a learning experience. I took another few minutes at the scene that summer day to do a very small study just a few feet upstream—if you look

Photo of scene

closely, you can see the same pool of reflective water and reaching limbs in the middleground of my "camo painting." But in the small study I zeroed in on a simpler subject and kept the shapes and values simpler as well. It was a much more successful attempt than the larger piece, and is more true to my feeling for the small pool in the little stream. And it took only a few moments more.

The picture on the following page, looking up into the foliage, shows just how involved even a relatively simple scene can be. Summer trees, leaves and branches, can be quite confusing and complex. Still, it needn't be intimidating. Look for ways to simplify it by deliberately painting only the most necessary details—the heart or essence of the scene, or by using your larger brushes for as long as you can, and by keeping colors to a minimum.

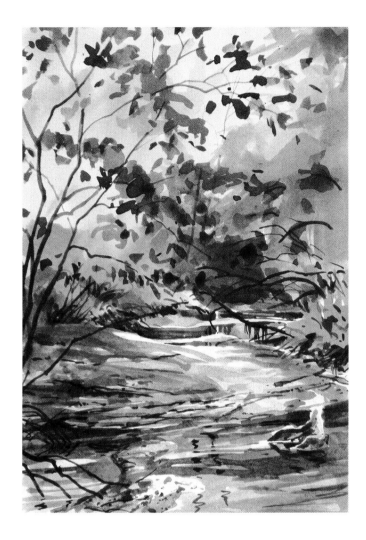

Camouflage
painting

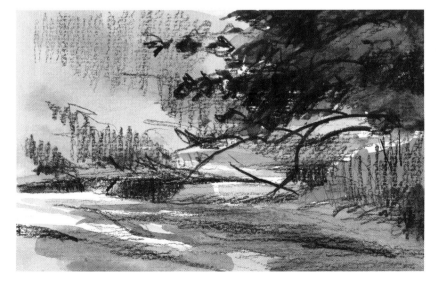

Small sketch of
scene, simplified

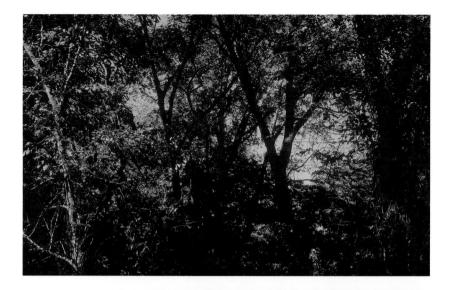

Photo of scene
with trees

Remember, it's not necessary to try to paint every leaf or twig. You can tell how much I simplified the subject, reducing it essentially to four values. It still captures a sense of place, to me, and I recall the day as though it were yesterday.

This little study was done using a fairly large brush throughout, which kept me from getting overinvolved in niggling details.

Human Nature

Actually, this play on words is meant to suggest not only painting man-made things in natural settings, be they bridges, buildings, wagons, or what have you, but the basic human need to create, and re-create. This little bridge is in fact the third bridge across my small creek—the first two, makeshift constructions that were too cheaply built, disappeared downstream over the years when high water battered them. The flood of '97 tore this one from its moorings and broke it in the middle as though it were a child's toy; we salvaged as much of it as we could to build the fourth bridge. (The flood of late '98 took it, too, and I do believe *this* human has finally learned that nature doesn't *want* a bridge there.)

Here is the scene as it appeared to me—a very green midsummer scene!

I settled myself to work, seated on the limestone bedrock, with my tools spread around me, and sketched the scene on my watercolor block. Since the skewed perspective of the bridge was a bit complex, I drew it in a little more carefully than normal. Then I added the first light washes.

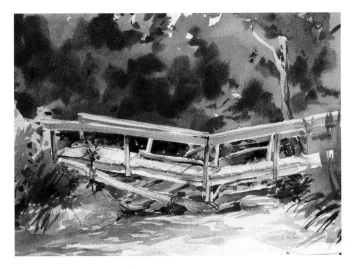

When that was completely dry, I added the first washes on the bridge itself. I wanted to make sure my subject stayed light enough to be in sharp contrast to its surroundings, and sometimes the best way to do that is to paint it in first. As you can see, it is fairly complete at this point.

This next view shows the wet-in-wet foliage behind the bridge— I used no masking agent but simply painted around my subject using a flat brush and flooding in strong darks to make the bridge pop out of the background.

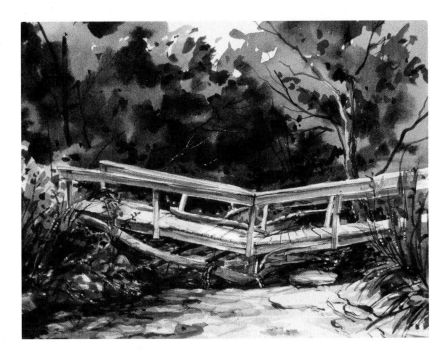

I waited again until everything was dry, then added the small details of limbs, grasses, cracks in the limestone, etc. I scratched a few small lighter branches out of the background with the tip of a sharp blade, then used the same point to scratch a few grasses and roots in the foreground, just to add a little interest in those areas.

Gouache and Foliage

Here I was interested in the lacy patterns of foliage and sky that I found beside Cooley Lake, an old oxbow of the Missouri River. It was very pretty against the blue sky, so I decided to experiment with using watercolor and gouache—transparent and opaque combined.

Photo of scene

Here, I used a strong, varied green underwash of transparent watercolor, even in the sky area. I wanted it to sparkle through the later layer, just a bit. I laid in the rough shape of the trees but didn't worry about detail. I let the dark green shadow shape in the foreground blend in the tree itself, and while that was damp, scraped out some lighter lines to suggest trunks.

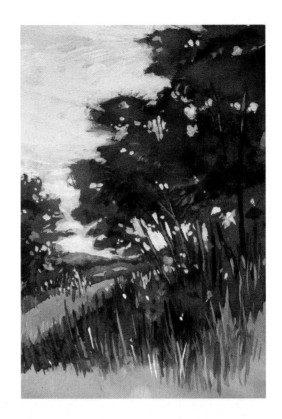

Here, you can see that I used a darker blue opaque mixture to suggest the far hills, and used a bit of yellow and white gouache for the lighter grasses and flowers in the foreground detail, below.

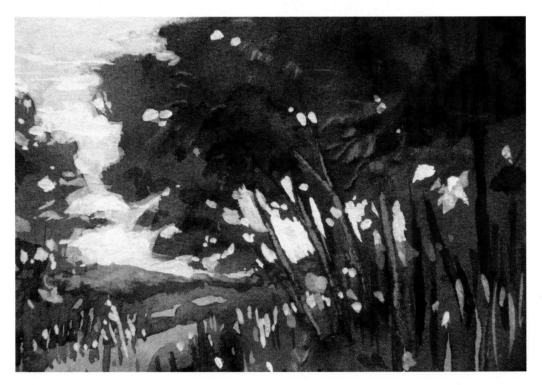

Autumn Colors in Acrylic

The colors of fall are sometimes tricky, as noted elsewhere—it's easy to get too garish. Somehow, using acrylic in an opaque fashion seems a way to avoid that pitfall. I wanted to focus on the bare locust tree against the oak forest beyond—it was a subject that could easily have gotten too complex and muddy, but I decided to handle it carefully, in layers, to see if I couldn't maintain a believable depth.

I am not as fond of the consistency of acrylics as I am that of watercolor or gouache—I find it harder to mix as quickly as I like. But it does work well for outdoor work since it dries quickly and I don't have to carry home a wet painting, as I would with oils.

Photo of autumn scene

In step one I mixed a nice autumn color with reds and browns to suggest the colors of the oak forest near my cabin and painted it on with a flat brush, varying the color as I worked by adding a bit more red or yellow. I suggested the limestone bluff at lower right with a cooler mixture that included white, blue, and brown. The sky color was laid in when that dried, and I "punched" some open areas for sky holes in the foliage at the top of the hill.

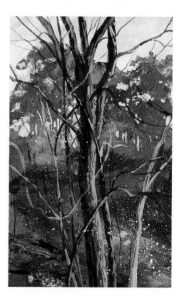

Acrylics dry quickly, so I waited a bit and then added the shape of the foreground tree, modeling it with lighter and darker mixtures of its basic tone.

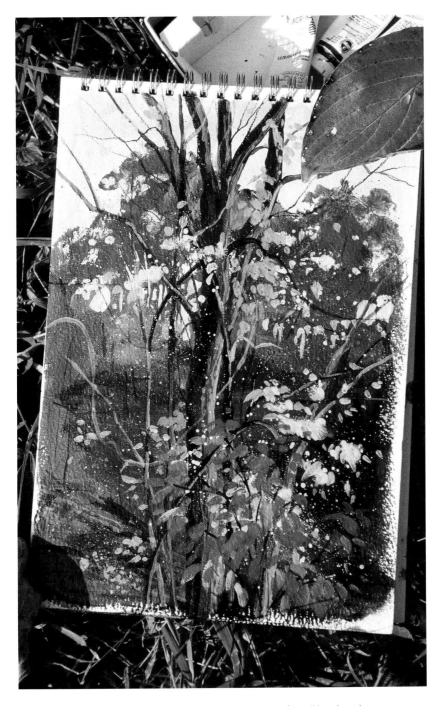

Finally, I added lighter-colored spatter and a warm, rosy bit of small brushwork to suggest the bright dogwood tree in the foreground. A smaller brush and both darker and lighter mixtures of pigment worked well for small limbs and vines and made them stand out from the background. I was delighted that just as I got ready to shoot this last picture, a leaf fell from the Virginia creeper vine to brighten the scene!

Focus on a Single Object—Acrylic

I am very fond of this old tree by my creek; it has appeared in every book I've written since I acquired my land ten years ago. A terrific storm took it down one night, but I still continue to paint it. I wanted to try it in acrylic this time.

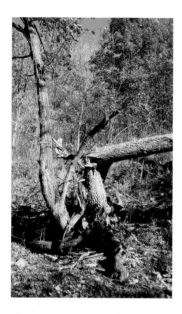

Photo of scene

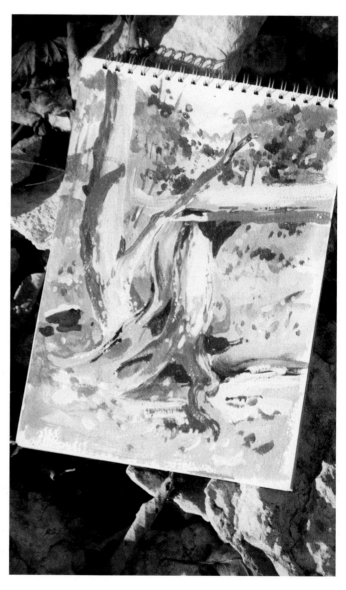

After drawing my tree onto the heavy paper in my sketchbook, I laid in the basic forms using quick, broad strokes and a bristle brush, covering my whole page at once.

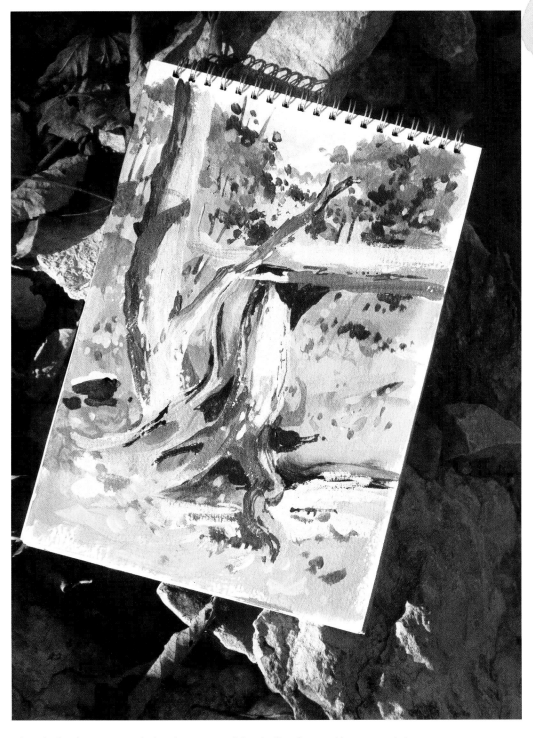

When the first layer was mostly dry, I began to model and refine shapes with stronger, darker
mixtures of basically the same colors.

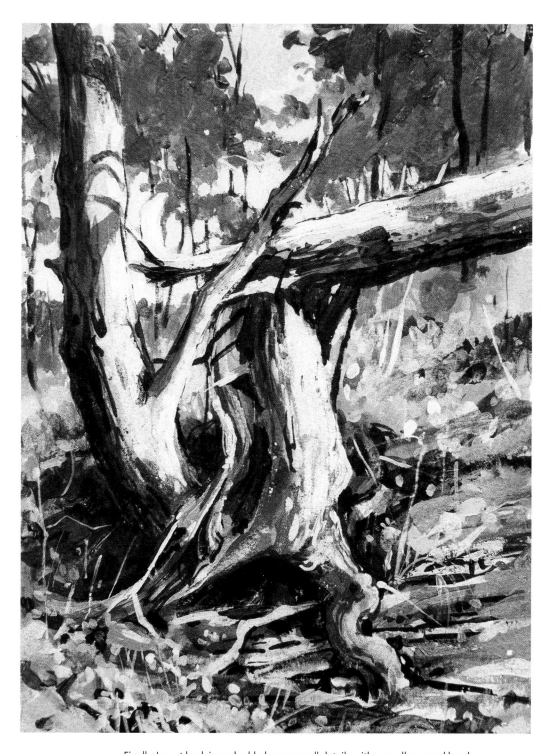

Finally, I went back in and added many small details with a smaller, round brush.

Notice how curved shadows on the trunk add to the illusion of roundness.

To suggest the leaf litter and small plants at the base of the tree, I used a subtle green and a small brush, with playful, dancing strokes.

As I write this I am looking across a farmer's field—it has been harvested and lies plowed for its winter rest. The fringe of trees between it and the small gravel road throws impossibly long shadows halfway to the next county. Beyond, a hill bristling with bare trees stands half lit in the afternoon sun. At its base the shadows pool, deep blue gray, and the pale trunks and branches of sycamores stand in sharp relief. It would make a wonderful painting with its myriad contrasts, and the image would remind me of my supper of fresh croissant and smoked cheese and Lemonade Brew and a crisp autumn apple, and the wild, timeless music of migrating geese. That's the beauty of painting in nature. We capture far more than a mere painting subject alone—we stop time in its tracks.

Appendix I

Where to Buy Equipment and Supplies

MOST ART SUPPLY STORES will carry the basics you will need for painting outdoors; it has become more popular in the last few years, and you'll find all sorts of small traveling painting kits. If the store doesn't have a special section of travel supplies, although many do, watch for things you can work with—a small watercolor box or palette, a pencil box in which to keep your sketching tools and watercolor pencils, small hard-bound sketchbooks that will take washes, watercolor blocks, larger backing boards to which to fasten your paper, knapsacks, toolboxes—although these last two might be bought as well at your local discount store, often for a lower rate.

Office supply stores may be a convenient source for pencils to do your preliminary sketches, erasers, pencil boxes, and sometimes even inexpensive watercolors and sketchbooks. (The inexpensive watercolor sets like Prang's are fine for getting started, but graduate to better quality as soon as possible.) Consider large folders or heavy manila envelopes for transporting your work, or briefcases, laptop holders, and such to work out of. I've used all with some success.

Hobby and craft stores often carry the basics—sketchbooks, knapsacks, tote bags (one of my students carried all her painting supplies in a soft, folding baglike tote meant for knitting), and paints and brushes. The larger ones may have *everything* you could ever need.

Stationery stores or departments often have their own versions of what we used to call "empty books," hard-bound journal-style books with blank pages. Some of these are quite useless for painting on, with paper too thin to prevent buckling, but others have satisfyingly heavy paper with a nice tooth for a number of mediums. I use one as my field journal and often do paintings in it as well. Some even have toned paper suitable for working with pastel or gouache.

Check with camping supply or army surplus stores for knapsacks or water containers—my old canteen-and-cup arrangement came from one of these. Newer army surplus models are olive drab green plastic—probably lighter to carry—and have a snap-on cap.

Consider mail-order if you're unable to find what you need nearby. These are some of the best sources I've found for traveling supplies:

Daniel Smith Inc., 4130 First Avenue South, Seattle, WA 98134, 800-426-6740, is, bar none, the finest source for the outdoor artist to my knowledge. Look in the large annual catalog for paints (oil, watercolor, gouache, acrylic), folding travel brushes (they carry a nice selection of their own brand of folding brushes in both Kolinsky sable and synthetic blends, along with those of other manufacturers), brush carriers, watercolor blocks from size five by seven to eighteen by twenty-four, pastels, watercolor pencil sets as well as individual pencils in open stock, hard and soft pastels in sets and open stock, painting supports, folding easels, traveling and field-style watercolor boxes, folding pack stools . . . You want it? They've got it. Add that to the fact that they're a pleasure to work with, have a customer-service department with encyclopedic knowledge, and fill orders with the care of a brain surgeon at work, and you see why I deal with Dan.

On the East Coast, check with **New York Central Art Supply,** 62 Third Avenue, New York, NY 10003. Discount prices and eighty years of experience plus a wide selection of specialty items recommend this company to the outdoor artist.

Dick Blick, Box 1267, Galesburg, IL 61401, has a very complete catalog of supplies; order from the location nearest you for quickest delivery. (Locations are listed on the back of the catalog, which is sent from the main offices, above.)

ASW (Art Supply Warehouse) has good sales prices. Contact them at 5325 Departure Drive, Raleigh, NC 27616-1835, or call 800-995-6778.

Cheap Joe's Art Stuff, at 374 Industrial Park Drive, Boone, NC 28607, 800-227-2788, offers books, art supplies, and equipment at discount prices.

Pearl, CC 308 Canal Street, New York, NY 10013, 212-431-7932, advertises itself as the world's largest art and graphic discount center; I've talked to people who have ordered from them and were quite happy with selection and service.

When you order from **Utrecht,** 33 Thirty-fifth Street, Brooklyn, NY 11232, 800-446-5550, you're ordering direct from a manufacturer for colors, canvas, etc., and savings can be impressive. They also carry

other manufacturers' products. My cousin has dealt with them for years, and happily. Catalog is free.

Jerry's Artarama, PO Box 58638, Raleigh, NC 27658, 800-U-ARTIST, carried the Jullian French easel at a good price.

For pochade boxes, contact:

Mike Maier, Open Box M, 1392 S. Fork Road, Cody, WY 82414, 307-527-4669. Mike also makes storage boxes for wet paintings.

Douglas Smith makes nice lightweight boxes. Try him at PO Box 4057, Old Lyme, CT 06371, 860-434-6225. He also makes carriers for wet paintings.

Or contact **McFarland Paint Box,** 1630 Roanoke Way, Mercer Island, WA 98040, 208-232-0836.

There are several types of wet painting carriers for those who prefer to work in oils—other suppliers include **Linda or Dean St. Clair,** 1008A Paseo Del Pueblo Sur, #253, Taos, NM 87571, 505-751-7822, or **Jack Warden,** 1633 Bennington Hollow Lane, Reston, VA, 20194. I don't have a phone number for the latter, but I understand he also makes pochade boxes.

Spectrum Manufacturing Co., 1313 Canal, Alamogordo, NM 88310, 505-437-8846, makes various sizes of prepared and gessoed panels to work on with oils or acrylics.

For some of the best in instructional books, contact **North Light Books,** 1507 Dana Avenue, Cincinnati, OH 45207, 800-289-0963.

Great books are also available from **Watson-Guptill** and **Storey Books.**

Duluth Trading Co. offers a wonderful variety of carrying cases and equipment meant for construction workers. Here you'll find a contractor's field bag, a contractor's portfolio, a briefcase that would hold tools and equipment nicely. There are bucket stackers, totes, and a great Czechoslovakian Plumber's Bag in leather, any of which would make wonderful traveling studios for the outdoor artist. Contact them at 5200 Quincy Street, St. Paul, MN, 55112-1426, 800-505-8888, or visit their website at *http://www.duluthtrading.com.*

Appendix II

Workshops and
Outdoor Painting Opportunities

IT IS OFTEN VERY helpful, your first few times out—or even after years of painting on your own—to attend a workshop. There are all too few of these available to the artist seriously interested in working outdoors, rather than in the studio, but there are some.

To find an area of the country, a workshop, or a teacher that interests you, look in one of the workshop issues of *The Artist's Magazine,* 1507 Dana Avenue, Cincinnati, OH 45207, 513-531-2222 (or check your newsstand or art supply store). Previously only listed in March, the September issue now also offers a roundup of fall and winter workshops. Look also in *The American Artist* (1515 Broadway, New York, NY 10036) for workshop information.

Colleges, junior colleges, or universities and other continuing adult education programs may offer painting sessions on a single weekend or as an ongoing class lasting a semester or more. There may be a summer or evening program or a workshop. Or you may just be able to find some kindred spirits who will want to go outdoors to paint, maybe weekly or monthly.

En Plein Air Art Excursions in Europe offers painting trips to Monet's garden, Giverny, the villages of Provence, a Burgundy waterways tour, or Venice, Italy. Contact them at 48, rue Damrémont, 75018 Paris, France, or call 301-961-1062, or e-mail at *enpleinair@compuserve.com.*

Maine Coast Art Workshops, PO Box 236, Port Clyde, ME 04855-0236, 207-372-8200. Contact Merle Donovan. A number of artists provide workshops through the June-to-October season; I enjoyed my teaching session there, and took my students to the shore and to a beautiful garden to paint.

Dillman's Creative Arts Foundation, Box 98, Lac du Flambeau, WI

THE SIERRA CLUB GUIDE TO PAINTING IN NATURE

54538. Contact Dennis Robertson at 715-588-3143. Dillman's has a full schedule, with several workshops a week, May through October. You may find possibilities among them.

You may want to check out **Flying Colors Art Workshops,** which arranges trips to Acapulco, Europe, and Japan, as well as Taos and Santa Fe. Write to Johanna Morrell at 5761 E. Ithaca Place #1, Denver, CO 80237, to see if any of their workshops would fit your needs. Or check their web page at *www.flyingcolorsart.com.*

Artist **Camille Przewodek** teaches plein-air painting in the south of France and in Northern California. She takes up to eighteen students in a single workshop. Contact her at 707-762-4125 to find out more about her schedule of classes.

You may prefer something more obviously nature-oriented, like the workshops offered by the contacts below.

Check with the **Roger Tory Peterson Institute,** named for the famous bird artist and field-guide author, 311 Curtis Street, Jamestown, NY 14701-9620, 716-665-2473. They sponsor workshops all over the country. Be sure to ask what mediums the classes are using.

If you'd like to travel to a spectacular locale to practice working in nature, as well as keeping a field journal, contact the **Teton Science School** (Ditch Creek Road, PO Box 68, Kelly, WY 83011, 307-733-4765, or visit their website at *www.info.tetonscience.org*), which offers a variety of seminars with excellent teachers including author/artist **Hannah Hinchman,** whose books appear in our bibliography. Hannah is wonderfully talented; her work has also graced the pages of *Sierra* magazine. She will offer a workshop on "The Nature of Art and Science" with **Bruce Thompson. Meredith Campbell** also teaches there on wildflower identification and documentation.

The Yellowstone Institute, PO Box 117, Yellowstone National Park, WY 82190, 307-344-2293, offers Hannah's classes, but they always fill up quickly. You may also want to check with the **Glacier Institute,** PO Box 7457, Kalispell, MT 59901, 406-755-1211, which offers the Illustrated Field Journal Class, taught by Hannah Hinchman; Glacier also offers outdoor watercolor classes taught by Barbara Mellblom, their artist in residence. **The Nature Conservancy's Tensleep Preserve,** 101 Rome Hill Road, Ten Sleep, WY 82442, 307-366-2671, offers a variety of outdoor classes that should be of interest.

Author, artist, and naturalist **Clare Walker Leslie** also conducts courses in field sketching all over the country. Contact her at 76 Garfield Street, Cambridge, MA 02138, for a schedule of where and when.

Organizations like the **Appalachian Mountain Club** sponsor work-

shops. Contact them at 5 Joy Street, Boston, MA 02198, for further information. Nature sanctuaries, state and national park visitor's centers, and local community centers sometimes sponsor outdoor painting workshops or seminars.

Art museums sometimes sponsor workshops; call to find out, or express your interest—they may look into the possibility just for you. Even local community centers sponsor such workshops; the Merriam, Kansas, Community Center hosts workshops all year.

Check the nature and outdoor magazines for workshop possibilities: *Sierra, Audubon, National Wildlife, Wilderness,* etc., for information on nature travel tours and photography workshops; you may also find outdoor painting opportunities.

Bibliography

You may find it difficult to find an outdoor painting workshop in all parts of the country, but there are several excellent books on the market that can guide your individual studies, whatever your field of interest—though at present there don't appear to be very many (other than this one!) that concentrate on the subject of working on the spot. In this list are some of my favorites, as well as a number of books that explore various techniques and mediums.

Blockley, John, *Getting Started in Watercolor;* North Light Books, Cincinnati, OH, 1985. This is a lovely book by an English painter—many delightful ideas about painting in nature. Blockley does much of his sketching and painting on the spot, some from memory, some from inspiration.

Crawshaw, Alwyn, *Alwyn Crawshaw Paints on Holiday;* North Light Books, Cincinnati, OH, 1992. A delightful book that invites you to paint on locations all over the world, and suggests ways to incorporate your sketches and photos into paintings once you return home.

Creevy, Bill, *The Oil Painting Book: Materials and Techniques for Today's Artist;* Watson-Guptill Publications, New York, 1994. A primer of oil painting techniques.

Cuthbert, David, *The Pastel Painter's Solution Book;* North Light Books, Cincinnati, OH, 1996.

Daly, Thomas Aquinas, *Painting Nature's Quiet Places;* Watson-Guptill Publications, New York, 1985. A wonderfully inspiring book, and one that will convince you that there is no need to work large to carry off an evocative landscape.

DeMore, Louise, *First Steps Series, Painting Oils;* North Light Books, Cincinnati, OH, 1996. Nice, basic, approachable stuff.

Doherty, M. Stephen, *The Watson-Guptill Handbook of Landscape Painting;* Watson-Guptill Publications, New York, 1977. Covers oils, acrylics, watercolors, alkyds, caseins, and pastels in one place.

Gair, Angela, *Acrylics: A Step-by-Step Guide to Acrylics Techniques;* Lett's of London, 1994. A basic primer of acrylics techniques.

Hill, Tom, *Painting Watercolors on Location;* North Light Books, Cincinnati, OH, 1996. Plenty of ideas and step-by-step demonstrations in beautiful locations.

Hinchman, Hannah, *A Life in Hand: Creating the Illuminated Journal;* Peregrine Smith Books, Salt Lake City, 1991. A wonderful and inspiring little book that comes in a slipcase with its own sketch journal for you to work in. A lovely place to start learning how to create.

————, *A Trail Through Leaves: The Journal as a Path to Place;* W. W. Norton & Co., New York, 1997. A beautiful book that leads you into new ways of seeing and making connections with the land around you—and suggests ways to bring your art to it as well.

Johnson, Cathy, *Creating Textures in Watercolor;* North Light Books, Cincinnati, OH, 1991. Covers a number of techniques to suggest nature's textures.

————, *Drawing and Painting from Nature;* Design Press, a subsidiary of Tab Books, New York, 1989. Covers painting, drawing, Old Masters and new.

————, *First Steps in Watercolor;* North Light Books, Cincinnati, OH, 1995. Step-by-step informational book covers the basics from supplies to easy techniques.

————, *Painting Nature's Details in Watercolor;* North Light Books, Cincinnati, OH, 1987.

————, *The Sierra Club Guide to Sketching in Nature;* Sierra Club Books, San Francisco, 1991. Includes some information on painting, basic information and inspiration on working outdoors, from nature; planning, techniques; how-to.

————, et al., illustrator, *The Walker's Companion;* Nature Company, 1995. This is noninstructional but I hope inspirational.

————, *Watercolor Tricks and Techniques;* North Light Books, Cincinnati, OH, 1987.

Khan-Leonard, Angelika, "Learn from the Masters" series, *Create Your Own Watercolors in the Style of J.M.W. Turner;* Search Press, Tunbridge Wells, Kent, Great Britain, 1992. (Others in this series include Cézanne, van Gogh, and Gauguin.)

Leslie, Clare Walker, *The Art of Field Sketching;* Prentice-Hall, Inc., Englewood Cliffs, NJ, 1984. A wonderful introduction to the

subject; includes the work of professional naturalists, illustrators, and students.

————, *Nature Drawing: A Tool for Learning;* Prentice-Hall, Inc., Englewood Cliffs, NJ, 1980. This book truly is "a tool for learning." Enjoy it.

———— and Charles E. Roth, *Nature Journaling: Learning to Observe and Connect with the World Around You;* Storey Books, Pownal, VT, 1998. Concentrates more on sketching than painting but does include some lovely ways of adding color to your work.

Lord, Vicki, *First Steps Series, Painting Acrylics;* North Light Books, Cincinnati, OH, 1996. Like North Light's other First Steps books, this one shows you the basics of using this medium in a number of applications.

Nice, Claudia, *Painting Nature in Pen & Ink with Watercolor;* North Light Books, Cincinnati, OH, 1998. Very nice mixed-medium effects that are beautiful and also quite useful if you are more comfortable with drawing than with painting.

Ranson, Ron, and Trevor Chamberlain, *Oil Painting, Pure and Simple;* Blandford Press, Poole, New York, Sydney, 1986. A delightful little book that takes you on location with oil painting in some very inspiring ways. Most of the paintings included are quite small.

Rocco, Michael P., *Painting Realistic Water Textures;* North Light Books, Cincinnati, OH, 1996.

Rodden, Guy, *Pastel Painting Techniques;* North Light Books, Cincinnati, OH, 1987. A nice variety of basic pastel techniques.

Seligman, Patricia, *The North Light Pocket Guide to Painting Skies;* North Light Books, Cincinnati, OH, 1997. These tiny Pocket Guide books are ring bound so you can tuck them into your knapsack and use them in the field for quick and easy reference. Demonstrations are in all mediums.

————, *The North Light Pocket Guide to Painting Trees;* North Light Books, Cincinnati, OH, 1997. A nice small reference book, also ring bound for easy access. Lots of ideas and eye-openers in all mediums.

Sidaway, Ian, *The Mixed Media Pocket Palette;* North Light Books, Cincinnati, OH, 1996. This one is more on mixing colors and getting the effect you are after in a variety of mediums. Excellent information and inspiration.

Sims, Graeme, *Painting and Drawing Animals;* Watson-Guptill Publications, New York, 1983. There is more drawing than painting here, and the technique is fresh and interesting.

Stobart, John, *The Pleasures of Painting Outdoors;* North Light Books, Cincinnati, OH, 1993. Very enjoyable book with some good suggestions for working on the spot.

Van Hasselt, Tony, and Judi Wagner, *The Watercolor Fix-it Book;* North Light Books, Cincinnati, OH, 1992. This book helps you get past your anxieties about doing everything right the first time. None of us does.

Wolf, Rachel Rubin, editor, *Basic Nature Painting Techniques in Watercolor;* North Light Books, Cincinnati, OH, 1998. A compilation of a variety of very useful techniques from North Light Books.

————, editor, *The Best of Wildlife Art;* North Light Books, Cincinnati, OH, 1999. Ninety-six different artists explore painting wildlife.

Don't overlook noninstructional books. Look for books on specific areas or ecosystems, or naturalist/artist's published sketchbooks, many of which are more paintings than sketches. Edith Holden's works were republished in the seventies—you should be able to find the *Country Diary of an Edwardian Lady* in a used-book store or library. Look also for Rein Poortvliet's beautiful books, and Sara Midda's. Study Matisse, Asher Durand, Thomas Moran, John Marin, Monet, van Gogh, Cézanne, Georgia O'Keeffe, and books on paintings of the American West, many of which were done on the spot. Look at books like *Karl Bodmer's America,* as well (Hunt, David C., and Marsha V. Gallagher, Joslyn Art Museum, Omaha, NE, 1984) and the works of George Catlin.

About the Author

CATHY JOHNSON is a writer, artist, naturalist, publisher, and lover of history who keeps a lot of plates in the air. She has written and/or illustrated twenty-five books on the subjects of art, nature, and history, including *The Sierra Club Guide to Sketching in Nature; On Becoming Lost; The Nocturnal Naturalist; Painting Nature's Details in Watercolor; The Naturalist's Cabin; Creating Textures in Watercolor; One Square Mile; An Artist's Journal of the American Heartland;* and *Nature Walks: Insight and Advice for Observant Ramblers.* She began her own small publishing company in 1996 as an outlet for her interest in history and historical interpretation and has published four books in a projected series of ten. Her art books have seen publication in Britain and Australia and have been translated for publication into French, Dutch, Italian, and Japanese; she sometimes laughs because she can't read her own books. Her work has been included in such books as *The Walker's Companion, Women in Wilderness,* and *The Earth at Our Doorstep* as well as John Elder's massive *American Nature Writers.* A longtime columnist and contributing editor for *The Artist's Magazine* and *Country Living,* where she has been staff naturalist since 1988, Johnson has also written and illustrated for such diverse periodicals as *Science Digest, The Mother Earth News, Sierra, Harrowsmith, Muzzleloader, Country Life, Sports Afield,* and *Early American Life* (now *Early American Homes*). Her writing has appeared on Sierra Club calendars. She has written scripts for Marty Stauffer's *Wild America.* Winner of the Thorpe Menn Award in 1992 for *The Naturalist's Cabin,* she is a member of the Author's Guild, Sierra Club, and the Audubon Society.